Students and External Readers	Staff & Research Students
DATE FOR RETURN	DATE

LITERATURE AND THE PLASTIC ARTS
1880 - 1930

LITERATURE
AND THE
PLASTIC ARTS 1880-1930

Seven Essays

EDITED BY

I. HIGGINS

SCOTTISH ACADEMIC PRESS
EDINBURGH & LONDON
1973

Reprinted from
FORUM FOR MODERN LANGUAGE STUDIES
Volume IX No. 1

———

Published by
Scottish Academic Press Ltd.
25 Perth Street, Edinburgh EH3 5DW

Distributed by
Chatto and Windus Ltd.
40 William IV Street
London WC2

SBN 7011 1973 X

Printed in Great Britain by
W. C. Henderson & Son Ltd., St. Andrews

FOREWORD

The relation between the linguistic and the plastic arts came to acquire particular importance for artists during the period covered by this volume. Yet most studies on the subject concentrate on biography and parallels in subject-matter. The problem for the artists themselves, however, was often not what the subject-matter should be, but whether there should or could be one, what the relation of subjective experience is to the objective world —whether to express or to transcend a mysterious and changing world. The problem is found in the work of Verhaeren, Barlach and many of the pre-revolutionary Russian *World of Art* group in the success or failure of *drama* as a meeting-point of the arts. For Verhaeren, its value is that it combines the plasticity of sculpture with movement, whereas for Barlach its movement betrays the static harmony he tries to evoke in his sculpture and graphic work. For many of the Russians, it turned out to be simply an exercise in synthetic techniques. The relation of the literary to the plastic in painting is something with which Apollinaire, in some ways the most influential of those considered here, never fully came to terms, as clearly emerges from the study of his interest in allegory. One possible solution to the problem which gradually came to the surface during the period was that of concrete poetry, and the work of Schwitters is a vital turning point in its development. Another solution was sought by the Surrealists in the exploration of the imagination : Eluard's poems for painters bring out clearly not only the interest of comparative aesthetics, but the Surrealists' concern with creativity itself as the vital problem. The relevance of this to the whole field emerges in the study on two schizophrenics who drew and wrote compulsively : it is clear that the aesthetic questions raised by the volume as a whole, which may be summed up as the problem of *metaphor* in and between the arts, cannot be fully grasped without some hypothesis of a common primary stimulus, not essentially verbal *or* pictorial.

These are preliminary studies on a relatively new subject, and there are necessarily links between the articles which cannot be brought out in a collective volume of this nature—for example the relation of Symbolism to Expressionism, or of both to Surrealism, or the question of abstract art, or what seems to be the vital question of *rhythm* in the study of art and creation. It is our hope that these articles will serve as a stimulus to a further investigation of this important and developing field.

I should like to thank Professor D. D. R. Owen, Dr W. H. Jackson, Miss Sylvia Easton and Mrs Esther Higgins for their great help in the editing of this volume.

<div align="right">I.H.</div>

CONTRIBUTORS

IAN HIGGINS, Lecturer in French at the University of St Andrews, has published articles on Verhaeren and Prévost. He is at present working on studies of Sartre and Ponge.

PETER MEECH, Lecturer in German at the University of Stirling, has published articles on Käthe Kollwitz and foreign literature teaching in schools. He is currently working on art and literature and on the reception of German literature in Britain.

JOHN BOWLT, at present Visiting Assistant Professor at the University of Texas, has published many articles on Russian Symbolism, particularly in the context of painting. His book, *The Modern Russian Masters*, will be published this year.

GEORGE T. NOSZLOPY, Senior Lecturer in the History of Art at Birmingham Polytechnic, is the author of a book on Bryan Pearce and many articles on art. He is at present working on Botticelli, Isabella d'Este's Studiolo in Mantua, and Robert Delaunay.

ULRICH FINKE, Lecturer in the History of Art at the University of Manchester, has published or edited books on German and French nineteenth-century art. His present research is on the structure of the quotation in the visual arts, as applied in Dürer's graphic work.

ANNE HYDE GREET, Professor of French at the University of California, has published a collection of poems, books and articles on twentieth-century French poets, and a number of translations of Greek, Latin and modern French poetry. She has in press a book on *Apollinaire et le livre de peintre*, and is at present working on several projects, notably one on Eluard and the *livre de peintre*.

ROGER CARDINAL, Lecturer in French at the University of Kent, has published articles and a book (with Robert S. Short) on Surrealism, and a book entitled *Outsider Art*, on *Art Brut* and extra-cultural creativity. He is preparing books on German Romantics and the poetic imagination.

CONTENTS

LIST OF ILLUSTRATIONS

39. J. Miró, *La Naissance du monde*. Private collection.
40. A. Klotz, *Keller, Wirtshaus, Salon, Stall in Einem. Cigarre weg*. Prinzhorn Collection, Heidelberg.
41. A. Klotz, *Der Luftkrieg (Bild mit Speeren)*. Prinzhorn Collection, Heidelberg.
42. A. Klotz, *Wurmlöcher*. Prinzhorn Collection, Heidelberg.
43. A. Klotz, *Walfischer (Haben Sie eine Jungfrau gebrochen ?)*. Prinzhorn Collection, Heidelberg.
44. A. Wölfli, explanatory text ("Erklährung. Das Fronttseittige Bild, Der Huht : —Kupfer-Stich ", etc.) on reverse of the drawing *Schützenfest im Skt. Adolf-Heim-Nord-Ost*. Archives of the Schweizerische Gesellschaft für Psychiatrie, Berne.
45. A. Wölfli, left-hand section of *Craw Fort, all fort 2:1 Grittli*. Archives of the Schweizerische Gesellschaft für Psychiatrie, Berne.
46. A. Wölfli, *Riesen-Stadt, Waaben-Hall, mitsamt dem gleichnamigen, Skt. Adolf-Ring, ditto, Schatz'l-Ring*. Kupferstichkabinett, Basle.
47. A. Wölfli, *Der Vatter Zohrn*. Archives of the Schweizerische Gesellschaft für Psychiatrie, Berne.

ACKNOWLEDGMENTS

The publishers have made every effort to trace copyright-holders, not always with success. They apologise in advance for any unauthorised use thus made of copyright material, and wish to thank the following for supplying photographs and permission to use them here (numbers refer to plates) : Art Institute of Chicago (15); Ernst Barlach Nachlaßverwaltung, Güstrow, D.D.R. (5-10) ; French Reproduction Rights, Inc., New York (38) ; Galerie Rothe, Heidelberg (41, 43, reproduced from *Bildnerei der Geisteskranken aus der Prinzhorn-Sammlung*, catalogue of an exhibition in Heidelberg, 1967) ; Galerie Zwirner, Cologne (33) ; Kunstsammlung Nordrhein-Westfalen, Düsseldorf (30) ; Kupferstichkabinett, Basle (46) ; M. François Lachenal (35) ; Musée National d'Art Moderne, Paris (37, cliché des Musées Nationaux) ; Museum of Modern Art, New York (36) ; Soprintendenza alle Galerie, Florence (1) ; Dr Th. Spoerri (44, 45, 47) ; Springer Verlag, Berlin/Heidelberg/New York (40, 42, reproduced from H. Prinzhorn, *Bildnerei der Geisteskranken*, reprint of 2nd edition, 1968) ; Verlag M. DuMont Schauberg, Cologne (29, 31, 34, reproduced from W. Schmalenbach, *Kurt Schwitters*, 1967).

I

TOWARDS A POETIC THEATRE : POETRY AND THE PLASTIC ARTS IN VERHAEREN'S AESTHETICS

H. R. Rookmaaker adapts Michaud in distinguishing three streams in both the literature and the painting of around 1890 in France. In literature, the first is *décadence*, the " poésie affective " of which Verlaine is the master ; the second is *symbolisme*, the neo-Platonist " poésie intellectuelle " whose chief figure is Mallarmé ; the third is that of *poésie fantastique*, centring on Rimbaud. In painting, artists typically corresponding to the first stream are Moreau and Khnopff, with their allegories ; to the second, Gauguin and the Synthetists and Nabis, with their rejection of allegory and their search for expression through plastic means before subject-matter ; and to the third, Redon, expressing estrangement from the outside world through a fantastic deformation of it.[1]

All three groups of painters turn away from photographic mimesis and are concerned with the meaning of the world lying behind appearances. For the Synthetists, the most important group, the great problem was to synthesise the world and the mind of the painter perceiving and reacting to it. In wanting to express the truth both of themselves and of the world, they come close in their theories to an idea of abstraction ; and their iconic simplification of form and reduction of modelling already indicated this in

[1] H. R. Rookmaaker, *Synthetist Art Theories*, Amsterdam, Swets and Zeitlinger, 1959. See pp. 66-84, 108-75. The reference is to G. Michaud, *Message poétique du Symbolisme*, Paris, Nizet, 1947. For the sake of brevity, I shall refer to the second group of painters simply as the Synthetists.

their practice.[2] There are minor variants in the theories and the practice, but they have in common a theoretic failure to integrate the iconic and the abstraction of line on the one hand, and the element of self-expression on the other. Sérusier is an example, wavering between a need to " bien connaître son sujet " and his insistence on the decorative.[3] Insofar as the decorative is taken to depend on objective laws of aesthetic harmony independent of subject-matter, as it generally was by the Synthetists, there is a double dualism : first, there is at best a parallel, but not identity, of the world represented and the mind of the artist ; second, there is a tendency, shared with the literary Symbolists, to see beauty as something static, a valuable permanence behind changing phenomena. There is thus an urge to synthesis which fails, because dynamic appearance and static essence are kept apart.

For the purpose of discussion I shall describe the aim of the Synthetists and the literary Symbolists as exemplification of the *idée* or law which is manifested in phenomena. That is, the aim is a work which would exemplify, in its own sensuous presence, the structures of the world and, through evocation or suggestion, the principle of the structures. This is what Sérusier, resuming the painters' tendency towards abstraction—albeit in religious terms—was to say in 1906 :

> la seule chose que puisse faire un artiste est d'établir une harmonie en formes et en couleurs. L'harmonie est le seul moyen, comme la prière, de nous mettre en communion avec Dieu. Tout le reste, dans l'art, n'est qu'illustration, sentiment personnel, individualisme, poésie humaine.[4]

[2] See especially the essays of their champion, G.-A. Aurier : " Le Symbolisme en peinture. Paul Gauguin", in : *Mercure de France*, mars 1891, pp. 155-65 ; and "Les Peintres symbolistes", in *Œuvres posthumes*, Paris, Mercure de France, 1893, pp. 293-309.

[3] I choose Sérusier because Rookmaaker sees him as having come closest, in the 90s, to realising a " seamless texture of two interwoven motifs, viz., that of the primacy of human personality (in his freedom) and that of the primacy of science motif (in its search for laws of nature) ", and as having, later, given up " the splendid unity of his theory " (pp. 167-72). I would contend that Sérusier is the most representative of Synthetist tendencies precisely in his hesitation between the two and his eventual recognition that it implies a theory of abstraction. See P. Sérusier, *ABC de la peinture*, suivi d'une correspondance inédite, Paris, Floury, 1950, p. 61.

[4] Op. cit., pp. 122-23. According to Rookmaaker (p. 170), Sérusier was at this time at the centre of a group of young artists which included Delaunay ! The " pure " extreme of this depersonalisation is invoked by Mondrian in his *Plastic Art and Pure Plastic Art*, New York, Wittenborn, 1945 : " [Pure reality] can only be established through *pure* plastics. In its essential expression, pure plastics is unconditioned by subjective feelings and conception [. . .] particularities of form and natural colour evoke subjective states of feeling, which obscure *pure reality*. The appearance of natural forms changes but reality remains constant. To create pure reality plastically, it is necessary to reduce natural forms to the *constant elements* of form and natural colour to *primary colour*" (p. 10). It is hard to see how the artist would abstract " pure reality " from appearances and express it without " subjective feelings and conception " being involved : Mondrian himself goes on to recognise that " the two opposing elements [i.e. expression of the world and of the self] are indispensable if the work is to arouse emotion " (p. 50). (Quoted in Herbert Read, *The Philosophy of Modern Art*, London, Faber, 1964, pp. 232, 235). At all events, it will become clear that in Verhaerenian perspectives, " pure abstraction " is as absurd a notion as " pure poetry " (in Bremond's sense), and expressionist abstraction as unlikely as Valéry's " sensation de ravissement sans référence".

3

It is a similar dream to Mallarmé's *explication orphique de la Terre*. But inasmuch as a law is an abstraction from phenomena, it cannot be exemplified. The law itself is only *manifested* in various ways in phenomena. Its *effects* are exemplified[5] and its *workings* are *typified* in phenomena. The typification of its workings is closer to exemplification of it insofar as they are perceived as relations ; but its effects and its workings both remain *expression* of it, not exemplification.[6] Further, to present a phenomenon in the outside world as an effect or a working is to interpret the phenomenon as expression—that is, subjectively to mediate or express the objective expression. In this subjective expression of the law, the phenomena invoked are simply correlatives of the abstraction. The evocation or suggestion remains analogy, and while an analogy may exemplify some things, notably analogy, it cannot usually exemplify the analogue.

It is instructive to study Verhaeren in the context of this painterly and literary struggle with the obliquity of expression because, while subscribing to the demand for *au-delà* or *idée* or *caractère* in art, he brings a post-Darwinian monism to his theory and practice in an attempt to transcend the dualism of movement and stasis, of phenomena and the law. Verhaeren wrote poetry in both the first and the third manners distinguished by Rookmaaker,[7] and in his constant drive towards expression of the law of change in the universe, something in itself inscrutable but whose effects are exemplified and whose workings are typified in phenomena, he is quasi-Symbolist (or *idéiste*, in Aurier's definition). But his monism excludes any neo-Platonism ; and he retains a belief in the dignity and importance of man as the being which both realises the law as having specific value beyond the generic, and experiences the world as the object of an imperative to assume the workings of the law by acting on the world—that is, the urge to integrate the objective expression of the law and the subjective human expression of it. For him as for the Synthetists and the literary Symbolists, since the law can at best only be expressed, the practical problem is the choice of expression—the choice of a mode of symbolism or analogy. But compared with the work of the literary Symbolists, there is a complicating factor in Verhaeren, in the socialist commitment present in his thought from the early 1890s onward. There are more elements to balance : it is a question not simply of attaining in the mediation the right proportion and relation of self-expression to reference outside the self, but of doing so in a *prescriptive* mediation. The

[5] Strictly, if an effect is unique, it is rather the quality of being an effect that is exemplified ; for the sake of concision I shall use the shorter formula.

[6] The effects (static) and the workings (dynamic, relations perceived in terms of cause and effect even in a static object) imply one another and will be manifested in any phenomenon. My purpose is to establish, for the sake of what follows, distinct points, however notional, on a scale of expression.

[7] Typical of the allegorical-affective manner are *Les Apparus dans mes chemins* (1891) and *Les Villages illusoires* (1895) ; and of the fantastic expression of estrangement, *Les Soirs* (1888), *Les Débâcles* (1888), and *Les Flambeaux noirs* (1891)—each of which Redon illustrated. The two manners overlap, naturally ; and neither survives, except occasionally, in Verhaeren's poetry after 1895.

creation of the work of art is itself an act, but the work implies and invites action in a particular direction in the world outside itself : the problem for Verhaeren is to provoke in the reader or spectator a formulation of the socio-ethical meaning of the *idée* or law whose effects are exemplified, and workings typified, in the sensuous presence of the work—to synthesise description with prescription and demonstration so that the latter should have the same objective authority for the reader or spectator as does the world-as-perceived outside the work. Verhaeren's theoretic writings and his poetry and drama bring together the major artistic and intellectual currents of the time, and to study his inevitable theoretic failure will shed light certainly on Verhaeren, and I hope also on aesthetic problems of the Symbolist and post-Symbolist periods in France.

Since Verhaeren wrote no formal aesthetics, no dramaturgy, and no full-length work on poetry or the theory of the plastic arts, I have assembled evidence from his numerous articles, inferring a theory of art which, although it is necessarily sketchy, I believe to be consistent with his statements of principle, his critical judgements, and his own poetic and dramatic practice. At the end, I shall suggest how Verhaeren's poetic theatre may be an attempt to combine the respective advantages of poetry and the plastic arts.[8]

When writing about poetry, Verhaeren rarely discusses technique other than in principle. His main concern seems to be with poetry as an instrument of self-realisation for both poet and public. At first, at the beginning of the 1890s, he sees poetry essentially as self-expression, free of collective considerations. Yet already there is a clear gap between him and much Symbolist theory. In an article of 1890, he rejects escape into " le rêve ", and welcomes the pain and contradiction of " la vie réelle ". This is because *rêve* tends towards a sterile changelessness, an attempt at escaping contingency. His poetry is an act of release, a safety-valve for his integral, physical, being.[9] During the 90s, Verhaeren's view becomes more outward-looking, and the poems after 1900 reflect this. But the view of poetry remains essentially the same. The poem is a product of the whole being, and some form of harmony, physical and mental balance, is involved in creating the poem : it is an act, in which he momentarily achieves the self-realisation he perpetually needs and seeks (*Imp*, I, 29-38). So the individual consciousness bears on the world through the creation of the poem, and realises for itself a place in the world. How does the poet experience this consciousness ?

Throughout his career, Verhaeren insists that rhythm is the most im-

[8] This is not, then, a straightforward examination of Verhaeren's art criticism. It will leave out much of interest : his discussion of technique ; his understanding of art history as evidenced, for example, in the fine article on Grünewald referred to below ; his relationships with contemporary artists. It is not the place, either, to discuss the poetry, or the dramas, except very briefly.

[9] The article is reprinted in Verhaeren's *Impressions*, vol. I, Paris, Mercure de France, 1926, pp. 9-16. The other two volumes of *Impressions* appeared in 1927 and 1928. References will be to *Imp*, followed by volume and page numbers.

portant material aspect of poetry. As one would expect from someone so interested in painting and sculpture, Verhaeren is a fertile creator of visual images and metaphors, but the most powerful experience of the materiality of a poem is for him in its rhythm.[10] Rhythm often comes as if naturally at the head of the list of qualities of a particular poet he is discussing. In a lecture of 1901, he says that the true poet has the gift, at the very moment a thought arises in his brain, of conceiving it as a living entity, endowed with a rhythmic action ; and that he cannot therefore but be a perfect master of rhythm.[11] This insistence on seizing the idea as it first bursts into the consciousness is important, as I will show later. The main characteristic of inspiration for Verhaeren is a rhythmic excitement of the entire being, and rhythmic expression of that inspiration is the main goal of the poet (Imp, I, 29, 30, 40). Verhaeren's poetry is meant to communicate and persuade, not simply to express, and not necessarily to prove ;[12] and rhythm is the principal means to this end.

After Verhaeren's many references to the importance of rhythm in inspiration and expression, it is instructive to read a description of how Verhaeren read. Reading the poem out was the climax of its creation for Verhaeren, and seems to have had the effect of re-creating in him the state of physical excitement which accompanied its conception :

> . . . le poète retrouve l'impression première ; elle pèse de nouveau sur lui qui doit alors s'en délivrer une fois encore. Ceux qui ont eu la bonne fortune de voir Verhaeren réciter ses vers savent combien le rythme de son corps est inséparable de celui de son poème. L'émotion se scande avec des mots vibrants, tandis que le geste s'y accorde. Le bras se dresse comme pour une conjuration. Les doigts se tendent, et en se séparant, comme d'un coup électrique, marquent la césure et martellent le vers. Dans la voix, les mots se précipitent et se changent presque en cris pour traverser l'espace [. . .] Chaque fois que Verhaeren lit ses vers, il se retrouve dans ce premier état créateur.

The reading produced a related effect in the listeners—the delivery became more and more powerful, " jusqu'à ce que tout fût rythme autour de nous et que nous en fussions pénétrés nous-mêmes, jusqu'aux moelles ".[13]

If this is Verhaeren's experience of the idée poétique, of what order is the idée itself ? If Verhaeren wants his poetry to " persuade ", what does

[10] Verhaeren gives due credit to what he calls " couleur ", generated by the juxtaposition of words as opposed to the words in themselves (see Imp, I, 13, 31, and Imp, III, 156). But the degree of importance he gives to rhythm sets him apart from the other major poets of the period, even those writing in vers libres.

[11] The lecture appeared in the Fortnightly Review, April 1901, pp. 723-38, in translation. For other references to the importance of rhythm, see e.g. Imp, I, 13-14 ; Imp, II, 122, 154, 209 ; Imp, III, 72, 75, 101, 124, 130, 155.

[12] Cf. Imp, I, 32 : " Il est des gens très intelligents qui, lorsqu'ils parlent, ont toujours raison—et ne persuadent jamais ".

[13] The first quotation is from Stefan Zweig's Emile Verhaeren, sa Vie, son Œuvre, Paris, Mercure de France, 1910, pp. 165-67 ; the second is from Zweig's Souvenirs sur Emile Verhaeren, Brussels, Kryn, 1931, p. 119.

he want to persuade his reader of ?[14] During the 1890s, the idea of collectivity occupied Verhaeren in a largely social form, but always closely associated with the individualism which one finds everywhere in his poetic theory. In 1893, he rejects Art for Art's sake, and all *a priori* formulae for poetry : he emphasises the individual poet's inspiration and concern to express himself totally, independent of schools or political doctrines, but says at the same time that self-expression is automatically expression of the world (*Imp*, III, 187-89). He goes further the following year, when he says that social commitment is perhaps a necessary condition for the self-fulfilment of the next generation of artists. He rejects the elaboration of programmes in poetry : the original source of the work is still the artist's spontaneous urge to self-expression. But without dropping the idea of collectivity, Verhaeren invokes the "âme de choix"—the genius, a vital figure in all his subsequent work. If such a man writes social poetry, Verhaeren says here, he does so without betraying his individual inspiration. Only, the development of the modern world seems to be such that individual inspiration will more and more involve awareness of a collective destiny.[15]

Verhaeren develops this idea elsewhere by suggesting that collectivity is a scientific fact. Scientific research has revealed the exclusively material structure and unity of the universe. Man is realising himself more and more fully, becoming more like the God in whom he formerly believed. The poet is one who expresses his " exaltation lyrique " at this evolution into an unknown future ; a part of the whole, he is as much its consciousness as any man, but unusual in his faculty for expressing the enthusiasm which that consciousness awakens. Again, he obeys no programme ; he automatically expresses the collective experience (*Imp*, III, 193-95 ; many of the poems express these ideas).

This view of poetry as a phenomenon in the monistic world is a touchstone in Verhaeren's criticism of other poets. Hugo and Verlaine are two of those he admires most. Hugo writes of " ce que tout le monde ressentit ", but with a " si personnelle interprétation des choses ", which makes of him a prophet in the line of great biblical visionaries (*Imp*, II, 114, 128, 136). Verlaine is a great poet because he is " tellement d'accord avec les idées de son siècle, avec l'incessante évolution de l'humanité qu'il s'affirme : la conscience de tous ". A masterpiece, Verhaeren says, is " un morceau de la conscience du monde [. . .] celui qui l'a écrit a dû sentir en même temps son être multiplié et éternel " (*Imp*, III, 62, 65-66). The great poet's inspira-

[14] In one sense, the poem " persuades " insofar as it communicates. But Verhaeren is concerned to ensure both that the poem communicates what it expresses, and that what it expresses is not simply a reaction to, for example, the world as beautiful, but to that beauty as having more than purely generic value, as involving prescription—to the world as inviting man to change it in a certain direction, and as being susceptible to that change. I shall use " persuade ", " persuasive " and " persuasion " in this sense of communication of a prescriptive expression.

[15] See *Emile Verhaeren. Les Meilleures Pages*, ed. L. Christophe, Brussels, Renaissance du Livre, 1955, pp. 126-29. References will be to *M.P.*, followed by page numbers.

tion is essentially a sense of his place in the collective destiny of the society he is writing for.

But such a contribution to the growth of universal self-consciousness is not the prerogative of poetry. Often Verhaeren writes of art in general rather than poetry, and often the poet is joined with the painter and the sculptor in a common destiny (e.g. *Imp*, I, 15 ; *Imp*, II, 30-34 ; *M.P.* 127-29). One article, " La Sensation artistique ", is of particular interest because it shows how close Verhaeren's experience of painting and sculpture is to his experience of poetic inspiration. Good art procures for the spectator an experience of the cosmic exaltation which originally inspired its creator—just as happened to Verhaeren when he read out his poems. The same thing happens to the art-enthusiast when he *talks about* works he has enjoyed : he feels an urge to re-experience and also to communicate the rhythmic excitement which the *idée* has provoked in him. The kinship of this with poetic inspiration is clear. Characteristically, Verhaeren refers to the *sensation artistique* as a " frisson divin ". The link between art and the divine, with the common denominator being beauty, shows how close aesthetics is for Verhaeren to considerations of man and his destiny, and recalls his idea that poetry inspires itself more and more from the spectacle of man's progress towards a state of " divinity ".[16]

It is not surprising, then, that in his art criticism Verhaeren applies similar criteria as to poetry. It is notable that broadly speaking he writes less of landscape and still life than of human subjects, and less of portraiture than of human action in a situation. This does not mean that he is interested in the anecdote for its own sake : even the painting representing an episode goes beyond the moment represented to the *idée*. Nor is the painting, whatever its subject-matter, a " pure " perceptual-aesthetic experience, it refers the spectator to something beyond itself. The problem with Verhaeren is that in the background there is always the notion of the *idée* not simply as the generic Truth or Beauty of the Symbolists, but as a value involving prescription for human agency in its own manifestations in the concrete world.

The great painter or sculptor conveys a new synthetic vision of the world through his work. Academic correctness matters less than the impression produced, if necessary by controlled deformation. Here the emphasis is on manner rather than subject-matter, and Verhaeren's view is close to that of the Synthetists.[17] The article on Grünewald is typical, Verhaeren playing down anatomical inaccuracy in the interests of expression. Grünewald's characteristic was to " pousser vers l'extrême, jusqu'à la dernière limite du possible, quoique toujours dans une direction logique,

[16] The article is reprinted in a selection of Verhaeren's best art criticism, *Sensations*, Paris, Crès, 1927, pp. xi-xiv ; see particularly pp. xi, xiii. References will be to *Sens.*, followed by page numbers.

[17] Cf. e.g. the " Notes synthétiques de Paul Gauguin " of around 1890, published by H. Mahaut in *Vers et Prose*, juillet-septembre, 1910, pp. 51-55 ; especially p. 54.

8

n'importe quel sentiment, n'importe quelle situation, n'importe quel geste ".
This corresponds in the plastic domain to Verhaeren's claim elsewhere that
to rise above " l'insuffisante raison " and to express the poet's inspiration
fully, all the poem's elements " doivent s'armer comme d'une aile d'exalta-
tion et apparaître un peu fous " (*Imp*, I, 32). The " mesquins critiques "
who criticise the anatomy of Grünewald's Christ are no doubt the brothers
of those who would insist " que ce soit la raison qui dose et dispose [les
éléments de la création poétique] d'une main sûre et froide " (*Imp*, I, 30).
By means of his exaggeration Grünewald has succeeded in achieving the
presence of a divinity in his *Crucifixion*, and with the *Resurrection* he pro-
duces " la sensation de voir un authentique miracle s'accomplir " (*Sens.*
38-63). Verhaeren admires the same gift in Rembrandt.[18] Rubens is another
who reinterprets the world for his age and ours.[19] What attracts him in
Pieter Bruegel, too, is the *idée*—the view of the individual as necessarily a
part of the whole, however terrible his fate may be ; the *Procession to Calvary*
and the *Fall of Icarus* are examples of this. Bruegel, like the poet-genius,
is " universel " (*Sens.* 67-77). It is notable that in the case of Bruegel,
manner shades particularly clearly into subject-matter and anecdote ; it is
Verhaeren's readiness to accept all three as legitimate, and perhaps insepar-
able, means of expression of the universal law that distinguishes him from
the Synthetists as precursors of abstraction. It is perhaps in the scorn these
painters affected for the "literary" in painting that one would find a clue
to help account for Verhaeren's apparent lack of interest in them.

Among the many studies on contemporaries, it is useful to look at one
on Constantin Meunier. Like the true poet in Verhaeren's view, Meunier is
not an " esprit à programmes " ; his sculpture " proves " nothing, it is
simply the " expression de l'heure où elle naît ". Yet, says Verhaeren, even
if Meunier's *intention* is not revolutionary, the *effect* is to arouse in the
spectator " l'anxieuse préoccupation de demain ", a political concern with
the destiny of the worker. Like Grünewald, Meunier is not afraid to "pétrir
l'exagération pour réaliser plus vivement l'idée ". This article shows partic-
ularly clearly the problems involved in Verhaeren's aesthetics. He says
Meunier's aim is to " donner l'expression esthétique du travailleur moderne".
What then is the " idée " ? Is it the beauty of the worker or his revolutionary
significance ? Can they be separated ? What is the relation of expression
to communication in interpretation of the work ? (*M.P.* 56, 58).

These fragments are typical of Verhaeren's writing on painting and
sculpture, and indicate that he had a consistent view of the problems raised
by the literary and plastic arts in a changing monistic world. Inspiration,
which typifies the workings of the law, involves some intuitive sense of
man's privileged, conscious and effective place in evolution. This inspiration
is sufficiently valuable for the guise in which it first comes to the artist to

[18] In his *Rembrandt*, Paris, Laurens, n.d. (1905), pp. 48, 55, 67, 120.
[19] See Verhaeren's *Rubens*, Brussels, Van Oest, 1910, pp. 42, 43.

be preserved as nearly as possible, in an appearance of spontaneity. But the preservation depends on a strict discipline in the expression : " la nouvelle forme poétique obéit aux règles les plus strictes ",[20] while Grüne-wald's strength was to have deformed his figures " toujours dans une direction logique ".

What has this to do with the theatre ? Verhaeren wrote very little drama criticism and no dramaturgy, although he did write four plays.[21] What there is on the theatre suggests that for Verhaeren drama can rank with poetry and the plastic arts in its power to express and communicate the *idée* of human destiny. This is the quality he sees in the plays he admires most, for example *Œdipus Rex* or Racine's tragedies. These are works which do without " les épisodes, ce chancre du théâtre contemporain ", and successfully convey an impression of vast forces active in human destiny. What is more, significantly for what is to follow, Verhaeren sees in *Œdipus Rex* an " admirable unité qui fait de l'œuvre, non la représentation d'un fait historique ou légendaire, mais une conception supérieure : l'Idée rendue concrète " (*Imp*, II, 62, 64). As in poetry and the plastic arts, Verhaeren's inclination is towards an art " realistic " only in its concern with the nature and conditions of human existence as a response to the universal law. Just how tempting the theatre might be to such a mind becomes clear in an article on art inspired by the Universal Exhibition of 1900—the time when Verhaeren was most active dramatically.

One of the items which has impressed him most is the reproduction of an Indo-Chinese underground temple, exact even in its erosion by time so that " tout y semble embryonnaire et mystérieux, [. . .] en puissance, en évolution, en devenir ". The " impression énorme " which Verhaeren seeks in all art is therefore best obtained by a reminder of change. It is the incompleteness of the broken statues of Greece and Rome that makes them so powerful ; they arouse the individual's receptivity to the grandiose *idée* : "ce qui est absent, chacun le devine [. . .] d'après son rite personnel de grandeur et de majesté ". The use of the word *rite* introduces the idea of the divine into the argument, and implies a ceremony with collective significance, depending on the presence of a congregation but addressing itself to the personal situation of each individual (*Sens.* 191).

Now Verhaeren expands his idea in discussing Michelangelo. Michel-angelo often leaves the figure with an appearance of uncompleteness, set in unworked marble, and Verhaeren's interpretation of this is typical : " Il n'a garde de rompre le lien entre l'univers et son œuvre humaine et personnelle. L'une n'est de l'autre que le prolongement, et tel colosse admirable semble taillé autant par la nature que par sa main" (*Sens.* 192).[22] (See Plate 1).

[20] See Verhaeren's contribution in F. T. Marinetti, *Enquête internationale sur le vers libre*, Milan, Poesia, 1909, p. 35.

[21] *Les Aubes*, Brussels, Deman, 1898 ; *Le Cloître*, Brussels, Deman, 1900 ; *Philippe II*, Paris, Mercure de France, 1901 ; *Hélène de Sparte*, Paris, NRF, 1912.

[22] Verhaeren does not refer to specific figures. He was thinking no doubt of the Boboli *Slaves*, now in the Academy at Florence, and perhaps of the uncompleted figures in the Medici Chapel. Verhaeren's interest here is in the *effect* of the uncompleted

It is man who gives matter an " existence expressive et passionnée ". On the sculptor's side, the *rite* is something consecrating the intimate relationship between man and the universe. The great sculptor's work derives from his sense of this continuity between material and man, unconscious and conscious matter : here, then, is a piece of dumb matter which apparently with a minimum of human intervention has acquired the power of communication. It is not a description of the continuity between mind and matter, it typifies it, and so may strike the spectator as tending towards exemplification of it. This induces in the spectator an exalted feeling of sharing the artist's inspiration. But for Verhaeren, Michelangelo is only part way to the modern genius, Rodin.

Rodin's sculptures, with their appearance of incompleteness, strike him as fragments of the dynamic universe : " Ce ne sont que prises sur le vif du rythme [. . .] comme nous voilà loin de la statuaire et près de la nature ! L'essentiel est conservé et tout paraît en mouvement ". In conclusion Verhaeren suggests that " ce qu'il y a de plus haut en art, ce n'est point l'achèvement et l'isolement d'une œuvre, mais son jaillissement même du cerveau et son lien avec la nature totale ". Once again, Verhaeren has widened his discussion of an art to include all art ; and of the works of art themselves he says " ce ne sont point les objets ; ce sont des réservoirs de vie continue " (*Sens*. 193, 194). So if artist, public and work are one, the *rite* celebrates this union by *reminding* its participants of it ; to use the words Verhaeren uses in speaking of language, it does not so much seek to be " right "—because it cannot be anything but " personnel ", relative, subjective—as to " persuade ", through intensifying the suggestive power of matter, which then forces itself into the individual's reflective awareness.

The sculpture, then, is a particularly suggestive piece of matter. But it is unclear how many people Verhaeren thinks are sensitive to the suggestion. Although he often writes of art rather than of an art, one has to consider the different means of expression in painting, poem and sculpture. In the plastic works which Verhaeren discusses, language is denied the spectator.[23] This may not matter as long as the communication is not meant to be persuasion ; but as soon as it is—as with Verhaeren—the artist has to reckon with misinterpretation. The poem, on the other hand, uses a medium potentially familiar to all, with a conventional system of meaning which its user can accept, reject or modify in trying to persuade.

The spoken poem must be distinguished from the written one. The first involves a rhythmic personal contact between speaker and listener, but is only apprehended as an external object for the duration of its delivery ;

figures ; when he goes on to distinguish Rodin from Michelangelo, this is partly because he is going to invoke Rodin's *intentions* as well as his effects. The article as a whole raises once again the problem of what account to take of the creator in art, as well as of the conventions in the different art-forms.

[23] Throughout, I shall understand " language " as " verbal language ", and " verbal " as " verbal " and not " oral ".

while the second misses the advantage of contact between speaker and listener but does retain a prolonged sensuous existence in ink and paper. This latter existence, however, is unsatisfactory as expression of the continuum between the work and the rest of the world, since the paper and ink do not bear any formal representational relation to the logical subject of the poem.[24] Further, the printed poem is static : it tries to freeze the experience of a moment in a stable, permanent language. The reader brings to it his own temporality : he can re-read it many times, and in any order he likes, so that it risks being prized for its " achèvement " and " isolement " rather than for its first irruption into the poet's consciousness. So the continuum between the sensuous presence of the poem, its inspiration and its subject risks being lost on the reader.

The temptation for the poet is then to rely on the conventional system of meaning in language to describe or evoke the circumstances and nature of his experience of inspiration, and in so doing to try and communicate it to his reader. This is what usually happens in Verhaeren's lyrical cosmic poems. The poet may then read his work to an audience, as Verhaeren liked to, and so take advantage of the physical contact this sets up between himself and his public. This relationship may stand a better chance of appearing to the audience as typifying the workings of the universal law which the poem is about. But the obstacle will remain that such a poem describes or evokes one man's experience of this law ; although the poem itself, in its sensuous presence, exemplifies the effects and typifies the workings of the truth it is talking about, it is talking about it, whereas for example the sculpture does not. That is, for the reader or listener, the poem includes two different modes of experience : it is to some extent about itself, it does not immediately typify, as the sculpture with an appearance of incompleteness may, the *jaillissement* of the original inspiration and its " lien avec la nature totale ". One alternative, which Verhaeren often uses, is the narrative or epic poem. Here already his concern with history begins to imply the dramatic. But the problem here is the same : does the past speak for itself, or does it need the mediation of history ? In such poems, Verhaeren's narrative is always lyrical and mediatory, so that the reader's immediate encounter is still with the poet or his persona.

The poet is therefore faced with an obstacle, which the sculptor does not have to reckon with. The sculptor makes stone or metal suggest something they otherwise might not have done. The poet of course makes ink suggest something which a bottleful might not have done, but the form he gives it has a conventional semantic content beyond its new shape, whereas the piece of marble remains a piece of marble, perhaps suggestive, but with no accretion of conventional significance beyond the formal resemblance it may have to something else. This is what Verhaeren is getting at when he says

[24] Verhaeren's ideas were formed before Apollinaire wrote any of his *idéogrammes*, while the typography of Mallarmé's *Coup de dés* does not seem to bear any formal representational relation to the subject of the poem.

of Michelangelo : " A la vie primordiale et sourde il ajoutait l'existence expressive et passionnée. Ses figures tragiques, ses corps musculeux et puissants, restent captifs de leur enveloppe rugueuse " (*Sens.* 192). The sculpture may be a more immediate manifestation of the *idée*, appearing to tend more towards exemplification than towards symbolic representation. Whether the figure is completed or not does not matter, because the sculpture is a three-dimensional object in the world, more immediately obviously one of the " réservoirs de vie continue " than the poem or even the painting. For although the painting is itself an object in the world, like the sculpture, the object it represents depends for its representation on the use of different colours, in two dimensions, on a circumscribed ground. An uncompleted painting would simply look as if it had not had enough brush-strokes— there would be an apparent plan which had not been carried out (see Plate 2).[25] The sculpture, however, is three-dimensional and monolithic, needing no circumscribed material to which it has to be applied ; it can therefore be left with its figures incomplete, and itself still be finished. The Michelangelo slave is an example of form partly emerged from formless matter, so that it stands a better chance of immediately appearing to the spectator as a *réservoir de vie continue* than an uncompleted painting, which is simply an example of a void not having been filled up with enough matter—and better still than an uncompleted poem, because the poem's visual form is not intended to be representational, so that the burden of communication falls on its conventional linguistic reference.

Nevertheless, it would appear from what Verhaeren says about poetry that he thinks the potential persuasive power of a piece of marble or bronze is less than that of language in poetry, however great a genius the sculptor may be. The problem is to present the spontaneity and authenticity of an individual's inspired insight into man's role in universal evolution at the moment of its first irruption into his consciousness, and to combine this manifestation with the power of persuasion which a mastery of language would give him. A possible solution is a poetic drama, a linguistic, three-dimensional plastic phenomenon which is a work only in performance. The

[25] In painting, Verhaeren's idea might in some ways be better realised in, for example, those Degas studies or Toulouse-Lautrec prints or Rodin drawings where there is an impression of movement, or momentary rest, which derives from the light and apparently rapid delineation of the whole. The point here is that the picture generates a single convention, whereas the Rodin nude study, for example, has the appearance of having been conceived and begun according to a certain convention, and then quite simply abandoned. A predecided plan has not been fulfilled. However, Verhaeren is speaking of many things in a short space in this article : sometimes of *jaillissement*, sometimes of the representation of movement in the subject, sometimes of the representation of change in the subject, and sometimes of the exemplification of the effects and typification of the workings of the law of change, in the sensuous presence of the work. A flaking fresco would presumably provoke in him a similar reaction to the broken statue, without necessarily assuming, in its manner and subject-matter, the law whose effects it exemplifies and whose workings it typifies in its sensuous presence. Equally, what most of Rodin's sculptures present is not so much their *jaillissement* as an expression, a symbolic representation, of a law of change of state : the act of creation is more apparent in sketches like the *Nijinsky* than in the work meant for public display.

temporality of drama is different from that of the static plastic arts, in that the spectator's temporal experience depends on the actors. In the static arts the spectator creates the time, as his eye moves over the surface of the object ; in the performed arts, the performer creates the time, so that there is a tension in the spectator's experience of the work : he apprehends it as an evolving external phenomenon, instead of supplying the evolution himself. Gauguin, for whom painting and music were near neighbours at the top of the hierarchy of arts because they both give the public's *rêve* full rein (he is typical of the Synthetists in this), nevertheless gives music a secondary place precisely because of the mode of its temporality : it seems fair to suggest, in the perspectives of Verhaeren's writings, that this kind of temporality could set drama above painting as an expression of universal law.[26]

In addition, it is interesting that Verhaeren should call the spectator's reaction to the plastic work an exercise of his " rite personnel ". Such a reference introduces temporality, and recalls both the collective and participatory nature of religious celebration and the origins of the theatre in such events. The theatre is characterised by the collective participation of the spectators and their intimate relationship—even if it is a relationship of alienation—with the celebrants, or actors. It contrasts in this respect with poetry, which tends to be read in solitude. Of the other " collective " arts, music and ballet do not enjoy the advantage of language, while opera is rarely effective as semantic communication.

So a further reason why Verhaeren should be drawn to the theatre may be discerned. As Zweig and others testify, the reading aloud of the finished poem is for Verhaeren the climax of its creation, which is not surprising in view of his emphasis on rhythm as the most important material characteristic of poetry. If the play showed someone experiencing the inspiration which characterises art, and if that person were gifted with a poet's powers of rhythmic verbal expression, then communication of such an experience might be possible on a relatively large scale, the speaker drawing the members of the audience into his experience so that they realised for a while the divine *grandeur* of their common identity, but each according to his *rite personnel*. The spectator's immediate encounter would not be with the playwright or his persona. Where the Verhaeren poem exists in two modes insofar as the original inspiration is its subject, this drama would present the spectacle of someone actually undergoing such an inspiration and realising it in expression. This expression might in theory, if endowed with the right qualities of rhythm and " exaltation ", be felt by the spectator to

[26] See Gauguin's " Notes synthétiques ", pp. 51-52. Verhaeren attended the rehearsals of his plays and was keen to perfect the performance. Far from agreeing with Mallarmé, that the " seul théâtre de nous-mêmes " (cf. Mallarmé's letter to Verhaeren on *Les Aubes*, in *Propos sur la poésie*, Monaco, Editions du Rocher, 1953, p. 223) is the equal or superior of the concrete stage, Verhaeren went so far as to prevent publication of *Hélène de Sparte* in France until the play had been performed. Verhaeren would never have shared Mallarmé's enthusiasm for the dance as a dramatic pinnacle—depersonalised, abstract and non-referential.

communicate spontaneously the state of mind which has inspired it. The dramatic character would not address himself to the spectator, he would not need to describe the circumstances of his experience—the spectator would hear an immediate linguistic materialisation of it : the lyrical speech *would be* the experience as the character realised it, bringing it through his surprised consciousness into language, thus affording himself some understanding of it, delivering himself as the poet does of the pressure of his inspiration, and in so doing defining for himself once more a position in the world. The audience would witness the inspiration in its " jaillissement même du cerveau " and, more immediately than in the poem, its " lien avec la nature totale ". What Rodin achieves through skilful manipulation of his material, the dramatic character would achieve through giving voice to his inspiration as it suddenly came upon him, the product of a dynamic concourse of events, and itself an event in the chain leading to the next such moment.

This is largely what happens in Verhaeren's plays, and it is particularly apparent in the first three, which are in a mixture of prose and verse. All are set at a time of change, and all emphasise the rhythmic or cyclic nature of historical change : for Verhaeren, history is linear, but change is brought about by the same principle reasserting itself, a fossilised institution being destroyed through its internal contradictions. In each of the plays, the future of a community is at stake, and the characters are constantly made aware of their involvement in the collective evolution. Whatever their standpoint, their reaction when the historical process impinges on them particularly sharply is always in verse—a sudden heightening of the expression, with an element of the unpredictable and the undefinable, created by the prosody, going hand in hand with the rhythm and conveying the spontaneity and surprise of the character's reaction.

The greater expressivity of the verse speech, to some extent surprising and eluding the character himself, perhaps corresponds in theatrical representation to the element of discovery involved for the poet writing in a predecided form. But in the play, although to a critic the language may be just as sophisticated as in a poem, the conventions are different. The spectator is not invited to pore over the speech and discern in it the relation of its subject to its creation : these circumstances are contingent and clear, the spectator sees them developing in a continuous chain throughout the play, and the speech need not explain itself, it is not about itself in the way that a poem, to a greater or lesser degree, usually is. In this sense, the verse speech in the play is perhaps never a poem, although it may well be poetry : it is a fragment, like the Rodin sculpture, which can only be fully understood by reference to the chain of phenomena of which it is a part. In this respect the play may be a more satisfactory form than the poem, because it is composed of moving parts, it is a living demonstration that the world is only to be experienced as shifting structures of relationships.

Insofar as it tries to have a fixed valid didactic sense, that is, to prove something, a Verhaeren poem tends logically inwards, it tends towards self-sufficiency. But if a text tends towards proving something about the world outside itself, towards descriptive proof, it is using words that refer to the outside world. Though every term in such a proof must be defined, as a function of the proof, it must be seen to refer to something outside the text. Such a poem, while tending logically inwards, therefore tends semantically outwards. Now in Verhaeren's monism, perception involves valuation, and insofar as the poem is a form of utterance which assumes and realises these two aspects, the descriptive element is prescriptive as well. Therefore, since it is impossible to speak of prescriptive proof as one can of descriptive proof, it is more apt to speak, with Verhaeren, of *persuasion*. But in trying to persuade, the poem tends logically outwards—that is, to make the logic depend on the *self-evidence* of a demonstrative link between the world outside the poem and the language in the poem. And in tending logically outwards to persuade, by use of the emotive, suggestive and logically imprecise (the terms not being defined *a priori* in the text), the poem tends semantically inwards by making the meaning of the words more than usually dependent on the context : the meaning is expected to emerge in action. As Verhaeren says : " Il faut chercher la poésie non dans les mots juxtaposés, mais dans l'atmosphère que créent ces juxtapositions . . . Les mots ne servent qu'à vider les idées de ce qu'elles contiennent de profond et de vrai " (*Imp*, I, 31).

Therefore a truly self-sufficient or " pure " poem is particularly unlikely from the pen of a Verhaeren, all the more as, if language is referential, the referents move. For the poem to be a permanently valid statement, to contain within itself at every moment a renewal of its sense consistent with itself, (this would be Mallarmé's *explication orphique de la Terre*), it would have to be so general a statement of the underlying principle of the world that the descriptive and prescriptive relation of the principle to specific phenomena would be left entirely to the reader. In Verhaeren it is precisely from the fact that the world moves that identity and value (which together are the " meaning " of the world) derive : insofar as the world is not left to speak for itself, but is the object of a mediating persuasive description, that description will from the point of view of both speaker and public be made obsolete by its own existence. Despite the need to express the world in language—a constant theme in Verhaeren's poetry—the specificity of each utterance deprives the ideas "de ce qu'elles contiennent de profond et de vrai ". This partly explains the abundance of Verhaeren's production, his frequent return to certain themes, and the reader's reaction to the poems as open-ended or provisional.

In the face of this drawback to the poem, the conventions of the theatre demand that the spectator see the speech in the play not as a literary composition tending towards isolation from the contingent dramatic world, but

as a reaction to that world presented as a part of it. The spectator witnesses what the sculpture may partly convey, and what the poem cannot. It may be possible to convey the *jaillissement* of the idea, and its " lien avec la nature totale ", more easily in a sculpture with an appearance of incompleteness than it is in a poem : to leave the poem uncompleted is not enough, because it is simply incoherent. The poem depends on the meaning of the language : for the movement to be communicated, the poem must be carefully shaped—but then the reader may admire " l'achèvement et l'isolement " of the work and not its *jaillissement,* which is only suggested in Verhaeren's poems, analogically, through the enthusiasm generated above all by the rhythm. In the sculpture, it does to a greater extent appear as *jaillissement,* momentarily checked but always renewable, because the sculpture does not draw exclusively or even at all on a conventional symbolic system. As a three-dimensional object in stone or metal the sculpture is self-coincident, and may then, through its partial resemblance to something else, suggest that it is itself in a state of emergence. To this extent, however inchoate the resemblance may be, the sculpture typifies change of state, and exemplifies the effects of interaction of a mind and the world—in a way in which, for example, the *objet trouvé* does not.

Yet insofar as the sculpture, presented as a sculpture, resembles something outside itself, it refers, to a class or to a quality or to both—or even to an individual, as in portraiture—and thereby expresses the interaction of a mind and the world. And insofar as it resembles something outside itself being in a state of emergence, the reference becomes more explicitly symbolic or metaphorical, both because the representation is so much more clearly not exemplification (sculptures being more or less the only objects which " emerge from " marble or bronze) and because movement is represented through a static object.

The sculpture, therefore, tends inwards to the extent that it is self-coincident, and outwards to the extent that it is seen as expressing the interaction of mind and world, rather than mutely exemplifying its effects. But Verhaeren does not refer exclusively to those of Rodin's sculptures which are in appearance fragmentary or unfinished. The expression of dynamism and change is theoretically independent of subject-matter. In the case of abstract sculpture, as with abstract painting, this may be understood by the artist as expressing a mind, or as expressing the world, or even as expressing the interaction of mind and world on the level of generic principle. In each case the work of art exemplifies the effects of the interaction of mind and world, but it is not necessarily seen to express the interaction : that is, it does not necessarily communicate it. And even if the spectator feels that it has been communicated to him, it is likely to be only as a generic principle : he will gather that there is interaction of mind and world, and perhaps that value does exist, but there will be no persuasive description of it. There is presumably no such thing as " pure plastics ",

having reference neither to specific elements of the concrete world outside
the work nor to the artist, but the work can remain so enigmatic as to come
close to the *objet trouvé* on the scale of expression.

Now the underlying law of the world, being in itself a more than usually
inscrutable phenomenon, will not bear too precise an expression. Yet it
seems that inasmuch as Verhaeren interprets it with reference to human
action in the future, he needs to indicate a direction for its application. In
all his art criticism, it is very rarely, if ever, that he sees the painterly or
sculptural expression of the law, the *idée*, as being thus specifically orientated.
His discussion of Meunier is a possible exception, but this is on the level of
effect rather than intention, communication rather than expression. It is
clear that in his call for departure both from slavish imitation of the model
and from *a priori* formal ideals, for expression of the *idée* through controlled
exaggeration, Verhaeren is situated in that part of the artistic movement
of the late nineteenth century which may be seen as tending broadly to-
wards abstraction, away from copy, " literature " and anecdote. Yet some
of the works he admires most have Biblical or legendary subjects, and
virtually all are to some extent anecdotal. And indeed it does seem that,
quite apart from those works which by their title automatically refer the
spectator to a known story, anecdote is inevitable as soon as movement,
temporality, is represented.

This is the case even with Rodin's *Balzac*, which is neither " incomplete "
in the same sense as his *Walking Man*—though undoubtedly there is dis-
tortion of mimetic detail in the interests of expressive unity—nor the
representation of an event, as so many of his works are (see Plates 3 and 4).
Verhaeren is surely right to react to a dynamism in the *Balzac*, and to see
a passage from one state to another (*Sens.* 193). There is gesture, a tension
in the body, under the drapery, and a multitude of tensions in the facial
expression, which force the spectator not to yield to some timeless " aura "
of personality, nor to lose himself in the contemplation of a quasi-Platonic
idea, but to ask himself what sort of man this is, what has formed him, why
he looks at this moment as he does, what his potential is. The reaction is
not to a specific anecdote but to the presence of Anecdote—here, as always
in Verhaeren, the interaction of man and the world.[27] Yet even assuming
that the spectator encounters in the work " la force hurlante " and the
rhythmic flow of " la vie universelle " (*Sens.* 193), the dynamism remains
ethically dumb in that there is no *realisation* of its value, its significance

[27] This work, Rodin's " enfant chéri ", was derided by the critics, when it appeared,
as a " literary " work. But, despite his distrust of works " qui ne portent pas en elles-
mêmes leur sens complet " (Rodin, *L'Art*, Paris, Gallimard [coll. Idées/Arts], 1967,
p. 130), he said of the *Balzac* : " Mon *Balzac*, [. . .] par sa pose et par son regard fait
imaginer autour de lui le milieu où il marche, où il vit, où il pense. Il ne se sépare pas
de ce qui l'entoure. Il est comme les véritables êtres vivants.

De même d'ailleurs de mon *Homme qui marche*. Ce n'est pas en lui-même qu'il
intéresse, mais bien plutôt par la pensée de l'étape qu'il a franchie et de celle qu'il doit
parcourir " ("Propos d'Auguste Rodin sur l'Art et les Artistes", in : *La Revue*, 1.11.07,
pp. 95-107).

for man. Certainly there is speculation as to what the anecdote might be —this is the exercise of the spectator's *rite personnel*—but it may go in any direction. People of opposite persuasions could each see in the *Balzac* an expression of their own points of view.

To resume, in addition to the possible anecdotality of the subject-matter itself, that painting or sculpture is anecdotal which brings the spectator to consider events and circumstances which are not represented in it. Now even in a crowd-scene full of events—for example, Bruegel's *Procession to Calvary* or Ensor's *Entry of Christ into Brussels*, to take two which Verhaeren admired—the plastic work suffers from this perpetual virtuality of the preceding and succeeding chains of events. In Synthetist and literary Symbolist theory, the work should evoke a static ideal virtuality, behind and superior to the concrete world, that world being simply an immense store of signs referring to the ideal. In Verhaeren, however, this virtuality is rather a future state of the concrete world, and, since the world has become conscious of itself in man, the future state is the implementation of values already realised by man in his evolving perception of the world. This is why the *idéiste* tendency to abstraction is inevitably balanced in Verhaeren by the need to make explicit reference to the outside world, as the condition and object of human action. The element of the virtual is inevitable, but it is presented, in the poems, as depending for its realisation on the contingent world—not simply on the level of the work (in the sense that even the Symbolist poem or the Synthetist painting, if such things exist, still depend for their existence on ink and paper, canvas and paint), but on the level of the world outside the work. If, in his art criticism, Verhaeren is reluctant to credit the *idée* with a specific orientation, this is no doubt because of the inability of the plastic work, despite its anecdotality, despite the tension between self-coincidence and expression, to refer in terms of intention and value to what it does not visually represent. In other words, in Verhaerenian perspectives, the spectator should not only encounter a mind in interaction with the world, he should encounter the mind as interpreting the world in a certain sense, with reference to human action in the future. In the case of sculpture, which has occasioned these inferences, it would seem that a certain kind of sculpture may have an advantage over the poem in that in its sensuous presence it typifies change of state and expresses the interaction of mind and world, standing as it does as a self-coincident three-dimensional object, apparently half way between two states, only to be understood by reference to a chain of past and future phenomena of which it is a part. Yet inasmuch as it acquires this quality from its sensuous presence, the reference will be predominantly to the simple fact of its creation, and so it suffers the disadvantage, as against the poem, that while it expresses through its shape the interaction of mind and world, it can only dimly, if at all, illuminate the chains of phenomena of which it is both concretely and symbolically a part. Though it may certainly move the spectator, his reaction risks being

very general : the sculpture's referential element is so limited that it cannot even be vague with precision. In Verhaeren's poetry, in contrast to the expression of the *idée* which he characteristically discerns in painting and sculpture, there is a specific field of value into which persuasive description falls—its terms are the mutual recognition of liberty (the so-called ethic of admiration), justice, social equality, and so on, all based on a materialist monism. Inasmuch as the poems are intended as description, their subject-matter is important ; inasmuch as the description is intended to be persuasive, it is important that it should be verbal, since it appears to be only through the uniquely abstract character of language—denotative and connotative but not imitative—that value, mutely present in all phenomena-as-perceived, can be *realised*, by both speaker/writer and listener/reader.

In the drama, the spectator's immediate encounter is with the *jaillissement* of ideas as functions of the contingent world. The drama has the same advantage over the sculpture as over the poem, or as the heard poem has over the read one : it has its own temporality independent of the spectator's, it is a series of phenomena succeeding one another in time, once only, and not a stationary visual object which is the object of the spectator's temporality in that his eye moves across it, at leisure, as often as he likes, in whatever direction he likes. The spectator in the theatre sees a stronger tendency towards exemplification, both because the effects exemplified and the workings typified are perceived in immediately dynamic phenomena, and because theatrical convention invites him to accept a certain degree of illusion.

In Verhaeren's plays, the speech in verse is communication as well as expression. It is not necessarily a deliberate attempt at persuasion, although some are meant to persuade the other characters. It expresses the character's reactions, or sometimes his convictions, and other characters and the spectator witness the expression. The characters' reactions are also communicated through the verse speech to the other characters present, in that the verse usually generates an emotional and ideological momentum which carries the other characters along with it. The verse speech also communicates the reaction to the spectator ; but at the same time it may communicate more to him than the speaker or the other characters would suspect : his reaction is experienced by the spectator as a function of a situation which is different from that of the characters in that he is outside theirs. So the verse speech invites the spectator to interpret and evaluate, in the same way as any dramatic speech, while at the same time admitting him into a greater intimacy with the character than is the case in naturalistic plays. It is a convention which enables him to see into the mind of the characters at the very moment their ideas burst into their consciousness. It is pre-reflective reaction and reflective realisation of this at one and the same time.

The spectator's position is therefore fairly complicated. Whether the speech is simply expression of a reaction or is meant to convince of an

opinion, it differs from the corresponding poem in that the data, the " premisses " of the persuasion or the objects of the reaction, do not all need to be introduced in the speech. Whatever the grammatical form of reference to them, it will be reducible to a simple demonstrative—" this ", " those ", etc. Both interlocutor and spectator therefore witness more immediately the interaction of a mind and the world : one term, the world, is clear, the interaction is expressed, without the speaker having to express the expression ; mediating the world in his spontaneous expression, the speaker does not need to mediate the mediation through describing or evoking its circumstances, as he would in the poem.

But it is important to remember that insofar as the character mediates the world through his speech, he expresses it as having value. To this extent, while the speech may be nearer to or further from the pole of persuasion on the scale of expression, the element of reaction and the element of opinion will never be fully separable, but will together constitute a point of view. So the spectator is brought to interpret and evaluate by the fact that he is encountering a mediation of the world, as in the poem, but also by the fact that he witnesses the theatrical events from outside : he encounters the world mediated as well as the world-as-mediated. Yet at the same time, he is drawn into complicity with the character through the communicative power of the verse—at the very moment of the character's realisation of his vision, he will momentarily see the world through his mind, from his point of view, even if he does not properly share his reaction or opinion.

The verse speech, therefore, more than the poem, is in one respect like the sculpture with an appearance of incompleteness : in its spontaneity and isolation as a phenomenon in the dramatic world. Yet it acquires this quality precisely from its provisional nature—it is only seen as isolated because it is preceded and succeeded by a chain of other events. To this extent, as with the sculpture, its self-sufficiency is its insufficiency, it illuminates and is illuminated by the surrounding phenomena. The same is true of the poem, of course. But the speech is different from the persuasive poem in that it does not try to resume the world in itself ; and it is different from the sculpture in that, being a linguistic phenomenon, it refers to the past and the future in terms of value and intention. So the aesthetic complexity of the verse speech lies in its being immediately experienced by the spectator at one and the same time as pre-reflective reaction and reflective realisation of the reaction, and therefore, given the material circumstances in which it occurs, as both exemplification and expression of the condition of reacting to the world, and of the interaction of mind and world. In its sensuous presence, as an oral utterance, and its reference to the world outside itself, it combines features of the sculpture and the poem into a different symbolism ; and in keeping before the spectator this quality of representation, as opposed to copy, it prevents illusion completely taking over and dulling his empathetic and critical faculties. The speech in verse is a particularly

artificial convention, but it is a good way of ensuring the critical tension set up in the spectator's rapid oscillation between detachment and participation.

There is certainly an alternation in the nature and degree of participation in those of Verhaeren's plays which contain both prose and verse, though the stylisation of most of the prose prevents the plays degenerating into naturalistic illusionism. The power of the verse to induce a momentary vision from the character's point of view is enhanced by its contrast with the apparently more controlled prose, and the overall result is an intensification of the spectator's reaction : he sees each speech as a function of the others, and so his understanding of the situation is increased ; but at the same time he appreciates or sympathises with the emotions both of the enlightened characters and of those who are wrong or destroyed. The verse brings the spectator to see the world and the individual in terms of one another, throwing each character's enthusiasm, doubt or fear into relief against the background of the ever-changing, still unfathomed world. In this respect it fulfils a function similar to that of the uncompleted sculpture or Bruegel's crowd-scenes or Rembrandt's lighting, pointing the irony but also the grandeur of human destiny. The essence of Verhaeren's poetic theatre is that it transforms a theoretical weakness of the poem into the thematic core of the play : it takes the limitations which individuality imposes on the persuasive power of the linguistic work of art and turns them into an affirmation of the uniqueness, dignity, and vital importance of the individual in the monistic world which science has revealed, of emotion and intellect in a material existence.

For Verhaeren, the universe is dynamic, a complex of rhythms, and the aim of art is to help both artist and public to a full awareness of the dynamism in terms of value. Rodin's sculptures are " prises sur le vif du rythme " : but Verhaeren's metaphor is a reminder of the qualities of analogy, of metaphor, of *expression*, in Rodin's work. What Verhaeren tries to do, in different ways, in his poems and poetic dramas, is to grasp the nettle of mediation and actually endow the rhythms of the physical world, embodied here as the rhythm of political change and the rhythm of oral utterance, with the superior denotative and connotative power of language, and so to persuade the public that his call to action is the valid one. The plays are increasingly sophisticated attempts at making the world exemplify what it expresses and express what it exemplifies. The uncompleted sculpture *may* come closer to this than the poem, only the meaning of the sculpture is anybody's guess, and Verhaeren wants his meaning to be clear. But how to be clear about an abstraction ? The world is dynamic, and, however far the conventions of the theatre may invite the spectator to forget it, the play is finally static.

For when the play is over, it is the play as a whole, and no longer the speeches in it, that is seen to tend logically outwards and semantically

inwards insofar as it illuminates the world outside itself. While individual speeches have their meaning largely in terms of the *dramatic* world, the fact that there is a coherent world within the play raises all the more acutely the gap between the play as a phenomenon and the world outside it. The paradigmatic element becomes particularly clear, and the play itself emerges as expression of the interaction of a mind with the world. The spectator then needs to *interpret* the paradigm in terms of value in the outside world —the more so as there are not the same explicit mediating links between the play and the outside world as between the poem and the outside world. It may be the dream of a work where description would be synthesised with prescription, where the world outside the work would be seen through the work to have unambiguous value, that accounts for the development to be traced through Verhaeren's four plays.

Les Aubes, set in an imaginary land in the future, presents a peaceful socialist revolution : but the description is of a way the world is not, the issue appears to have been decided *a priori* by the prescribing mind of the play's creator—the mediation has been mediated, as in the poem. *Le Cloître*, set at an indeterminate time in an indeterminate country, presents the takeover of power in a monastery and the conflict between progressives and conservatives. It is a paradigm of how the law of change affects even the most closed of communities. But for this reason, and because of its vague setting, it may be felt to have little demonstrative power for the socio-political world outside the play and the monastery. *Philippe II*, however, is a sophisticated illustration of how the law has actually manifested itself in history. But still the law, being an abstraction, can only be evoked, linguistically, symbolically. *Hélène de Sparte* is the final attempt at the impossible synthesis of abstraction and reference, expression and exemplification. In presenting a political conflict in the past, Verhaeren has turned this time to myth, where the convention permits what cannot be tried in the historical play. The law, in the form of Zeus, plays a part.[28] Verhaeren is careful, through elaborate staging and the roles played by the characters, to present Zeus as a projection of human consciousness. Yet precisely because of the attempt to exemplify the meaning in the work, the element of symbolism erupts on the surface. It is notable that, from an imaginary case-history of successful revolution, in *Les Aubes*, Verhaeren progresses to generalities in *Hélène de Sparte*. Zeus' intervention can be reduced to a general statement that the world perpetually changes : there is no suggestion of the right way of assuming this law in action. And indeed, the more such a symbolic mediation (as making Zeus speak) went into detail, the more it would draw attention to itself as mediation—exemplification would be seen completely to give way to expression. In *Hélène de Sparte* the world is both mediated and seen to need mediation, but the mediation

[28] While the first three plays are in a mixture of prose and verse, *Hélène de Sparte* is all in verse. All the action revolves round the embodiment of divine beauty, Hélène. The verse is reaction to this perpetual immediacy of the cosmic inspiration.

by definition does not have the unquestionable integrity of the unmediated world. As communication, *Hélène de Sparte* is powerful ; it may even communicate much of what it expresses : but in the end it lacks, as persuasion, the authority and prescriptive clarity which Verhaeren seems to have dreamed of for a committed art.

Verhaeren is clearly a product of his age, artistically and intellectually. He was also a great defender of modernity and experiment both in the arts and outside them. Does it not seem extraordinary, then, that despite his technical knowledge of painting and his friendship with so many painters of the day, he should have paid little or no attention to the Synthetists or the Fauves or the Cubists ? The problem with Verhaeren is that as he matures he is less content with a " pure " aesthetics and purely painterly questions : his work is an early attempt to integrate ideological commitment to something in the world outside art with the gains in technique made by the writers and painters of the age. In the urge to express the universal law, there is always the tendency to abstraction, found in the various techniques of suggestion ; but this is at the pole neither of pure expressionism nor of what Mondrian was to call " pure plastics ". At the very moment when painters begin explicitly to concern themselves with the new problems brought to light notably by Mallarmé, Verhaeren parts company with them because he retains a belief in the importance of subject-matter and—dare one say it ?—Anecdote. Aesthetically there is the same drive towards synthesis of expression and exemplification, the same dream of a self-expressive *évidence* : but apart from the irreducibility of mind and outside world, there is the problem in Verhaeren that aesthetics is inseparable from morality, and individual morality from collective.

A further problem is Verhaeren's consistent belief in the primacy of language in human experience of the world. This is an idea which occurs constantly in his poetry. Perception as recognition, and valuation, depend on language ; and this is as true of the plastic arts as it is of the world outside them. One of the most striking features of " La Sensation artistique " is that the spectator is said to feel the need to express his reaction and communicate it to others. In Verhaeren, not only is language mediation of the world, but mediation of the world is essentially linguistic. It is therefore wholly consistent, in Verhaerenian perspectives, to ask the artist to assume the linguistic aspect of mediation and the mediatory aspect of language, in an attempt to provoke the public to a particular formulation of the world mediated. In other words, if it is impossible not to interpret the world, art should demand to be interpreted, and in a particular direction.

In the retention of subject-matter, and a relatively discursive poetic style, Verhaeren looks back to the past ; in the search for a moral *évidence* inseparable from a phenomenological one, and the related hesitation as to whether expression or communication is the object of criticism, he looks forward to the debates over committed art of the mid-twentieth century.

St Andrews IAN HIGGINS

THE FROG AND THE STAR :
THE ROLE OF MUSIC IN THE DRAMATIC
AND VISUAL WORKS OF ERNST BARLACH

Towards the end of 1971 was published the third volume, covering the drawings, of the *Ernst Barlach. Werkverzeichnis*.[1] Thus was completed the definitive catalogue of the visual works, compiled by the artist's friend Friedrich Schult, which has appeared over a period of thirteen years. Of more than 2000 drawings documented the vast majority are reproduced in miniature, from the derivative *Jugendstil* designs of the turn of the century through the sketches made on the decisively influential Russian journey of 1906 to the distinctive style of his artistic maturity. Together with its companion volumes[2] this recent publication confirms Barlach's status as an artist of exceptionally wide-ranging abilities. In the drama, in sculpture and graphic work, notably the woodcut and lithograph, his achievements are such that they claim attention from critics in each of these fields. In addition to which must be mentioned two volumes of narrative and descriptive prose, including two unfinished novels, and a correspondence as extensive as it is illuminating. Yet for all the wide formal range of his *œuvre*, there are striking coincidences of theme and intention which underlie the works in the various media and produce a fundamental unity in diversity.

As a recurring motif in Barlach's work, music appears relatively insignificant in comparison with others. Certainly it has received little attention from critics. And yet it is invaluable in that it provides an insight both into his *Weltanschauung* and, more important for this study, into his understanding of the expressive potential of the different media at his disposal. An ostensibly artless story told by Barlach to his son serves as a convenient starting-point for an analysis of these topics. According to the writer Hans Franck, the boy Nikolaus was puzzled one day as to how a frog and a (reflected) star could inhabit the same puddle. The child's curiosity prompted the following explanation from his father :

> Der Frosch im Wasser sah den Stern am Himmel und fragte : Ist es da oben schön ? Der antwortete : Ja, schön ! Spring doch herauf ! Da sprang der Frosch hinauf, aber er fiel wieder herunter, und da sitzt er noch heut. Da fragte der Stern : Ist es im Wasser schön ? Ja, schön ! antwortete der Frosch, spring doch herunter ! Da sprang der Stern herunter, und da sitzt er noch heut.[3]

[1] *Ernst Barlach. Werkkatalog der Zeichnungen. Werkverzeichnis Band III.* Bearbeitet von Friedrich Schult, Hamburg, 1971. (Sch. III., followed by a figure, indicates the catalogue number of a drawing.)

[2] *Ernst Barlach. Das plastische Werk. Werkverzeichnis Band I.* Bearbeitet von Friedrich Schult, Hamburg, 1960 (Sch. I).
Ernst Barlach. Das graphische Werk. Werkverzeichnis Band II. Bearbeitet von Friedrich Schult, Hamburg, 1958 (Sch. II).

[3] Hans Franck, *Ernst Barlach. Leben und Werk*, Stuttgart, 1961, pp. 69 f.

Venturing beyond the simple surface, it is possible to interpret this fable as having a metaphysical significance. The puddle can be taken to represent the material world—the " vale of tears " in another aqueous metaphor— the frog stands as a cipher for mankind, and the reflection of the star becomes a representative in this world of a distant and inaccessible realm of perfection. Additional evidence to support what may appear at first sight to be a far-fetched interpretation is provided by Barlach himself in another, quite distinct context. Writing in 1923 to his publisher Reinhard Piper, he first confesses his antipathy to the work of Max Beckmann, then expresses his own contrasting attitude :

> Mich verlangt instinktiv, elementar nach dem Anzeichen, daß über diesem Pfuhl ein Himmel ist, möchte über dem Schauder einen Reflex der ewigen Harmonie spüren.[4]

In letters and in the diary written during his self-imposed isolation in the little Mecklenburg town of Güstrow he makes clear that he regarded Classical and sacred music as just such a reflection or hieroglyph. Listening to it, he was able to divert his attention from everyday concerns to the contemplation of the sublime, to merge his individual identity with something ineffably greater, supra-personal. Thus, he notes after a performance of Beethoven's Ninth Symphony in Güstrow Cathedral : " Das ist Segen, und der Fluch wird aufgehoben, aber leider—wieder aufgelegt."[5] Music of this kind can be seen to have fulfilled for Barlach a similar function to that of the reflected star in the fable, for which reason it will henceforward be referred to as " star-music ". In contrast, other varieties, such as popular music, drinking songs and dancing will be classed as " frog-music ", for reasons which will become clear. The distribution of these two aspects of the tonal art is of particular interest. While instances of " frog-music " are found in the dramas, the graphic work and drawings, examples of " star-music " feature almost exclusively in the visual media.

To take the former category first : from his second play *Der arme Vetter* (1918) onwards crude snatches of song or grotesque and tasteless dancing are employed to portray the depravity of a wholly egoistic, worldly outlook. In this work, which invites comparison in terms of developmental significance with Goethe's *Die Leiden des jungen Werthers*,[6] a young man, Hans Iver, escapes through suicide from a world that has become intolerable to him because of its crass materialism. But this neurotic idealist, while himself sinking ever deeper into an all-pervading gloom, nevertheless manages to

[4] Ernst Barlach, *Die Briefe I* (1888-1924), Hrsg. von Friedrich Dross, Munich, 1968, pp. 694 f. (quoted as *Briefe I*).

[5] *Briefe I*, p. 629. This statement, augmented by the knowledge that Barlach had a deep affection for the cantatas of J. S. Bach (Herr Friedrich Schult in conversation, Güstrow, 7.8.1965), suggests that it was choral works in particular that produced this quasi-mystical state in him. It is as if in purely instrumental music the human element was insufficiently in evidence for someone whose own work in all the media was exclusively concerned with the human form and morality.

[6] Karl Graucob, *Ernst Barlachs Dramen*, Kiel, 1969, p. 39.

bring about a spiritual awakening in one Fräulein Isenbarn, which culmin-
ates in her breaking off her engagement to the boorish Siebenmark in the
presence of the corpse. In an earlier scene, a crowd of day-trippers awaiting
the arrival of the steamer back to Hamburg comment as a chorus on highly
emotional moments for the protagonists by breaking into songs of a nonsense
character. On one occasion, when the couple are commanded to find a new
partner each, Fräulein Isenbarn refuses Siebenmark's suggestion that they
should leave to avoid any possible unpleasantness, adding : " Geh du—ich
nicht ".[7] This firm, unambiguous statement is picked up by the drunken
crowd (referred to as a *Chor der Rache*) and, to the melody *Krambambuli*,
distorted into the trivializing chant : " Geduichnicht—gedaichnicht—ge-
daichnicht—gedu—geda—geda—ich nicht ". Shortly afterwards they be-
have again in a similar fashion, when to the tune of the Wedding March
from Wagner's *Lohengrin* they sing : " Am Kattegatt, am Kattegatt—da
ward de Katt dat Gad ver-er-gatscht—am Kattegatt usw ",[8] thereby creat-
ing an atmosphere of ridicule for what is the first, though belated exchange
of words between Iver and Fräulein Isenbarn. Dancing, too, is mentioned
by Iver in this context. The first reference is in connection with his past
life (" Gott, wenn ich bedenke, wo ich schon manchmal getanzt habe, es
können nicht immer feine Lokale gewesen sein "),[9] and secondly, at the end
of their tête-à-tête, alluding to Fräulein Isenbarn's future (" Sie müssen
wohl noch einmal rumtanzen ").[10] As used by Iver the verb *tanzen* is a
metaphor for the kind of existence from which he seeks release, and in
which, he implies, Fräulein Isenbarn must continue for a while longer. As
before, the assembled company overhears and derides what it cannot com-
prehend. Appropriately, Siebenmark, whose earlier renderings of Negro
spirituals have been considered out of place on an Easter Sunday by his
sensitive fiancée,[11] chooses to dance round the corpse of her spiritual mentor,
taunting her with a tactlessness that is both heavy-handed and savage.[12]

There are further examples of such dancing elsewhere in the dramas,
reminiscent as they are of frogs leaping about in their murky pools. There
is also an instance of another form of dance which, though apparently more
civilized than the last, is in reality just as loathsome. Sibylle and Volrad
in *Die gute Zeit* (1929), the nymphomaniac and the pansy, in dancing to-
gether[13] produce a sense of distaste in the reader or audience through such
close contact between incompatible sexual types. A reaction of this kind
is clearly Barlach's intention in viewing the frivolous, hedonistic community,

[7] Ernst Barlach, *Das dichterische Werk. Band I : Die Dramen*, Munich, 1959, p. 147
(*Dramen*).
[8] Ibid., p. 150.
[9] Loc. cit.
[10] Ibid., p. 151.
[11] Ibid., p. 107.
[12] *Dramen*, p. 177.
[13] Ibid., p. 461.

of which they are members, as a whole. In this his last play he employs satirical means to criticize the utter sterility, the dead-end pleasure-seeking of a seemingly utopian society, wealthy enough to afford a claimed " Absolute Versicherung "[14] against all of life's risks. Later, after the catechizing of the residents of the society's commandments (performed by the Hugh Hefner-like Atlas, the establishment's director), music and dancing again take place.[15] On this occasion they serve to celebrate the ideal of self-satisfied contentment, acquired at considerable expense, that is boasted of in Atlas' valediction.

It will suffice to mention just two further examples of " frog-music " in the dramas. The figure of the organ-grinder in *Die echten Sedemunds* (1920) forms a link between the singing and dancing in this work, in which, through a bogus report that a lion has escaped from a menagerie, a North German provincial community is temporarily driven into a panic of soul-searching and self-criticism. The jangling notes of his instrument firstly lend emphasis to the sarcastic lyrics of a song aimed at the local militia and the ensuing criticism of the entire community for their hypocrisy.[16] And later, as the leader of a grotesque, hysterical procession to the local cemetery—immediately before the discovery of the hoax allows the majority to resume their old identities—he is described as the " Musiktrabant der Höllenreise ".[17] In this role he strengthens the character of the procession as an evocation of the medieval Dance of Death, expressive of human vanity and transience.[18]

The conclusion of this section is provided by Barlach's only drama to incorporate extensive verse passages, the mystery play *Der Findling* (1922). In this work the miraculous transformation of the deformed, diseased and deserted child of the title into an object of radiant beauty results from the love of a young couple, Elise and Thomas, the only ones to manifest an attitude of concern for others. The remaining characters, including their parents, are refugees in flight, but are presented as a totally unsympathetic group, scornful of youthful ideals and absorbed in their own predicament to the extent of indulging in cannibalism. At the end of the work, immediately following the mystical testimony of the *Beter*, the essence of which is that truth cannot be approached or expressed through language, Sauerbrei makes a final statement of his own attitude to life. Having enthused about the simple existence of the mole and scratched out a hole in the earth into which to put his head, he sings " ein Lied in der zufriedenen Maulwurfsweise ".[19] This seven-line song of praise, in being addressed to the *Muttererde* or *Mutterboden*, combines the ideas of the physical soil and the

[14] Loc. cit.
[15] Ibid., p. 467.
[16] *Dramen*, p. 226.
[17] Ibid., p. 248.
[18] In 1923-24 Barlach returned to this theme in his illustrations to Goethe's poems. Cf. Sch. II. 229, 230, 231, and Sch. III. 1704, 1705, 1706.
[19] *Dramen*, p. 315. Cf. Sch. II. 303.

conventionally anthropomorphic Mother Earth (normally *Mutter Erde*). According to Sauerbrei, this composite object displays a maternal solicitude both for the living (" Sie nährt dich wie sie soll und kann ") and for the dead (" Umfängt mit Liebesarmen den toten, / Mühselig müd gewordnen Mann ").[20] But the comfort that he preaches *im Singsangton*[21] is only for those whose concerns are wholly worldly and physical, for whom in short there is no problem of reconciling the rival claims of the spirit. If God exists for Sauerbrei, then he is nothing but a *Gott der Würmer*,[22] as another character puts it, a chthonic entity to be sought in the ground underfoot rather than in contemplation of the firmament. Earlier, Thomas' father, the puppeteer Klinkerfuß, throws his puppets out, then climbs into their box. After uttering some particularly crude threats, he sings a song to the couple :

> Hähnchen hupft auf einem Beenchen,
> Lenchen säugt ihr süßes Söhnchen,
> O du liebe Luderliese,
> Lümpchen wackelt mit dem Stümpchen,
> Evchen hält ein Schäferschläfchen,
> O du liebe Luderliese,
> Hunger macht den fetter Vater junger,
> Liebe herzt ihn mit dem Hiebe,
> O du lose Luderliebe.[23]

What is noteworthy here is not the generally coarse tone, the proliferation of diminutives, the bad scansion in line 7, or even the crass alliteration of the apostrophized Elise (" O du liebe / lose Luderliese "), but the fact that the initial letters of the lines (HLOLEOHLO) can be read as an imperfect acrostic of the word *Hölle*. This, in conjunction with Klinkerfuß' reference to the box as his *Sarg*, demonstrates the mental and spiritual distance that separates him from Elise and Thomas, through whom the transfigured child begins a new life. Klinkerfuß' song and the blasphemous, gargantuan parody of the Lord's Prayer by the *Tenor* in the previous scene[24]—though not specifically *sung*—constitute what is arguably the ugliest instance in the dramas of " frog-music ", that is, the singing and dancing expressive of unregenerate, complacent man.

In the visual media there are a number of equivalent examples of this phenomenon. *Die Wandlungen Gottes* (Sch. II. 164-167, 169-171), a cycle of seven woodcuts depicting the transformations that God undergoes at the hands of mankind, was produced in 1920-1 and published in 1922, the same year as *Der Findling*. Just as in the play Thomas and Elise are surrounded by abuse, so in the print entitled *Totentanz* (Sch. II. 167) a young couple walk hand in hand, shielding themselves with a blanket from a hostile

[20] Loc. cit.
[21] *Dramen*, p. 315.
[22] Loc. cit.
[23] Ibid., p. 284.
[24] Ibid., pp. 278 f.

crowd behind. This *verlästertes Paar*,[25] as Barlach himself described them, are taunted among others by two musicians, one playing a flute, the other a concertina. Here music functions as an agent of division, uniting one group in aggressive opposition to another, as in the case of many children's and soldiers' songs, and national anthems. Barlach's first three plays all appeared together with his own illustrations : 27 lithographs in the case of *Der tote tag* (1912), 34 lithographs for *Der arme Vetter* and 20 woodcuts for *Der Findling*. In the second of these series there is a print, entitled *Verzweifelter Abtanz* (Sch. II. 151), depicting the incident discussed above, in which Siebenmark performs a callous, if somewhat premature dance of triumph around the dead Hans Iver, his rival for the attentions of Fräulein Isenbarn. The clumsy inappropriateness of the dance is expressed in the print by the awkward stance of the figure. In particular, the left leg is drawn straight across the bent right leg and the elbows shown flung up and out to their limit, as each hand lifts a coat-tail. The overall angularity, its jagged outline, is a feature this graphic figure has in common with the sculpture *Tanzende Alte* (Sch. I. 223 ; see Plate 5).[26] Although the tone here is more lighthearted, even comic, a similarly grotesque character is projected, here not unlike the Dame of traditional British pantomime. There is an exaggeration in the length of the toes and fingers, and a low centre of gravity emphasized by the solid support section between the feet. Of special interest are the suggestion of a centrifugal force at work, scattering areas of detail and interest (face, fingers, raised foot) out to the periphery, and the enclosed space on each side of the body, similar to the previous figure, resulting from the lateral movement of the arms. These features are distinctive for the group and contrast markedly with those of the " star-music " group of figures. Apart from the series of prints for his own plays, Barlach only published one other set of illustrations for a dramatic work : the 20 woodcuts based on the " Walpurgisnacht " scene from Goethe's *Faust* (1923. Sch. II. 203-206 & 208-223). On the whole they interpret the literary text with a much greater licence than previous attempts, with Barlach's visual imagination creating often fantastic figures, as in the case of the bizarre *Reitender Urian* (Sch. II. 213), springing from the slightest of textual hints.[27] As regards *Faust, tanzend mit der Jungen* (Sch. II. 220 ; see Plate 6), however, the print is a straightforward graphic realization of a stage direction.[28] A greater sense of movement, appropriate for the mood of lecherous abandon,

[25] Ernst Barlach, Sch. II, p. 106.

[26] Scratched into the plinth of this plaster study (1920) for the subsequent limewood (Sch. I. 225) and bronze (Sch. I. 224) versions is the word *Kulegraaksch*. This was apparently the name of a Mecklenburg matron who used to arrive uninvited at weddings to entertain the guests with jokes and dancing. Ernst Barlach, Sch. I, p. 134). The fact that Barlach individualizes the work, in this case through the incised name, is characteristic of these examples from the visual media.

[27] " Verlangst du nicht nach einem Besenstiele ?
 Ich wünschte mir den allerderbsten Bock."
Goethes Werke, Hamburger Ausgabe, vol. III, 7th edition, 1964, p. 121.

[28] Ibid., p. 129.

is suggested here than in either *Verzweifelter Abtanz* or *Tanzende Alte*. Faust's cloak swirls round his shoulders. Feet, "frozen" in mid air and foreshortened in the case of the young witch, are emphasized by the contrasting white area alongside. The hatching on the naked female body, which continues across the background and appears too on the first fold of Faust's cloak, strengthens the diagonal and forward movement inherent in the composition as a whole. Another interesting feature is that, except for her legs which appear not without significance between Faust's, the outline of the woman's body is contained within his. Thus the line of her back continues into his right leg, while his left leg is an extension of her arm. The effect is to streamline the triangular form of their seemingly integrated torso, so throwing into sharper contrast the zig-zag configuration of their legs and feet. With this woodcut is concluded an examination of some examples from the dramatic and visual works that express a negative attitude of irresponsibility, vulgarity and self-satisfaction, the products, for Barlach, of a wholly secular outlook.

In turning to the topic of " star-music ", it will be remembered that the star in the puddle was in reality simply a reflection of a star in the sky. One interpretation makes of this a symbol in the physical world of a sphere of perfection for ever beyond man's grasp ; and evidence was adduced to suggest the analogous role of certain kinds of music in Barlach's works.[29] The contrasting category of " frog-music " has been shown to find expression in all fields, which distinguishes it further from " star-music ", a feature almost entirely limited to the sculptures, woodcuts, lithographs and drawings. Here Barlach was faced by the perennial problem of rendering in visual and spatial terms something that is essentially abstract and temporal. In common with other artists, he attempts to realize in a metaphor of line and volume (though not of colour) his emotional response to a particular musical work or his conception of the symbolic, metaphysical character of music in general.[30] As might be expected, it is the figure of the singer or instrumentalist that is most frequently chosen to fulfil this function. On the other hand there are several examples too where the connection with music is far less overt. To the first group belongs the small figure of *Der singende Mann* (1928, Sch. I. 343 ; see Plate 7), one of his best known bronzes. A strong rhythmic movement is created by a series of triangles in various planes, e.g. knee—feet—knee ; shoulder—hands—shoulder, head —hands—waist. Bold vertical and horizontal forms hold in check the diagonal emphases, so that the work achieves a balance of expressive rhythms and overall restraint. The broad stylized folds of the drapery are arcs of concentric circles, whose centre is located in the figure's head. Simi-

[29] That all music is in the final analysis a human product finds a possible parallel in the fable : the reflected star is as it were " created " from the perspective of the frog.

[30] As early as 1898/99 Barlach had drawn the ethereal *Sphärenklänge* (Sch. III. 124). Otherwise these works post-date the Russian journey.

larly, the long straight arms lead the eye to the focal point of the work : the slightly reclining head with its closed eyes and open mouth, suggesting a complete absorption in the activity of singing. The vigour, coupled with self-control, with which the song is produced, in contrast to the impetuous dancing already discussed, reveals itself on the one hand in the flowing movements of the constituent parts, and on the other in a detail such as the modelling and set of the toes. Based on an original drawing of 1919/20 (Sch. III. 1366) is the bronze sculpture *Der Flötenbläser* (Sch. I. 469 ; see Plate 8) made in 1936, two years before his death and one year before the infamous *Ausstellung der entarteten Kunst* in Munich, which included work by Barlach. So compelling did he find the earlier design of the rustic flautist during the period in which he fell victim to official Nazi censorship, that he produced in addition a teak (Sch. I. 470) and an oak version (Sch. I. 471) in the course of the same year. These works can be considered as at once an escape from current persecution into a timeless world of tranquillity and as an affirmation of a belief in the symbolic significance of music. A diagonal movement up to the head, whose eyes are once again closed, links them with *Der singende Mann*. But in contrast to the previous work, they exhibit a closed form, a fusion of individual parts, with no space between them. To this end, the knees are drawn towards each other and the flute itself held close to the chest. In addition, the outline is softly contoured, with the width of the shoulders reduced and the left arm and elbow minimized. Thus the calm, relaxed playing of the man, the source of whose inspiration seems to lie entirely within, finds its appropriate expression in a compact design of gentle, sweeping curves.

Perhaps more than any other sculptural work of Barlach's the clinker figure *Singender Klosterschüler* (also called *Der Sänger*) (Sch. I. 389 ; see Plate 9) best represents the category of " star-music ". This work, one of only three which were able to be completed by Barlach for the series *Die Gemeinschaft der Heiligen* (Sch. I. 355, 389, 411), was restored in 1947 to its original niche position on the facade of St. Katharine's Church, Lübeck, after a dozen years of concealment from unsympathetic and hostile forces.[31] Finished in a matt violet-grey and a little over life-size, the figure is of a simple construction, since its site requires it to be seen from afar and from below. With the exception of the hair, the work is almost perfectly symmetrical. As in the case of *Der Flötenbläser*, the form is of a closed variety, with the limbs contained within the overall shape of the garment. On this occasion, however, the standing figure thus composed is lent the compactness and concentrated strength of a pillar. Yet, despite this somewhat monumental character, the main quality that is projected is one of sublime composure. C. G. Heise, the erstwhile director of the Lübeck museum who instigated the original commission, conveys this in his description of the

[31] The troubled history of this work, the anxieties over finance, personal ill health and political reactions, can be followed in Barlach's correspondence from 1929. (Ernst Barlach, *Die Briefe II* (1925-1938). Hrsg. von Friedrich Dross, Munich, 1969 (*Briefe II*).

work : " Ein ganz in sich ruhender, gottseliger Diener des Herrn steht gelassen da ".[32] The collective name of the group to which it belongs, the site they occupy, and the title of the figure itself all suggest that it is a hymn that is being sung. Whether this is addressed directly to God as an act of worship, or sung in His praise to all men, it would appear that it has become so much a part of the singer that he need no longer refer to the score. Despite the general avoidance of specific characteristic detail, there is evidence on the brow and in the throat of the energy needed to project the voice. However, this does not substantially impair the serenity and control of the figure, exemplified by its symmetrical form. An extension of this attitude is to be found in the nine oak figures constituting the *Fries der Lauschenden* (1930-35, Sch. I. 351, 370, 371, 452, 456, 457, 460, 462). Originally planned as reliefs decorating the vase of a memorial bust of Beethoven (Sch. I. 314), they were eventually commissioned for a music room by the tobacco magnate Hermann Reemtsma, so that a musical context was always the intention. Once again, each figure is column-like, exhibiting little outward movement and a tendency to the symmetrical. They themselves do not sing or perform music, but are shown rather in the act of listening. This activity may concern itself simply with terrestrial music, or it may involve an extra-sensory contact with the sublime, with God, through the agency of such music. The counsel that the ghost of Moses receives from the Christian ascetic Hilarion in the posthumous *Der Graf von Ratzeburg* (1951) provides a useful parallel :

> Hättest du gelernt, der Stille und ihrer Stimme zu lauschen, so vernähmest du deutlich ihr Graben und Schaben am Stein. Gottes Stille ist gewaltiger als Gottes Donner. . .[33]

The silent contemplation advocated by Hilarion is in marked contrast to the row in the *Wirtsstube* scene of *Der arme Vetter* and to the din of the shooting festival that provides the background for *Die echten Sedemunds*. C. S. Lewis' devil Screwtape might almost have been describing these scenes, when in his ironic way he writes :

> Noise, the grand dynamism, the audible expression of all that is exultant, ruthless, and virile. Noise which alone defends us from silly qualms, despairing scruples, and impossible desires. We will make the whole universe a noise in the end. We have already made great strides in this direction as regards the Earth. The melodies and silences of Heaven will be shouted down in the end.[34]

Barlach's reference to the figures of the *Fries der Lauschenden* as "Heiligen - und Andachtsgestalten "[35] suggests that, through their outward silence,

[32] C. G. Heise, *Ernst Barlach. Der Figurenschmuck von St. Katharinen zu Lübeck*, Stuttgart, 4th edn., 1964, p. 13.

[33] *Dramen*, p. 551.

[34] C. S. Lewis, *The Screwtape Letters*, London, 1944, p. 114.

[35] *Briefe II*, p. 634. That Barlach was conscious too of their musicality is shown by the extended musical metaphor contained in his request for the return of the first three figures to assist the completion of the remainder (*Briefe II*, p. 526).

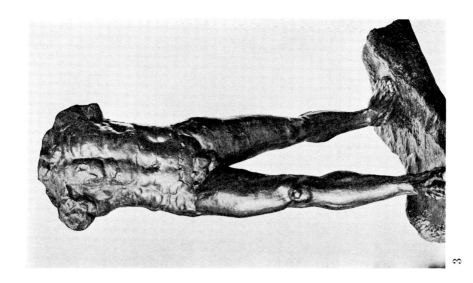

3

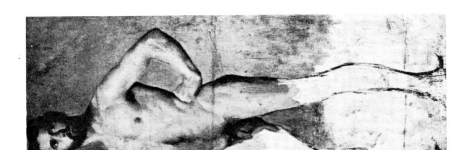

2

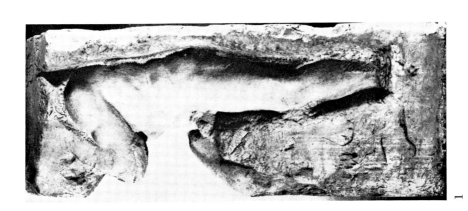

1

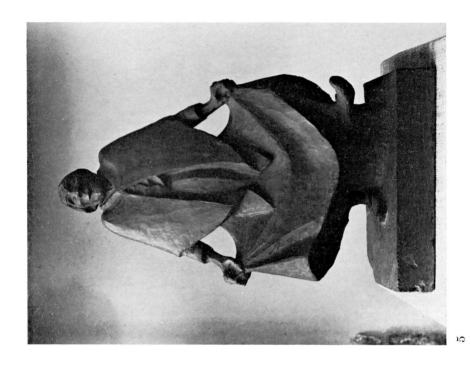

5

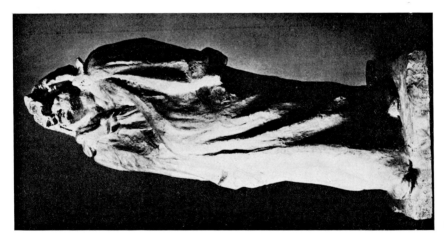

4

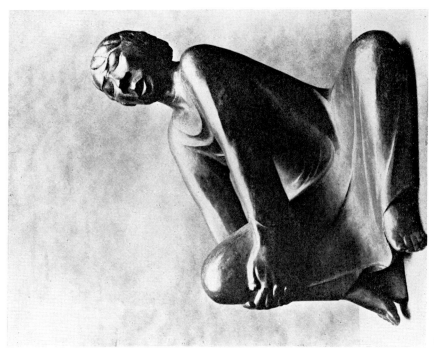

7

6

6

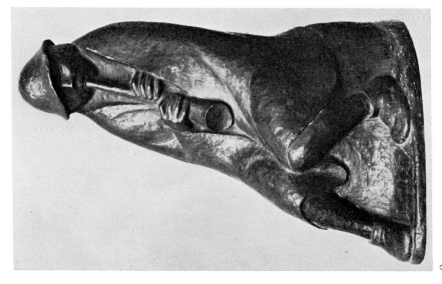

8

10

11

12

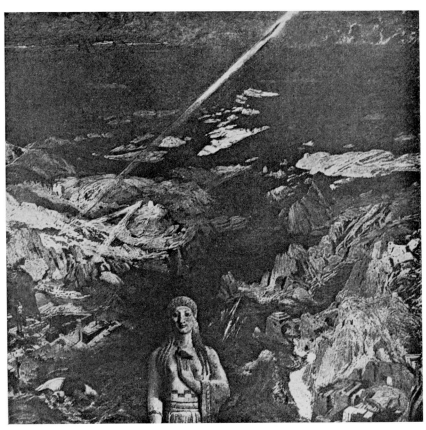

13

14

15

16

17

18

they at least are in communion with the " melodies and silences of Heaven ". In comparison with these melodies, even those of Bach and Beethoven lose their semblance of perfection, to reveal a relationship as of the reflection to the brilliant star.

In a letter of 1924 Barlach speaks for the first time of illustrating Schiller's ode *An die Freude*, adding : " Freude als Sinn, Zweck, Wesen der Welt, eine längst beliebte Vorstellung in meinen Gedanken über Zeit und Raum hinaus ".[36] The resulting series of nine woodcuts (Sch. II. 271-9) was completed during the following winter, though not published till 1927. " Lied an die Freude ", the title by which the series is referred to in his letters,[37] indicates Barlach's conception of this work as " musical " (in the " star-music " sense). An exemplary print from the series is *Engelreigen* (Sch. II. 273 ; see Plate 10). Round a small, but intense light source, whose rays inform and enliven the whole picture, hover angelic figures in an arc formation. While those in the foreground are linked by the outstretched arms of one of them, the rest, who are made to appear to extend beyond the limits of the print, are depicted as separate, though contiguous. The floating figure, an abiding preoccupation of Barlach's in all the visual media, expressing a release from mundane concerns and anxieties, here finds its most vivid statement. All reference to the physical world, to the *Mutterboden* of Sauerbrei's song, is excluded. Instead, the myriad shafts of light radiating from the star-like source stress the other-worldly joy of the angels' song. Thus Barlach, in supplying a visual equivalent for Schiller's poetry and Beethoven's music, achieves a form of synthesis of the arts, which, since Romanticism, has been regarded as an expression of the unity of all creation.

Absolute perfection, whether of beauty, truth, goodness or love, is not confined by the limitations of time or space. In its unchanging condition it remains a sublime ideal which man can only aspire to, never attain. Acknowledging this, Barlach nevertheless recognized in music the closest approach to this ideal, through its being at the one time the most abstract of the arts and the one most able to express directly the emotions experienced in contemplating the absolute. However, even music cannot escape the category of time, but must continually unfold and develop in a sequence of elusive sounds. In sculpture, however, in addition to the other visual media, Barlach had a mode which permitted him to suggest at least a sense of " stasis ", of removal from time, one of the qualities of the absolute. This he emphasizes, for instance, in the quoted examples of visual " star-music ", by an anti-Realist avoidance of the particular and the characteristic in his figures, depersonalizing them both in form and title. In addition, he inclines, especially in his later years, towards representations of contemplative states in preference to depicting figures in action. Thus the inward experi-

[36] *Briefe I*, p. 73.

[37] *Briefe II*, pp. 42, 567, 637, for example, Beethoven's setting of the poem in the last movement of his Ninth Symphony clearly provided an additional source of inspiration.

ence of blissful self-forgetfulness through music lends itself particularly, for Barlach, to being realized visually in motionless figures of a generalized character. In contrast to the ideal of timeless perfection, the inherent imperfections of humanity manifest themselves above all in conflict and change. Individual traits of character or appearance, in reality unique constellations of imperfections, may be the features which distinguish human beings, giving them " personality ", but this particularizing is also the source of tensions. These tensions, or dissonances, have been labelled " frog-music " and identified as such, especially in the dramas. Here the need for proper names and speech forms befitting the personality of the speaker serve to individualize and set apart one character from another. But these are merely the surface expressions of a deep-rooted aggressive instinct, which reveals itself in its most extreme form dramatically in murder, suicide and mutilation. Related, although less extreme, are the immoderate singing and impetuous dancing of the dramas and visual works, in the latter case performed by similarly individualized figures. Above all, the drama, being the art-form at Barlach's disposal that is dependent on chronological time, becomes the means to expression of the fundamental characteristic of the human condition : transience. The contrast with sculpture is clear.

Unlike his literary cousins in Aesop, La Fontaine or Luther, Barlach's fabulous frog acquires a self-knowledge that enables him to accept the patent inadequacies of his existence. Moral sustenance is provided by the stellar image, a constant reminder of a desired, but unattainable perfection. As has been shown, Classical music can be similarly sustaining, particularly for those who perceive in it a distant echo of the music of the spheres. Since this characteristic is at no time more conspicuous than in periods of tension and conflict, it is appropriate to conclude by quoting from a diary entry of 23 August 1914 :

> [Ich] hörte aus der Nachbarschaft ein bißchen Musik, es schien echte Musik und erschütterte mich so stark wie die Kriegserlebnisse. Eine andere Welt zog mich unversehens an sich, da schaltete wie hier die höchste Gewalt mit den Seelen, und die Gewalt brach sich als Unendlichkeit im stillen Spiegel klarer Klänge, einfacher Töne. Wenig und Alles, wie das Stück Sternhimmel, in einer Pfütze gespiegelt, ebenso unermeßlich ist wie der ganze Weltraum.[38]

PETER MEECH

Stirling

[38] Ernst Barlach, *Das dichterische Werk. Band III : Die Prosa II*, Munich, 1959, p. 24.

SYNTHESISM AND SYMBOLISM :
THE RUSSIAN *WORLD OF ART* MOVEMENT

Over the last few years Russian and Western scholars have been giving long overdue attention to the history of Russian Symbolism, a move which has produced a variety of informative articles and books. These publications have been devoted, unfortunately, almost exclusively to the literary theory and practice of the Russian Symbolists, and the other arts, painting and music in particular, have received only marginal treatment. This disproportionate concentration on literature is especially lamentable in the context of Russian Symbolism since this movement was, as so many observers hasten to point out, a synthetic one, whose intellectual horizons extended far beyond the art of the written word. We have but to consult the work of the Russian Symbolist writers, such as A. Bely, A. Blok, V. Bryusov and V. Ivanov, to understand their deep concern with non-literary art forms and their common aspiration towards artistic wholism. In the late 1890s and early 1900s this aspiration was particularly evident within the framework of the St Petersburg group known as the *World of Art*, which, as its name would imply, served as a common basis for many, varied, cultural activities. True, the *World of Art* favoured the visual arts, but it maintained the closest contact with writers and musicians and hence contributed to that deep interest in synthesism which became such an integral part of Modernist aesthetics both in Russia and in the West.

Essentially, the *World of Art* was a title applied to a cultural " club " of artists, literati, musicians and aesthetes, to a journal issued by them (1898-1904) and to a series of art exhibitions (1899-1906, 1910-1924). The organizational force behind many of the *World of Art*'s activities was S. Diaghilev who achieved subsequent renown in the West as the leader of the *Ballets Russes*, and it was through him that many of the *World of Art* artists, L. Bakst, A. Benois and N. Rerikh among them, also attained international repute from their stage and costume designs for his ballet productions ; conversely, some of their colleagues, such as E. Lancéray, A. Ostroumova and K. Somov, did not assist in Diaghilev's enterprise and hence, unjustly, are not known by Western historians. The artistic sensibility which Diaghilev and his confrères cultivated was maintained, even intensified, by the contingent of literati, D. Filosofov, Z. Hippius, D. Merezhkovsky, N. Minsky, V. Rozanov, L. Shestov and, later, Bely and Bryusov. But despite the weight of such names, the *World of Art* remained oriented towards art and art history, rather than towards literature, an inclination which became especially pronounced during the last two years of the journal's existence. But outside of this basic division, the *World of*

Art was not easily identifiable with one aesthetic principle. Certainly, it shared common ground with the so-called first generation of Russian Symbolist poets, led by K. Bal'mont and Bryusov, but its eclecticism allowed for a world-view broader than theirs alone could provide. Despite the *World of Art*'s tendency to regard art as " craft ", rather than as " religion " —a tenet which distinguished the first from the second generations of Russian Symbolist writers—it sympathized with the later Symbolists such as Bely, Blok and V. Ivanov and, in turn, with the group of mystical painters, the *Blue Rose*. Indeed, the *World of Art* was in communication with the most diverse cultural figures of the time and served as a forum for the ceaseless discussion and interchange of aesthetic ideas. Hence, as a general rubric, the *World of Art* covered a multiplicity of artistic phenomena—the demonic art of M. Vrubel' and the stylized primitivism of V. Vasnetsov, the incisive graphics of Beardsley and the Art Nouveau designs of Mackintosh, the poetry of Bal'mont and the prose of Merezhkovsky, the individualism of Diaghilev and the historicism of Benois. Chronologically, however, the *World of Art* existed as a cohesive society during the hegemony of the first Russian Symbolist poets (late 1890s until c. 1904), and by the end of 1904, when a new wave of philosopher-poets had come to dominate the literary scene, it had lost its original physiognomy. Indeed, by then its place had been usurped by other publicist and artistic groups and, thenceforth, much of its energy was channelled into other activities, the theatre and the ballet among them.

The aestheticism of the *World of Art* artists, their alienation from social and political reality—reflected in their highly stylized, retrospective depictions of Versailles executed with unfailing technical finesse—indicated their tentative acceptance of " art for art's sake " and linked them to such adroit poets as Bal'mont and Bryusov. Just as the verse of the latter was opposed to the civic poetry of the 1860s and 1870s, so the artistic output of such painters as Benois and Somov was alien to the art of the Realists with their imitative presentations of social disorders. The motto which appeared as an insignium on some *World of Art* publications epitomized their attitude towards the function of art : " Art is Free, Life is Paralyzed "—in other words, art was something too etherial, too mobile to be anchored to depictions of the realities of life. Indeed, not until the 1905 revolution did some *World of Art* painters and writers turn their attention to the burning social questions of the day by contributing to satirical magazines, but even then, only a few worked at all effectively in this area. Most of the *World of Art* artists confined their political involvement to the signing of a joint communiqué or to private statements welcoming the 1905 revolution and criticizing the status quo.[1] But, for the most part, their efforts were abortive and they retired to the calm world of their Epicurean dreams at least until

[1] See, for example, A. Benois, M. Dobuzhinsky, E. Lancéray and K. Somov, " Golos khudozhnikov ", in : *Syn otechestva*, 12 Nov., 1905 ; reprinted in *Zolotoe runo*, 1906, No. 1 pp. 132-133.

1917. This clarity of aesthetic vision distinguished them from the second generation of Russian Symbolists who treated art as a spiritual force by which to move *ab realia ad realiora*. Ultimately, however, this lack of a consistent and definite ideological system within the perimeter of the *World of Art* contributed to its own creative enervation.

The neglect of ideological and philosophical questions which we can identify with much of the *World of Art*'s artistic and literary output found a striking compensation in the resultant emphasis on intrinsic artistic properties, a move which connected many of the *World of Art* members with their Symbolist predecessors in France. The attention to the poetical fabric which Bal'mont and Bryusov, or, for that matter, Mallarmé and Verlaine, demonstrated in their verse, tended to reduce the poem to an independent arrangement of sounds, rhythms and visual images. This approach to the poem as something self-sufficient, although still associated semantically with concrete reality, found a figurative parallel in many of the paintings of the *World of Art* artists. Not only did such artists as Bakst, Benois and Somov concentrate on technical mastery and thence on specific painterly properties such as line, colour and mass, but also, quite deliberately, they confined the narrative content of the picture by resorting to a scenic format, i.e. by using equidistant trees or statues as theatrical wings and thereby forcing the eye to remain within the frame (see Plate 11). This theatricality was expressed, above all, by the artists' concentration on line—just as the poets tended to exaggerate sound—and this led, unexpectedly, to a partial syncretism, i.e. to " architectural painting " and to " musical poetry ". In poetry the disruption of versification, noticeable especially in the early Bal'mont and Bely, can be compared therefore to the linear landscapes of Benois or Somov in which normal visual priorities are displaced. In other words, both in the poetry and in the painting of the time perceptual sequences are shifted : firstly we become aware of the formal devices employed and only then do we understand the action or narrative theme. In short, in both disciplines we see a tendency towards abstraction through technical and formal prerogatives. We can note a similar dislocation of traditional values within the framework of colour : the preponderance of white and blue in so much Symbolist verse not only symbolizes spiritual purity or, alternatively, " le grand néant ", but also presents an unnatural and abstracted conception of visual reality. The same is true of pictures by Puvis de Chavannes, Maurice Denis, V. Borisov-Musatov or Vrubel'—where highly subjective and exclusive colour schemes are applied regularly. In Vrubel's canvases, for example, the emphasis on blue, violet and purple reaches such extreme proportions that the subject becomes at times unrecognizable, a transformation which prompted poets to speak of the " poison " of Vrubel's painting.[2]

[2] A. Bely, *Vospominaniya ob Aleksandre Bloke*, Letchworth, 1964, p. 117. See also A. Blok, " Pamyati Vrubelya ", in : A. Blok, *Sobranie sochinenii*, Moscow-Leningrad, 1960-1963, vol. 5, pp. 421-424.

The intense concern with formal ingredients experienced by the writers and artists of the *World of Art* anticipated the distinct orientation towards form peculiar to the Russian avant-garde after 1910. It was logical, therefore, that Bryusov could think subsequently in terms of " scientific poetry "[3] or that Bely should have aspired to create an exact aesthetics,[4] since both endeavours were the direct results of their preoccupation with poetical craft at the beginning of the century. Despite Bely's misleading statement that " we didn't trouble about form or style, but about inner vision ",[5] his very awareness of the need to revitalize poetical vocabulary and his deep interest in formal analyses pointed to the contrary. Even in the context of a profoundly philosophical and thematic poet such as Blok, the concern with poetical form is self-evident : for example, any examination of his famous poem, the *Stranger* (*Neznakomka*, 1906), reveals immediately its architectonic, hermetic composition founded on a rigid, triangular structure (first six verses—reality ; seventh—reality/dream ; last six—dream). In this, Blok and his colleagues shared common ground with Benois, Somov, etc., whose landscapes rested very often on a central axis within a symmetrical planear arrangement. Since in many cases the poems and paintings of the Symbolists reflected such general themes as moral disintegration and spiritual fatigue, this overt structuralization emerged as an ironic comment on the actual content. Ultimately, the intense concentration on one or more specific artistic elements contributed directly to a loss of methodological balance and hence to a loss of aesthetic totality. In poetry the emphasis on sound detracted automatically from the visuality of its imagery, in painting the cult of line weakened the role of colour and in music the attention to the harmonic or vertical structure of the score overshadowed the value of the melodic or horizontal factor. It is because of this that, despite the formal accuracy described above, a certain dissonance or extremism is often identifiable with the *World of Art* and the Symbolist movement in general. But, in turn, it was the awareness of this failing and the wish to overcome it that contributed to the general synthetic tendency within the *World of Art* and inspired such remarkable essays as Blok's " Colours and Words " (1905).

The apolitical, asocial, even aphilosophical behaviour of many of the *World of Art* members should not allow us to apply the term " art for art's sake " as a blanket term for the aesthetic direction favoured by all of them. Indeed, together with its advocation of the Symbolist heroes, Ibsen, Nietzsche and the Russian philosopher, Vladimir Solov'ev, the *World of Art* tolerated, even publicized, such names as Dostoevsky, Repin, Ruskin and Tolstoi as well as the theurgic Symbolists, Bely and V. Ivanov. In this way, it acted as a junction of interests, rather than as the champion of a single trend.

[3] See V. Bryusov, " Literaturnaya zhizn' Frantsii. Nauchnaya poesiya ", in : *Russkaya mysl'*, 1909, No. 6.

[4] See A. Bely, *Simvolizm*, Moscow, 1910.

[5] A. Bely, *Vospominaniya* . . ., p. 31.

As Filosofov remarked : "The *World of Art* never had a definite programme. . . . It was a cult of dilettantism in the good and true sense of the word."[6] But despite the confusion of artistic currents harboured by the *World of Art* we can detect certain rudimentary ideas whether in its literary or in its artistic output, and perhaps the most important of these was the whole concept of cultural integration.

The quest for artistic synthesism undertaken by so many of the *World of Art* painters and writers was particularly evident from their discovery and support of Wagner and the operatic drama. Although he was admired by all associates of the *World of Art*, the reasons for his popularity differed among them. In the case of Benois and Diaghilev it was admiration for the way in which Wagner had combined musical and visual forces to produce an expressive and emotive whole having little in common with the light Italian and French operas frequented by their forebears. Their appreciation, however, was not limited to passive observation : as early as 1893 Diaghilev had given a formal concert on the Filosofovs' estate when he had performed two arias from *Parsifal* and *Lohengrin* and in 1902 Benois realized one of his first stage sets by designing the Imperial Theatre's presentation of *Götterdämmerung*. In the case of both men Wagner remained a life-long interest and his name was mentioned frequently on the pages of the *World of Art* journal. The principal essay on the composer, G. Lichtenberger's "Wagner's Views on Art", expressed many thoughts similar to those of the Russian Symbolist philosophers : such statements as : "Drama is nothing but myth" or "Greek drama was 'collective' because it included not only many people, but also a union of the arts"[7] were to find parallels in the writings of Bely and V. Ivanov. Just as Wagner, according to many of the *World of Art* members, had at times succeeded in creating a synthetic art, so Rimsky-Korsakov and Skryabin were regarded also in the same light. Rimsky-Korsakov's equation of notes with colours and his own mastery of operatic form endeared him to Diaghilev in particular who at one time received lessons from him and who propagated his works so successfully in the West. To Diaghilev, "heathen and hedonist",[8] Skryabin's exotic and mystical music meant much, witness to which was his invitation to him to appear as a soloist at the season of Russian music in Paris in 1907. Skryabin's efforts to draw distinct parallels between the seven colours of the spectrum and the seven notes of the European scale acted as a pseudo scientific basis for his further investigation into the possibilities of total art ; but in this Skryabin was not isolated, for he had affinities with N. Medtner, Rachmaninov and, above all, M. Chiurlienis.

[6] Quoted from A. Grishchenko and N. Lavrsky, *A. Shevchenko. Poiski i dostizheniya v oblasti stankovoi zhivopisi*, Moscow, 1919, chap. I.

[7] G. Lichtenberger, "Vzglyady Vagnera na iskusstvo", in: *Mir iskusstva*, 1898/1899, No. 7/8, pp. 107, 108.

[8] The words belong to Hippius. See T. Pachmuss, *Zinaida Hippius*, Southern Illinois University Press, 1971, p. 414, note 14.

When Chiurlienis moved from his home-land, Lithuania, to St Petersburg in 1909 he was treated immediately as a long lost relative by the Symbolist fraternity, especially by V. Ivanov. For the Symbolists Chiurlienis was perhaps the most synthetic artist of all since his search for wholeness was undertaken on two levels : on the one hand his interest in folk-lore, both of the West and of the East, associated him with Bakst and V. Ivanov, on the other hand his attempts to " paint music ", i.e. to unite two art forms in one whole, merited him comparison with Wagner and Skryabin. But it was not only his retrospectivism and visual music which linked him with the *World of Art* and post-*World of Art* intellectuals, but also his familiarity with the work of Beardsley, Puvis de Chavannes, Ibsen, Nietzsche and Wilde ; structurally, too, his pictures had much in common with those of the St Petersburg painters, particularly in their elements of linearity and symmetry. It was this which prompted V. Ivanov to speak of the " geometrical transparency "[9] of Chiurlienis' pictures and another critic to observe that " one of the main peculiarities of Chiurlienis' compositions is the dominance of the vertical line. He is the poet of the vertical. . . . Every vertical is a denial of earthly life "[10] (see Plate 12). The " transparency " of Chiurlienis' work, by which V. Ivanov must have meant the fusion of shapes and absence of strict delineation identifiable with the painter, was, however, a quality alien to the graphic clarity of Bakst, Benois or Somov ; the ensuing tendency towards abstractivism in painting linked him more closely, in fact, with the second generation of Russian Symbolist painters, the *Blue Rose*.

The endeavours of Chiurlienis to " fuse time and space "[11] and of Skryabin to raise musical performance into a grand *Poem of Ecstasy* in which all took part were, of course, seen by most of the Symbolists, especially Bal'mont and V. Ivanov, as experiments in artistic wholeness, pointing back to Greek drama : in the words of V. Ivanov, " the theatre must stop being ' theatre ' in the sense of spectacle—zu schaffen, nicht zu schauen. The crowd of spectators must fuse into a choral body, like the mystical community of ancient ' orgies ' and ' mysteries ' . . .".[12] Essentially, all the Russian Symbolist writers and artists regarded drama as the only medium which could guarantee direct communication between artist and spectator, one in which the word could become flesh.[13] It was logical, therefore, that Bely should have advocated that the " author become a producer " (" rezhisser "),[14] a desire fulfilled, albeit ironically, in such plays as Blok's *Fair Booth (Bala-*

[9] Quoted from a letter from V. Ivanov to S. Makovsky, in : S. Makovsky, " N. K. Churlyanis ", in : *Apollon*, 1911, No. 5, p. 25.

[10] V. Chudovsky, " N. K. Churlyanis ", in : *Apollon*, 1914, No. 3, p. 30.

[11] V. Ivanov, *Borozdy i mezhi*, Moscow, 1916, p. 321.

[12] V. Ivanov, " Novaya organicheskaya epokha i teatr budushchego ", in : *Po zvezdam*, St Petersburg, 1909, p. 205.

[13] Many Symbolist writers favoured this concept. See, for example, A. Bely, *Simvolizm*, p. 95 ; V. Ivanov, *Po zvezdam*, p. 302.

[14] A. Bely, *Arabeski*, Moscow, 1911, p. 40

ganchik) and N. Evreinov's *Fourth Wall*. The *World of Art* painters were equally interested in the theatrical art, although they were still very conscious of artistic boundaries and of aesthetic canons peculiar to each artistic discipline within a dramatic performance. Paradoxically, it was their observation of these specific limitations and not their dismissal of them which contributed to the success of Diaghilev's presentations of ballet, surely like opera and drama, one of the most convincing examples of a synthetic art form. Diaghilev's opera and ballet productions remained purely artistic and, of course, had no religious or theurgical purpose : they remained in V. Ivanov's word, " spectacles ", rejecting any notion of audience participation. The success of the *Ballets Russes* was the result very much of the general approach to art observed by Bakst, Benois and Diaghilev within the *World of Art* : that it was a supreme human expression which depended, nevertheless, on severe rules of technique, aesthetic balance and thematic resemblance. The attention to fine detail demanded by Diaghilev in the dance, stage design and musical performance was therefore symptomatic of the *World of Art*'s emphasis on the " how " rather than on the " what ", on technical precision, rather than on mimetic representation. In this respect, the *World of Art* painters shared the same conception of the theatre as Bal'mont and Bryusov, regarding it primarily as an exercise in the use of the intrinsic properties of a synthetic medium and not as a cosmic force of social unification.

The sense of form, composition and emotional restraint identifiable with much of the *World of Art* art—in Somov's water-colours or in Bryusov's verse—reached its creative apotheosis in the graphics of such masters as Bakst, Benois, Bilibin, M. Dobuzhinsky, Lancéray, A. Ostroumova and Somov. Their unfailing sense of line, in itself indicative of their innate artistic discipline, demonstrated a technical prowess so lacking in the Realist works of the preceding decades. Their technical mastery in graphics displayed itself in their many designs for stage productions as well as in miniatures, embroidery and fashion designs, above all, in book illustration where an abundance of detail had to be included within strictly curtailed limits. Perhaps the greatest book illustrator of the time was Somov, whose love of the *Commoedia dell'arte* enabled him to produce such a striking cover to the first edition of Blok's dramatic works (1907, which Blok did not care for, as a matter of fact) ; in the same year, he executed his equally famous covers for V. Ivanov's *Cor Ardens* and Bal'mont's *Fire-bird*. Mention might be made also of Bilibin's exquisite covers and illustrations for a series of Russian fairy-tales published in 1901 onwards and the edition of Pushkin's *Queen of Spades* published in 1911 with illustrations by Benois. The graphic expertise encountered in the decorative and ornamental pieces of the *World of Art* artists might be seen, in broader terms, as the result of their non-philosophical approach to art, for without a definite ideological justification, their art was left to turn in on itself, to manipulate to the

fullest extent its own properties of line, colour and mass. In this respect Bely's remark that schematization (stylization) pointed to the " inability to cope with reality "[15] was particularly relevant, for the elegant, yet brittle examples of technical bravura encountered in much of Somov or the early Lancéray (or, for that matter, in Bryusov) speaks so ironically of the nothingness beyond. This philosophical vacuum was emphasized by the cyclical and hence insulatory structure of many poems and by the symmetrical arrangement evident in many portraits and landscapes : it was with meaningful irony, therefore, that V. Ivanov could have referred to such art as " flowers to cover the black void ",[16] for the highly contrived poetry of Bryusov or the refined 18th-century scenes of Somov were in direct opposition to the basic premise of the later Symbolists, i.e. that Symbolist art lay outside aesthetic categories. Bely, for his part, extended this argument to conclude that aestheticism was almost a synonym for creative insolvency and that " as a form of liberation from the will it was the consequence of the philosophy of a dying century " ;[17] in this respect, Bely considered Maeterlinck's dramas, so esteemed by the initial *World of Art* members, as the embodiment of an " ideology of sleep ".[18]

The tendency of the *World of Art* artists to " lightheartedly leave aside religious questions "[19] was to a certain extent counteracted by their own intellectual curiosity. The " myth-making " and " god-searching " peculiar especially to the second generation of Russian Symbolists was identifiable also with the *World of Art* albeit on a less conscious level, and the reaction against Positivism which Merezhkovsky had sanctioned in his Symbolist manifesto of 1892,[20] contributed substantially to the *World of Art*'s immediate interest in certain spiritual problems. Bakst, for example, while not stating his tenets in explicit terms, shared the *Zeitgeist* of eschatological mysticism as his famous picture, *Terror Antiquus*, indicated (see Plate 13) : the apocalyptic event which this picture harbingered was hence a visual parallel to the sunsets and falling stars described in so much of the early verse of the Russian Symbolist poets. Painters and poets shared common ground also in their mutual cultivation of the necrological, the demonic and the erotic ; and what is important here is that both parties not only selected such themes, but also treated them stylistically in similar ways : just as the sensation of inescapability is transmitted in much verse of the time by frequent recourse to a uniform montage of blackness, to an insularized locale, to a process of dehumanization, to a circular poetical structure,

[15] B. Bugaev (A. Bely), " Formy iskusstva ", in : *Mir iskusstva*, 1902, No. 2, p. 343.

[16] V. Ivanov, *Borozdy i mezhi*, p. 177.

[17] A. Bely, *Vospominaniya* . . ., p. 14.

[18] Ibid., p. 13.

[19] Hippius made this accusation. See N. Sokolova, *Mir iskusstva*, Moscow-Leningrad, 1934, p. 61.

[20] D. Merezhkovsky, *O prichinakh upadka i o novykh techeniyakh sovremennoi russkoi literatury*, St Petersburg, 1893.

etc., so in many *World of Art* pictures reality is reduced to a symmetrical nocturnal landscape (see Plate 14), to a portrait of a lifeless figure against a hollow background or to an *intérieur* full of objects, but devoid of people. This desperate, pessimistic interpretation of life observed within the *World of Art* was not, however, exclusive. For example, we can recognize a less morbid, less negative attitude in some of Bryusov's urban verse where he presents the bourgeois city as a symbol of creative energy and not of moral and social disintegration. This conception was shared by Dobuzhinsky, whose remarkable graphic scenes of St Petersburg, Riga and London betray the artist's admiration of human ingenuity and technological advance (see Plate 15). In their tentative support of urban culture, both Bryusov and Dobuzhinsky anticipated the Futurists' advocation of industry and mechanical dynamism, although, of course, neither the poet nor the artist destroyed basic poetical or graphic conventions.

The association between representatives of art and literature within the *World of Art* led to the fine series of portraits of its members and contributors executed by such painters as Bakst and Somov. Among these figured Bakst's portraits of Bely and Hippius, Vrubel's unfinished portrait of Bryusov and, perhaps the most remarkable, Somov's portrait of Blok (see Plate 16). Somov's small crayon and gouache rendering of Blok's head must surely rank as one of the most successful interpretations of a Symbolist character by a contemporaneous artist : Blok's head appears as if carved from a piece of stone, an impression emphasized by the symmetrical hairstyle, the Roman nose and the empty background ; gazing out from this cold, pale montage are the eyes : " In Blok's eyes, so clear and seemingly beautiful, there was something lifeless—and it was this, probably, which struck Somov ".[21] It was a fortunate coincidence that both the poet and the painter should have shared a similar world-view at this time : Blok, plunged into despair and urban decadence, breathed the same vapid air as Somov, whose pictures of fireworks at Versailles and depictions of erotic play served only to hide the deep cynicism and sense of isolation felt by him throughout his life. His insertion of a pale vacuum as the background to the Blok portrait was therefore in keeping with the spiritual state of both and brought to mind immediately the ending of Blok's play, the *Fair Booth (Balaganchik)* : " Harlequin jumps through the window. The distance visible through the window turns out to be drawn on paper. The paper burst. Harlequin flew head over heels into emptiness ".[22] Indeed, the profound awareness of the artificiality and farcicality of life, which dominated the whole Symbolist arena, permeated many levels of the *World of Art*. But nowhere did Blok and Somov share more closely the same absence of metaphysical values than in the terrible symmetry and weary sensuality of Somov's portrait of Blok.

[21] G. Chulkov, *Gody strantsvii*, Moscow, 1930, p. 125.
[22] A. Blok, " Balaganchik ", in : *Sobranie sochinenii*, vol. 4, p. 20.

The pessimistic conclusion both in Blok's play and in Somov's portrait was to a certain extent the direct result of an artistic style founded on morbid subjectivism (a transient mood with Blok, but constant with Somov), a faith of futility. Within the sphere of the *World of Art* several such parallel positions can be perceived, i.e. between writers and painters, and form specific aesthetic patterns within its overall prism. Somov's introspection and preoccupation with sex and death had much in common with Diaghilev's fundamental notion that art should be the summation of the ego : ". . . the meaning of [a work of art] consists of the highest manifestation of the creator's individuality and in the closest possible relationship between this individuality and that of the perceptor ".[23] At its face value such a statement was a virile, assertive plea for the artist's liberation from civic duty and, in turn, recalled the egocentric, yet dynamic and elemental verse of the early Bal'mont. But just as this conception turned " inward " and led directly to the emotional disintegration and contrived confusion of some of Bryusov's verse in the early 1900s or in much of Blok's work between c. 1904 and c. 1910, so, thematically, at least, much of Somov's work reflected the same *taedium vitae* and served as a practical extension of Diaghilev's argument. In contrast to Bakst, Benois or Rerikh who turned to past cultures as embodiments of social and moral cohesion, Somov regarded his subjects, normally from 18th-century France, with bitter irony depicting them as equally corrupt and artificial as his own age. In this way, he might be compared with Bryusov parodying Classical values in his cycle of verse, *Tertia Vigilia*, or with Blok raising the cardboard sword of the Middle Ages in his play, the *Rose and the Cross*. Somov's " People—ghosts playing at being people " were,[24] however, the consequence of only one intellectual premise among several found within the *World of Art*. Benois, Diaghilev's closest colleague and, at one time, mentor, was opposed to such a philosophy of introspection as he indicated in a long and sensitive article, "Artistic Heresies": " Does not individualism, the cornerstone of contemporary artistic life, teach us that only that has value which has arisen freely in the artist's soul and has poured freely into his creation ? . . . Artists have scattered into their own corners . . . and at all costs try to be only themselves. Chaos reigns, something turgid which has scarcely any value and which, strangest of all, has no physiognomy. . . . Individualism is heresy mainly because it denies communication ".[25] To a considerable extent it was this awareness which prompted Benois to look back to the rationality and integration of 17th- and 18th-century France and to Classical culture since for him they presented a panacea to social ills, a source of spiritual inspiration, which for Somov they were not. Benois' naive and often humorous depictions of

[23] S. Diaghilev, " Osnovy khudozhestvennoi otsenki ", in : *Mir iskusstva*, 1898/1899, No. 3/4, p. 57.

[24] V. Dmitriev, " Konstantin Somov ", in : *Apollon*, 1913, No. 9, p. 35.

[25] A. Benois, " Khudozhestvennye eresi ", in : *Zolotoe runo*, 1906, No. 2, pp. 80-81.

Versailles emerged almost as evocations of some distant, yet fondly remembered childhood ; his admiration for, and erudition in, this " enchanting lie "[26] was matched only by V. Ivanov's love and knowledge of Greece and Rome.

The retrospectivism favoured by the *World of Art* was not confined to praise of specific historical periods such as Classical Greece or Versailles. A profound interest in popular myth and in the primordial state of Man also occupied painters such as Bakst as well as several writers. Indicative of this was the illustrated contribution on V. Vasnetsov to the first number of the *World of Art* journal, which, by its very presence, acted as a visual declaration of policy. Vasnetsov's work, like that of Vrubel', was seen by many of the *World of Art* members as the incarnation of an archaic, barbaric force, a world of ancient legend and elemental unity. In addition, Vasnetsov's interest in the traditions of the Russian Church attracted him to the images of the Virgin Mary and St Sofia ; and this, in turn, explained his popularity amongst Solov'ev, Blok and Bely with their earnest cult of the Eternal Feminine. As early as 1901, in his series of " Philosophical Conversations ", the writer and thinker, Minsky, had defined the predicament of his contemporaneous culture as one which lacked the " wholeness and harmony of the child's soul ",[27] a statement which anticipated V. Ivanov or even the Neo-primitivists with their conscious recourse to naive art. V. Ivanov extended Minsky's thesis to conclude that " True Symbolism must reconcile the poet and the mob in a great, universal art. . . . We are taking the path of the symbol to the myth ".[28] Within such a world-view it was easy to accommodate the work of Bakst, Chiurlienis, Vasnetsov and Vrubel'. Bakst's depictions of Grecian landscapes which combined ethnographical accuracy and intense imagination were bound to appeal to the Hellenism of V. Ivanov and summarized in visual terms the Symbolists' belief in the need to return to a barbaric, elemental state. This concept Bakst developed later in his highly important article, " The New Paths of Classicism " : " Painting of the future calls for a lapidary style, because the new art cannot endure the refined. . . . Painting of the future will crawl down into the depths of coarseness . . .".[29] Although this statement was relevant to the emergence of the Neo-primitivist painting of N. Goncharova, M. Larionov, *et al.*, it also had wider implications, especially when examined through the lense of V. Ivanov's terminology—" Dionysius . . . anarchy . . . the mob " : for V. Ivanov and his fellow Symbolists the return to a primitive condition was to be a synthesizing factor, a process which would overcome the superstructure of rational and individualistic ideas created by Western Man and reach the pure essence of reality ; for the

[26] A. Benois, *Istoriya russkoi zhivopisi v XIX veke*, vol. 1, St Petersburg, 1901, p. 12.
[27] N. Minsky, " Filosofskie razgovory ", in : *Mir iskusstva*, 1901, No. 7, p. 3.
[28] V. Ivanov, " Poet i chern ", in : *Po zvezdam*, pp. 41-42.
[29] L. Bakst, " Puti klassitsizma ", in : *Apollon*, 1909/1910, No. 3, p. 60.

Neo-primitivists, however, the return was only part of their endeavour to revitalize art and had none of the cosmic dimensions identifiable with the later Symbolists. This, as a matter of fact, was one of the main differences which separated the Russian Symbolists from the so-called literary and artistic avant-garde after c. 1908.

Apart from such general terms as synthesism, escapism and retrospectivism, the only definite philosophical system recognizable within the framework of the *World of Art* belonged to Bely. But since he established contact with the *World of Art* only during its last years, his statements must not be regarded as the general credo of the original *World of Art* group. Like Benois, Diaghilev, A. Nourok and W. Nouvel', Bely gave particular attention to the phenomenon of music, but he developed their basic concepts into an elaborate metaphysical system far removed from the ordinary tonal interpretation. In his article, " Forms of Art ", Bely defined the essence of reality as music : " Movement is the basic feature of reality. . . . Only music goes to the heart of images, i.e. movement. Every artistic form has as its starting-point reality and as its finishing-point—music. . . . In music images are absent ".[30] While Bely considered music as the absolute of art forms, because it was based on temporal movement (and for him time was an inner, intuitive sensation), he did not reject poetry and painting out of hand. For Bely and for V. Ivanov poetry was the second most vital art form because of its prerequisites of rhythm and of sound, although painting for them contained " empirical " elements of colour and perspective. What Bely and V. Ivanov chose to ignore was that music, like painting, was based also to a large extent on perspective—i.e. the need to arrange orchestral instruments at a certain, predetermined distance in order to hear a certain sequence of sounds—and that painting, in turn, had its own equivalent of rhythm, namely line. If, for Bely and V. Ivanov, rhythm was the mobile and cohesive factor in a piece of music or poetry, then line should have been seen to play the same role in a landscape or portrait. This is evident, for example, in any landscape of Bakst, Benois or Somov where the whole composition is constructed so as to transmit a sensation of rhythmic dynamism, especially by the " reflections " of verticals, horizontals and diagonals in various planes and by the rapid perspective achieved by a sequence of horizontals. Both in poetry and painting, therefore, we can interpret the emphasis on rhythm as an attempt to connect artistic units and thereby to gain artistic wholeness. Bely's comprehension of music as the fundamental and essential form of reality was but another symptom of the general aspiration towards monism within the *World of Art*, but his development of the basic concept into a theoretical premise—and hence his attribution of art with a philosophical purpose—was something alien to its original scale of values and closer to Blok or to the *Blue Rose*. In this respect, the fact that one of the last literary contributions to the *World of Art* journal was by

[30] B. Bugaev (A. Bely), " Formy iskusstva ", in : *Mir iskusstva*, 1902, No. 2, p. 347.

Bely, creates a convenient bridge from the first Symbolist generation to the second. In this article, Bely continued to talk of the intensity of " musical symbols " and of the " approach of inner music to the surface of the consciousness "[31] : such mystical, abstracted thinking would explain his admiration for the musical canvases, evocative allusions of the *Blue Rose* painters, already far removed from the formal accuracy of the *World of Art* artists. In this context it is important to repeat Bely's specific ideas regarding painting, expressed on the pages of the *World of Art* : " In painting we are concerned with the projection of reality on to a plane. . . . It is not the picture itself which should come to the foreground, but the veracity of the emotions and moods being experienced which this or that picture of nature evokes in us ".[32] The idea that evocation of mood was more important in art than the representation of a given part of reality was especially relevant to the painting of the *Blue Rose* artists. Indeed, it was their reaction against the rigidity of the *World of Art* painting and their interfusion of mass, their subtle gradations of pastel colours and loss of contour which recalled the musicality of Chiurlienis' work and hence the cosmic artistic synthesism of such diverse figures as V. Ivanov, Kandinsky and Skryabin.

Bely's article of 1904, with its provocative ideas so contrary to the aesthetics of the original *World of Art* members, pointed to the decline of the *World of Art* as a cohesive, cultural centre : in the same year the journal ceased publication, Diaghilev turned his eyes Westward and new, progressive directions soon dominated the Russian cultural arena. Even if the *World of Art* had continued to exist as a society and as a journal, it would have been no match for the flamboyance and ebullience of the subsequent movements of Neo-primitivism and Futurism. For Benois, steeped in the traditions of the 18th century, the Futurists embodied the " cult of emptiness, of darkness and of nothingness ".[33] In point of fact, Benois failed to recognize that the new avant-garde, by destroying conventional disciplines, maintained the synthesist traditions of the *World of Art*—albeit in a different way—and united the arts even more closely. In this respect the *World of Art* set a valuable precedent for ensuing Modernist movements and despite the outward hostility between the aristocratic aesthetes of the *World of Art* and the radical leftists of the Futurists, both strove to renew cultural values by conceiving art as a total activity. This approach to art was manifest, above all, in Diaghilev's *Ballets Russes* which emerged as the fruition of the artistic principles practised by the *World of Art* at the turn of the century. But despite its admiration of Western culture, the *World of Art* remained at heart a Russian phenomenon. Witness to this was its very aspiration towards artistic synthesism, since this, in many ways, was

[31] A. Bely, " Simvolizm, kak miroponimanie ", in : *Mir iskusstva*, 1904, No. 5, p. 176.

[32] B. Bugaev (A. Bely), " Formy iskusstva ", p. 351.

[33] A. Benois, " Poslednyaya futuristicheskaya vystavka ", in : *Rech'*, 9 Jan., 1916, No. 8.

the direct result of its members' reaction to the social and political fragmentation present during the last years of Imperial Russia. It is a sad paradox, therefore, that the grand, synthetic *Ballets Russes*, which owed so much to the *World of Art*, should have been seen and applauded only outside Russia. In this sense we might regard the *World of Art* not only as the progenitor of the *Ballets Russes*, but also, therefore, as the greatest, universal monument to the Russian Silver Age.

JOHN E. BOWLT

Austin, Texas

APOLLINAIRE, ALLEGORICAL IMAGERY AND THE VISUAL ARTS

Car il y a tant de choses que je n'ose vous dire
Tant de choses que vous ne me laisseriez pas dire
("La Jolie Rousse")

By becoming an art critic Apollinaire was continuing a French literary tradition of more than one and a half centuries. What originated with Diderot's *Salons* in the middle of the eighteenth century, with Baudelaire's dictum that " tous les grands poètes deviennent naturellement, fatalement, critiques " became a *sine qua non* for any self-assertive ambitious young man with great poetic aspirations.[1] Yet for Apollinaire the role of the critic was more than an aesthetic attitude and an absorbing literary genre. Whilst from the beginning it was inseparable from his lyric poetry and literary prose, it eventually became the gravitational force of his own universe of which he himself was the centre. Art criticism for him, therefore, was the recording of what he and his contemporaries thought to be a new revival in literature and in the arts, and partly a means by which the philosophical and artistic theories underlying this revival could be spread and clarified.

As for Apollinaire, there was little doubt that in all aspects of modern life a new Renaissance was taking place. Paradoxically, his much acclaimed " modernity " sprang from a deep belief in the periodicity of human history. He seems to have accepted the notion that historical and philosophical ideas repeat themselves in cycles. Revivified by Nietzsche at the end of the nineteenth century, this ancient myth became fashionable in Symbolist and especially in Unanimist circles, with which Apollinaire had many associations between 1908 and 1910.[2] By assuming that conceptions arise, prosper, decline and are revived by great men who are making a fresh start by reverting to the pure first principles, he found himself an all-embracing personal role as well as a universalist philosophy with close affinities with eschatological expectations. The belief in the possibility of " revival " stemmed from the firm conviction that at a certain moment of history the truth of perfect harmony had been revealed. This truth, first developed in classical antiquity, was claimed to have embodied latently the whole of human history. And since it represented perfection, it has become the pattern, not to be copied in detail but imitated in the sense of following its example. Contrary to academic historicism—which claimed the heritage of Antiquity and the Renaissance but actually only assimilated mythological subjects and classicizing formal devices while trying to preserve the immediate past—Apollinaire conformed in spirit to the classical, by modifying once more its principles of life and action.

Despite his admiration for some poets and artists of the nineteenth century, Apollinaire rejected the immediate past as a period of aberration, transience, disintegration and decadence. On the other hand, it is symptomatic that when proclaiming his doctrine of *l'esprit nouveau*, from which he expected a profound social and cultural change and the coming of a new golden age, he invoked the myth of pure primary principles. For fusing the divergent forms of life and art into a comprehensive organic unity, he deliberately tried to revitalize the classical heritage of a rational conception of harmony, a universal view of reality and man, as well as a moral responsibility for the containment of the sensuous and the emotional within an intellectual order. In this respect he rightly claimed that the new twentieth-century renaissance as a conception of life and art, " sans être la simple imitation de l'Antiquité, ne soit pas non plus un pendant du beau désordre romantique."[3] Yet both in his poetry and in his aesthetic views, Apollinaire occasionally reverted to a narrower conception of classical revival. Like the humanist poet-philosophers of the fifteenth and sixteenth centuries, whom he not only admired but on whom he probably modelled himself, Apollinaire freely borrowed from Antique and Renaissance sources which, however, never resulted in outright plagiarism. The apparent contradiction was resolved by him at a personal level :

> Le cortège passait et j'y cherchais mon corps
> Tous ceux qui survenaient et n'étaient pas moi-même
> Amenaient un à un les morceaux de moi-même
> On me bâtit peu à peu comme on élève une tour
> Les peuples s'entassaient et je parus moi-même
> Qu'ont formé tous les corps et les choses humaines
>
> Temps passés Trépassés Les dieux qui me formâtes
> Je ne vis que passant ainsi que vous passâtes
> Et détournant mes yeux de ce vide avenir
> En moi-même je vois tout le passé grandir
>
> Rien n'est mort que ce qui n'existe pas encore
> Près du passé luisant demain est incolore
> Il est informe aussi près de ce qui parfait
> Présente tout ensemble et l'effort et l'effet.[4]

★ ★ ★

In spite of being a poet for whom the written word had to be more important than the sensuous world, Apollinaire considered the visual image of the utmost significance. He saw all art forms in a universal synthesis, and besides music,[5] he postulated a parallel between the vicissitudes of literature and the visual arts. Of course, the role of imagery in Apollinaire's poetry and prose cannot be over-estimated. From the beginning he made an emotive as well as a symbolical use of real and imaginary architecture, as he did also with other natural and man-made objects. Whether such motifs were

derived from actual experience of reality or from literary and visual works of art is only of philological interest, as they were completely transcended by the poet's ego. Yet the choice of images and the context in which they appear in his lyric poetry and literary prose are always significant. While they are so thoroughly personalized that they often lose their naturalistic representational meaning, nevertheless, they not only retain those mythical and legendary connotations which by tradition were imposed on them, but within the convention of their universal and abstract symbolical meaning, they also tend to absorb new ideas.

This is the case, for example, with " La Vierge à la fleur de haricot à Cologne ",[6] a poem inspired by an early fifteenth-century triptych—then attributed to the legendary Meister Wilhelm (Maître Guillaume) von Köln[7] —which Apollinaire had seen in 1901 and had also described in an article as *Vierge à la fleur de pois* in 1902.[8] Whether the blossom in the Virgin's hand is that of the haricot bean as in the poem, or that of the pea as in the article, or that of the vetch as recognised by modern iconographers, is of no special significance when seen in the context of the rosary beads offered by the Christ-child to the Virgin. While the vetch, like any other legum-inous plant, signifies the spirit of man imprisoned in matter since the Fall, the rosary symbolizes the Christian faith by which like Christ man may be reborn as a new Adam. The symbolical image of the rosary, which, by becoming a conventional devotional object, had lost its originally enigmatic character, is replaced in the poem by the gnostic concept of the paraclete, identified by St John with the Holy Spirit,[9] which will remove original sin by changing the grosser elements of human nature into higher spiritual qualities.

Similarly, juxtaposed images of architectural monuments in Apollinaire's work have shed their local particularity and are presented to the reader as absolute and universal concepts. The freedom in the contextual use of such imagery is, generally, in the very nature of imposed allegory.[10] Thus the analogical relation between Cologne cathedral and *La tour Eiffel et le Palais de Rosemonde* in the early Orphic poem " Le Dôme de Cologne ",[11] and the fusion of the Eiffel Tower with the cathedral of Paris, the Notre-Dame, in the calligrammatic poem " 2e canonnier conducteur ",[12] despite the con-textual difference, seems to have the same symbolical significance.

The poetic images and metaphors which Apollinaire borrowed from the visual arts were re-translated into a visual idiom in his *calligrammes*. Here the conceptual symbolical meaning was also evoked in its visual actuality, so that it became the form both of the representational and the symbolical meaning of the verbal image. By combining the poetic and pictorial ex-pression, Apollinaire revived a pictographical tradition of several centuries.[13] Probably invented by Alexandrian poets in the Hellenistic Age, its practice was preserved right through the Middle Ages in the production of the Jewish Masorah.[14] Having had a great literary revival in the Renaissance, pro-

foundly influencing early typography, it remained popular in Baroque literature and had only gradually disappeared in the second half of the eighteenth century. However, pictorial typography was occasionally used in advertising and in other popular forms of the graphic arts during the nineteenth century, such as the engraved portrait of Queen Victoria which D. Israel composed of 173,000 words.[15] Apollinaire, who was familiar with the original literary use of pictographical devices and probably knew of its later popular use as well, had considered it the nearest to a synthesis of literature and the visual arts.[16] His conception of *peintre-poésie* was also affirmed by the title, *Et moi aussi je suis peintre*, he had chosen for a collection of his early *calligrammes*, which was announced but never published due to the outbreak of the war.[17]

All these seem to corroborate the claim that Apollinaire had a painter's eye. Indeed, like Goethe, Mörike, Hugo, Yeats, and Apollinaire's friend Max Jacob, he was a keen amateur draughtsman. Yet, apart from the manuscripts of his *calligrammes*, known drawings and paintings by him are surprisingly scarce.[18] They show a taste for literary subject-matter and tend to be eclectic in style. Sketches, like the drawing of the famous fourteenth century *Pestkreuz*, which he had seen in St Maria im Kapitol in Cologne,[19] were only intended for reference. Marginal drawings in his literary manuscripts and letters, representing objects and caricature-like portraits, are merely doodles and, at their best, are in the casual style of a visual shorthand. None the less, they are animated by the same Apollinairian wit that characterizes the whole of his poetic *œuvre*.

* * *

Apollinaire was depicted by contemporary artists more often than, perhaps, any other figure in literary history. The range of his portraits is exceptionally wide, varying between allegoric portraiture and caricature. Irrespective of their style and genre they are revealing personal and socio-cultural documents. There is a subtle and elaborate symbolism in especially those portraits which were done by artists whom art historians today would not have thought to have had a knowledge of iconographical conventions and classical myth. As both artist and sitter were closely linked by friendship and by a mutual interest in the creation of a future art, it is likely that Apollinaire had an active share in working out the allegorical and philosophical part of the subject-matter, and was perhaps even consulted on aspects of form. He seems to have known of the humanist practice of joint authorship between painters and poets of the Renaissance.

After all, it would be too much of a coincidence that the first of these allegoric portraits, Marie Laurencin's *Apollinaire et ses amis* of 1908,[20] was painted soon after she became the poet's mistress. Picasso as a " nouveau Jean-Baptiste " with a lamb,[21] and his then mistress, Fernande Olivier,

wearing an elaborate floral head-dress, are here depicted in the form of a Botticellesque triangular composition. At its centre, Apollinaire is seated with the solemn expression of an Egyptian Scribe, while on his right Marie Laurencin, like a Muse, holds a sweet-william, appropriately also called *l'œillet de poète*. And immediately in the following year she painted her masterpiece. Her *Réunion à la campagne* of 1909,[22] commemorates the banquets and outings where Apollinaire and his friends gave each other classical or biblical names, assumed titles, and enacted initiations and other cryptic rituals, so reminiscent of humanist evocations of ancient times during the Renaissance.[23] Here Apollinaire is depicted as a modern Orpheus. Behind him on his right the three-arched bridge, signifying the tripartite span of human life, and the gruesome dark dog at his feet, alluding to Cerberus, are traditional of the Orpheus paraphernalia.[24] Besides its macabre allusions, the dog, however, also signifies " le sainct escriptuin ou vng prophete ou celluy qui enterre les trespassez ou la Rate ou le sentement ou le Ris ou lesternuer ou le prince ou le Iuge ", in the 1543 French edition of Horapollo's *Hieroglyphica*,[25] which probably had also influenced the imagery and typography of *Le Bestiaire*. Once again, there is something Botticellesque in the magically floating line and the overall rhythmic pattern of the eight figures, as if Marie Laurencin had modelled this composition on the *Primavera* with the grouping reversed.[26]

Completed in the same year, *La Muse inspirant le Poète* (see Plate 17)[27] by the sixty-four-year-old Henri Rousseau, shows also a free adaptation of a famous and appropriate painting : Poussin's allegory of the same subject, from which, nevertheless, explicit mythological figures had been omitted. The photograph here published for comparison shows, of course, an already synchronized form of Poussin's painting (see Plate 18).[28] The correspondence between painter and poet indicates that the allegorical aspects of the painting were carefully considered.[29] The garland of periwinkle round the neck of the Muse (Marie Laurencin) is an attribute of Flora and promises Spring, while the sweet-william in the foregound not only refers to the sitter's name and vocation but also alludes to the Christian neo-Platonic conception of reincarnation which played an important role in " phoenix "-Apollinaire's life and aesthetics.[30]

Picasso, perhaps the greatest artist to whom Apollinaire was closely linked by friendship and reciprocal influences, had also depicted him in several paintings. Both painted early in 1905, the sturdy buffoon in *Les Bateleurs*[31] and the young seated athlete in *Acrobate à la boule* (see Plate 19)[32] (the latter resembling Alciati's emblem ARS NATURAM ADIU-UANS—see Plate 20),[33] have generally been identified as idealized portraits of the poet.[34] In the *Ex-Libris* he drew for Apollinaire, Picasso depicted him as *le bon roi Dagobert* of the French popular song, one of those legendary figures with whom he identified himself.[35] Bordering on the mock-heroic, Apollinaire also appears in two unrelated series of drawings : in the first as

a muscle-bound athlete devoted to " physical culture ",[36] and in the second later series as the Pope or an Academician with a dolphin at his feet.[37] However, it is the cubist etching *Portrait de l'auteur* which Picasso made as the frontispiece of the first edition of *Alcools* in early 1913, that has the most distinguished place among Apollinaire's portraits.[38] Despite its hermetic appearance and disintegrated form, it reveals the complex unity of Apollinaire's personality, a paradox of strength and refinement, urbanity and conceit, placidity and action, humour and seriousness, naive simplicity and cryptic pomp.

Yet when discussing the origins of cubism in *Les Peintres cubistes*, Apollinaire remembered that it was " Jean Metzinger qui exposa le premier portrait cubiste (c'était le mien) au Salon des Indépendants en 1910."[39] By representing the poet in quasi-naturalistic surroundings on which a geometrical pattern is imposed, both in respect of iconography and the relationship between objects and space, this painting still falls in with a post-impressionist conception of portraiture. This dichotomy in the artist's style can probably explain Apollinaire's dubious compliment in a later passage of *Les Peintres cubistes* :

> Son œuvre sera un des documents les plus certains lorsqu'on voudra expliquer l'art de notre époque. C'est grâce aux tableaux de Metzinger que l'on pourra faire le départ entre ce qui a une valeur esthétique dans notre art et ce qui n'en a point. Une peinture de Metzinger contient toujours sa propre explication. C'est peut-être là une noble faiblesse, mais c'est certainement d'une haute conscience et je crois un cas unique dans l'histoire des arts.[40]

Apart from obvious personality factors, iconographical and stylistic differences in Metzinger's and Picasso's portraits of Apollinaire seem to correspond with changes in cubist history. Between the Summer and the Fall of 1910, Picasso painted a series of half-length portraits in an undefined environment cluttered with objects of private and symbolic significance, resembling sixteenth-century humanist portraiture. As in the rest of his analytical paintings, object and space are integrated by means of shifting viewpoints and arbitrary lighting which illuminates only the conceptually significant aspects of the geometrical structure, without traditional modulation of tone or colour. Yet it was not by Picasso but in a portrait of him, *Hommage à Picasso* of 1911-12, by Juan Gris, that the spatio-temporal and symbolic aspects of cubist portraiture were developed to the full.[41] Painted in a transitional style, it foreshadowed the sensuality of tactile synthetic elements. And it is here that Picasso is shown as the *chef d'école* of the cubist movement. He is represented with a palette from which three flame-like shapes in the symbolic colour of primaries emerge, referring to Apollinaire's metaphor, used in the preface to an exhibition catalogue of 1908 : " La flamme est le symbole de la peinture et les trois vertus plastiques (la pureté, l'unité et la vérité) flambent en rayonnant."[42] Its immediate influence can be seen in two contemporary works, Metzinger's *Portrait of Gleizes*[43] and Louis Marcoussis's engraved *Guillaume Apollinaire* (see Plate 21).

The fate of this remarkable portrait is symptomatic. Commissioned by Apollinaire as the frontispiece for his long delayed collection of poems *Eau de Vie* in 1912, it became obsolete just before publication when he changed the title for *Alcools* and replaced Marcoussis's engraving with Picasso's etching, already discussed above. Whatever was the poet's motivation, whether it was due to Picasso's growing reputation, to personal quarrels, internal disagreements, or to the more concealed subject-matter disguised by Picasso's more advanced cubist style, remains a matter of speculation. None the less, Marcoussis's portrait has the rare quality of fusing physical likeness and psychological expression with a cubist conception of volume and space. In pose and composition it resembles Quentin Massy's famous portrait of the humanist Pierre Gilles (see Plate 22),[44] which in turn resembles Hans Burgkmair's woodcut " memorial " of Conrad Celtes which this translator and imitator of ancient poets commissioned soon before he died.[45] In the true humanist spirit the books in the background bear the published titles of Apollinaire, yet with some cunning Marcoussis replaced Pierre Gilles's conspicuous chalice, signifying *Aqua Vitae* in the context of the Eucharistic wine,[46] with a volume of *Eau de Vie*. The lines to which the poet points in his manuscript on the table :

> Un jour
> Un jour je m'attendais moi-même
> Je me disais Guillaume il est temps que tu viennes
> Pour que je sache enfin celui-là que je suis
> Moi qui connais les autres[47]

is quite revealing.

But the prophetic portrait of Apollinaire was still to come. In 1913 Giorgio de Chirico began to attend the poet's " sundays " at 202 bis Boulevard Saint-Germain, and at the beginning of the following year he completed his so-called *Portrait prémonitoire de Guillaume Apollinaire* (see Plate 23).[48] This appears to be a Nietzschean juxtaposition of the Apollonian and Dionysian aspects of the Orphic poet. In the form of a classical Roman bust wearing dark glasses he appears fullface together with a shell in the foreground, while his profile shadow image marked by a white circle is shown together with a fish opposite. This white circle has been said to be similar to that formed by the bandages he wore after the head injury he received at the front in March 1916. In two of his letters to the dealer Paul Guillaume, Apollinaire showed his concern for this painting. First, on May 6, 1915, he asked him : " I would be grateful if you would ask G. de Chirico to take or have sent my janitor, who will put it in my apartment, my portrait *en homme-cible* " ; and on May 16, he wrote that

> I would have preferred that *l'homme-cible* was at my house, where my mother could have looked at it when she felt like it, since in addition to being a singular and profound work of art, it is also a good likeness as a portrait—a shadow or rather a silhouette such as people made at the beginning of the nineteenth century.[49]

Yet this portrait did not become prophetic by magic or misfortune but was originally conceived as such. Apollinaire was not only familiar with the neo-Platonic mystery of cosmogonic death and humanist preoccupation with Orphic blindness, but in a metaphorical sense he believed that "like Orpheus, all the poets were on the verge of violent death."[50]

The fable of the oyster and the herring and the memorial of Croniamental in *Le Poète assassiné*[51] are also helpful when deciphering the allegoric aspects of this painting. However, for the image of *l'homme-cible* we have to turn to a sixteenth-century mystic treatise on the divinatory art of judging man's character and his destiny from the lines formed on his forehead. One of the woodcut illustrations in Cardanus's *Metoposcopia* (see Plate 24) shows the head of a man marked by a line touching his left eyebrow : "Lineae hae malignum denotant morte violenta moriturum."[52]

<p style="text-align:center">★ ★ ★</p>

Despite Apollinaire's well-known exclamation, " Le sujet ne compte plus ou s'il compte c'est à peine,"[53] referring to a naturalistic depiction of external reality, he anticipated a new sublime art of poetic subject-matter and monumental form. In the Spring of 1910 he praised José María Sert's *La Danse de l'Amour* : ". . . témoigne d'une longue culture et d'une sûre discipline artistique. Ce peintre ne se défend point d'avoir une imagination poétique. Elle est rare de nos jours."[54] And two years later he seems to have had reason to claim that

> Voulant atteindre aux proportions de l'idéal, ne se bornant pas à l'humanité, les jeunes peintres nous offrent des œuvres plus cérébrales que sensuelles. Ils s'éloignent de plus en plus de l'ancien art des illusions d'optique et des proportions locales pour exprimer la grandeur des formes métaphysiques. C'est pourquoi l'art actuel, s'il n'est pas l'émanation directe de croyances religieuses déterminées, présente cependant plusieurs caractères du grand art, c'est-à dire de l'Art religieux.[55]

Undoubtedly, between 1911 and 1914 many young avant-garde artists submitted mural-size cubist allegories at the annual *Salon des Indépendants*. Conceived as monumental museum pieces of the future, the artists tried to incorporate all their experiments of the previous year. The first of these was Henri Le Fauconnier's *L'Abondance*, which he began in the Autumn of 1910 and exhibited at the *Salon des Indépendants* in the Spring of 1911. Both in size and subject-matter it had an overpowering effect among the cubist paintings of the famous *salle 41*, and had a good critical attention. Apollinaire praised it as a " riche composition, sobre de couleurs et où les formes des figures, des objets et du paysage sont conçues dans un même esprit et se lient excellement par l'accent et la sensibilité."[56]

While this was a conventional allegorical subject-matter on which a cubist-like geometrical pattern was superimposed, those cubist allegories

which emulated Le Fauconnier's initial attempt during the next three years, showed contemporary themes which were allegorized to convey a multidimensional, collectivist and universal meaning. Even when traditional personifications were used, as in Robert Delaunay's *La Ville de Paris* which was the celebrated Salon piece in 1912, they were correlated with emblematic objects distant in time and space, simultaneously not visible in the real world, thus surrounding the figures with a wide-sweeping modern *paysage moralisé*.[57] However, by 1913, conventional iconographical devices were generally abandoned in cubist allegories, which were entirely devoted now to the epic heroism of modern life. While some of the most important paintings at the 1913 *Salon des Indépendants* showed rugby players in the midst of fragmented images of Paris, as a kind of metropolitan ritual, in the following year aeronautical subjects signified both the romantic idea of flight and the machine aesthetics of the new air-borne age. At this time, writing about Rude's sculpture, Apollinaire claimed :

> L'allégorie est une des formes les plus nobles de l'Art. L'académisme en avait fait une déformation banale de l'imagination, tandis que rien n'est plus susceptible d'être en accord avec la nature, car notre cerveau ne peut guère se représenter les choses composées autrement qu'en allégories . . .
> *La Marseillaise* de Rude est la première œuvre qui exprime du sublime moderne, le sujet est moderne, le mouvement, la vie y est moderne et la dramatisation synthétique de ce qui est représenté est moderne aussi.[58]

It is more than probable that this sudden emergence of systematically executed, monumental, visionary and poetic cubist allegories was inspired by Apollinaire.[59] Moreover, as such large canvases and such a self-conscious attitude to the technical and creative aspects of painting were without precedent in the works of these artists—from whom knowledge of such sophisticated iconography could not have been expected—it can only be assumed that they were helped in both choice and rendering of their subject-matter. Surely it is not a mere coincidence that there are many similarities between the themes and imagery of their paintings and those in Apollinaire's poetry and aesthetic views. Since most of these artists were not only associated with the cubist movement, but were also in the intimate circle of Apollinaire, it is possible that the cubist allegories were the outcome of a temporary practice of joint authorship. Though the completion of these paintings often preceded the publication of Apollinaire's writings, it does not necessarily mean that he was influenced by them, as his poems and ideas were often personally disseminated in lectures and conversations long before they were actually published.

By the beginning of 1912 Apollinaire had learnt how to make his artist friends succumb to his allegorical inventions. Though his most admired friend, Picasso, taught him that it is hard to nail down geniuses to definite iconographical programmes, he usually succeeded with the less imaginative

minor artists. Apart from working out the symbolical aspects of his own portraits which, after all, had an essentially private significance, Apollinaire gained his experience as an inventor of designs when he planned the printing and illustration of his first two books : *L'Enchanteur pourrissant*, for which the wood engravings were by André Derain, and the *Bestiaire ou Cortège d'Orphée*, illustrated by Raoul Dufy. On the fringe, even Picasso was involved in these projects as both artists and the poet were at this time in constant touch with the celebrity of the *Bateau-Lavoir*.[60] The blurbs for both books, written by Apollinaire, celebrate the joint authorship between the poet and the respective artists :

> On connaît peu de livres où l'accord des génies de l'auteur et de l'artiste apparaisse mieux que dans *L'Enchanteur pourrissant*. Cette harmonie, qui a fait en grande partie le prix de la fameuse édition aldine du *Songe de Poliphile*. . . .[61]

and for the *Bestiaire* :

> Ce recueil, très moderne par le sentiment, se lie étroitement par l'inspiration aux ouvrages de la plus haute culture humaniste. Le même esprit qui inspira le poète anima l'illustrateur, Raoul Dufy. . .[62]

And though, even in private correspondence, he was unsparing with praise : ". . . Je suis certain qu'avec votre art que vous possédez bien et votre culture, un idéal vous transportera, et que le résultat de votre travail sera merveilleux . . .",[63] he left little to the artist's imagination. As has been mentioned above, the typography and to some extent the imagery of the *Bestiaire* was influenced by Horapollo's *Hieroglyphica*, which Dufy was unlikely to have had previous knowledge of. It is less surprising that this treatise, which concluded the mediaeval bestiaries and anticipated renaissance emblembooks, was one of the few cryptic works to which Apollinaire made no reference.[64] Yet, for example, the illustration of "Le Dauphin", signifying " la vie est encore cruelle " (see Plate 25), closely resembles Horapollo's emblem of big fish eating little fish signifying " une chose indigne d'estre dicte, & abbominable ", and referring to the perversion inherent in the natural law of constant interchange (see Plate 26).[65] Here Dufy had only converted the sailing boat into a steamer and brought the stylistic aspects of the perspective more up to date. Moreover, the first " Orphée " signifying " la voix que la lumière fit entendre ", both in image and text corresponds with the emblem of *le cœur d'un homme pendu à sa gorge*, signifying " la bouche d'un homme de bien ".[66] However, the conspicuously juxtaposed schematic Eiffel Tower, with projected legs as if it were on a three-arched bridge, and the three-edged obelisque recall the similarly juxtaposed images of a ruined Roman arcade and a three-edged obelisk in Horapollo's Orphic emblem of God's eye.[67]

Despite the differences in scale, medium and genre, Dufy's Orpheus images show the same tendency towards a monumental allegoric style which has already been noted in connection with Le Fauconnier's much admired large canvas of *L'Abondance*. Even so, Dufy's Orpheus images

have a very different poetic and visionary dimension. Their pre-cubist style and symbolist iconography combines modernity with classical dignity. For example, in the first *Orphée*, the arbitrary viewpoints located in the Eiffel Tower, obelisk and the inorganic trees with tripartite foliage are visually and conceptually unified by the monumental figure of the mythical poet and by the floating puffs of clouds. While the motifs of this unrealistic landscape both representationally and symbolically refer to the neo-Platonic conception of the triple ordinance of the universe, the contrived structure of the composition conveys the idea of simultaneity of time and space. In these iconographical aspects it anticipates Robert Delaunay's *La Ville de Paris*.

<p style="text-align:center">★ ★ ★</p>

On 19th March 1912, the day before the opening of the *Salon des Indépendants*, Apollinaire in his regular column in *L'Intransigeant*, enthusiastically praised Robert Delaunay's monumental allegory of *La Ville de Paris*, the paint on which had hardly dried :

> Le grand événement, c'est sans conteste le rapprochement entre Robert Delaunay et les néo-impressionnistes qui exposent dans les dernières salles. Décidément, le tableau de Delaunay est le plus important de ce salon. *La Ville de Paris* est plus qu'une manifestation artistique. Ce tableau marque l'avènement d'une conception d'art perdue peut-être depuis les grands peintres italiens. Et s'il résume tout l'effort du peintre qui l'a composé, il résume aussi et sans aucun appareil scientifique tout l'effort de la peinture moderne. Il est exécuté largement. La composition est simple et noble. Et tout ce que l'on pourra trouver pour l'amoindrir n'ira pas à l'encontre de cette vérité : c'est un tableau, un vrai tableau, et il y a longtemps qu'on n'en avait vu.[68]

And on the following day, in *Le Petit Bleu*, he wrote about it with even more delectation and zeal, giving also an unusually detailed description of its iconography and style :

> Tout d'abord, dans la salle 38, on trouvera le tableau le plus grand aussi bien par les proportions que par l'inspiration qui l'anime. Cette œuvre intitulée *La Ville de Paris* est due à un jeune peintre qui nous avait montré jusqu'ici des œuvres intéressantes certes, mais inachevées. Ses interprétations dramatiques de la tour Eiffel avaient fait voir qu'il avait de la puissance, mais on n'aurait encore osé espérer de lui une réalisation aussi complète de ses promesses. *La Ville de Paris* est un tableau en quoi se concentre tout l'effort de la peinture depuis peut-être les grands Italiens.
>
> Il faut oser le dire. Il ne s'agit plus de recherches, d'archaïsme ou de cubisme.
>
> Voilà un franc tableau, noble, exécuté avec une fougue et une aisance auxquelles nous n'étions plus accoutumés. A gauche la Seine, Montmartre, à droite la tour Eiffel et des maisons, au centre trois corps élancés et puissants que les censeurs disent copiés de Pompéi et qui sont cependant la grâce et la force françaises, comme les avait ainsi conçues Jean Goujon. La simplicité et la hardiesse de

cette composition se combinent heureusement avec tout ce que les peintres français ont trouvé de neuf et de puissant depuis plusieurs générations. Aucune prétention, aucun désir d'étonner ou d'être obscur et voilà une œuvre importante qui marque une date dans la peinture moderne. Maintenant, les artistes des jeunes écoles oseront aborder des sujets et les interpréter plastiquement. . . .[69]

Yet this painting had to mean more to Apollinaire than " une réalisation aussi complète de ses promesses," as it was the greatest confirmation of the basic concepts of his Orphic aesthetics which he had been advocating since early 1908.[70]

Within a year of its completion, *La Ville de Paris* became the best known cubist painting in France and abroad.[71] Delaunay followed Apollinaire's advice when he continued to show at the annual *Salon des Indépendants*—until the outbreak of the war—only one, but a representative, monumental canvas, with the intention of producing a synthesis of previous achievements, and forecasting latently some aspects of the artist's future development.[72] In the Spring of 1913 he showed an even larger painting, entitled *Troisième représentation, L'Équipe de Cardiff*.[73] While in Apollinaire's view *La Ville de Paris* marked the beginning of *cubisme orphique*, Delaunay's new masterpiece signified the expansion and enrichment of the new orientation. He immediately drew attention to the historical role of this Salon, claiming :

Le rôle historique du Salon des Indépendants est aujourd'hui défini. L'art du XIXe siècle n'est qu'une longue révolte contre la routine académique : Cézanne, Van Gogh, le Douanier Rousseau. Depuis vingt-cinq ans, c'est au Salon des Indépendants que se révèlent les tendances et les personnalités nouvelles de la peinture française, la seule peinture qui compte aujourd'hui et qui poursuive à la face de l'univers la logique des grandes traditions.

Cette année, le Salon des Indépendants est plus vivant que jamais.

Les dernières écoles de peinture y sont representées : le cubisme, impressionnisme des formes, et sa dernière tendance, l'orphisme, peinture pure, *simultanéité*.

La lumière n'est pas un procédé. Elle nous vient de la sensibilité (l'œil). Sans la sensibilité, aucun mouvement. Nos yeux sont la sensibilité essentielle entre la *nature* et notre âme. Notre âme maintient sa vie dans l'harmonie. L'harmonie ne s'engendre que de la simultanéité où les *mesures* et *proportions de la lumière* arrivent à l'âme, sens suprême de nos yeux. Cette simultanéité seule est la création ; le reste n'étant qu'énumération, contemplation, étude. Cette simultanéité est la vie même.

L'école moderne de peinture me paraît la plus audacieuse qui ait jamais été. Elle a posé la question du beau en soi.

Elle veut se figurer le beau dégagé de la délectation que l'homme cause à l'homme, et depuis le commencement des temps historiques jusqu'à nos jours aucun artiste européen n'avait osé cela. Il faut aux nouveaux artistes une beauté idéale qui ne soit plus seulement l'expression orgueilleuse de l'espèce, mais l'expression de l'univers dans la mesure où il s'est humanisé dans la lumière. (. . .)

Salle XLV. C'est l'orphisme. C'est la première fois que cette tendance que j'ai prévue et annoncée se manifeste.

Delaunay est un des artistes les mieux doués et les plus audacieux de sa génération. Sa dramatisation des volumes colorés, ses ruptures brusques de perspective, ses irradiations de plan ont eu beaucoup d'influence sur un grand nombre de ses amis. On connaît aussi ses recherches de peinture pure que j'ai signalées dans *Le Temps* du 14 octobre 1912. Il recherche la pureté des moyens, l'expression de la beauté la plus pure.

Avec ce dernier tableau, Delaunay est encore en progrès. Sa peinture, qui semblait intellectuelle, ce dont se réjouissaient les privat-dozents allemands, a maintenant un grand caractère populaire. Je crois que c'est un des plus grand éloges que l'on puisse faire à un peintre d'aujourd'hui.

L'Equipe de Cardiff, troisième représentation, de Delaunay. La toile la plus moderne du Salon. Rien de successif dans cette peinture où ne vibre plus seulement le contraste des complémentaires découvert par Seurat, mais où chaque ton appelle et laisse s'illuminer toutes les autres couleurs du prisme. C'est la simultanéité. Peinture suggestive et non pas seulement objective qui agit sur nous à la façon de la nature et de la poésie ! La lumière est ici dans toute sa vérité. C'est la nouvelle tendance du cubisme et nous retrouverons cette tendance à l'orphisme dans la salle suivante, dans presque toutes les toiles. . .[74]

In September 1913, the first *Deutscher Herbstsalon*, organised by *Der Sturm* in Berlin, was entirely devoted to Orphism.[75] And the following Spring André Salmon pointed out that there is a school of Delaunay ;[76] indeed, the *Salon des Indépendants* of that year was generally recognised as a salon of *Simultanéisme orphique*, the universal period-style in the modern world.[77] Robert Delaunay once again showed a single representative large canvas, entitled *Hommage à Blériot ; premiers disques solaires simultané forme ; au grand constructeur Blériot 1914*,[78] but now there was reservation and irony in Apollinaire's appraisal when he reviewed it :

M. Robert Delaunay réalise ses recherches de composition par la couleur et voici le titre de sa composition : *Disques solaires simultané forme ; au grand constructeur Blériot 1913-1914*. Le point virgule joue sans doute ici un rôle important ; le point comme but, la virgule comme fil d'Ariane à travers tous ces labyrinthes d'un futurisme tournoyant. En somme, du talent.[79]

The controversy about the origins of the concept of simultaneity, raging in Futurist and Cubist circles and especially between Umberto Boccioni and Robert Delaunay at this time, had inadvertently spoiled the friendship between the painter and the poet. As Apollinaire's aim was to create an international front of avant-garde art based on the principles of *cubisme orphique*, defined as " peinture pure, *simultanéité* ", he made several attempts to reconcile the adversaries.[80] However, the chauvinistic combativeness of the Futurists, the narcissistic attitude of Delaunay intoxicated with world-wide fame, and the cosmopolitan aesthetics of Apollinaire looking at Paris as the artistic centre of the world, were incompatible.

If the titles of Delaunay's annual salon-pieces are to be taken seriously, as all contemporary sources suggest, he originally intended to follow his *3e Représentation simultanée : l'Equipe de Cardiff* by a monumental final version of *4e Représentation simultanée : Paris, New York, Berlin, Moscou, la Tour simultanée, Crayons de couleurs, la Représentation pour le livre des Couleurs de la Tour simultanée,* a preparatory study exhibited at the 1913 Berlin *Herbstsalon* and later destroyed.[81] Yet the theme of his 1914 salon-piece was inspired by Roger de la Fresnaye's *Conquête de l'air,* an ambitious mural-size painting which was well received at the 1913 *Salon d'Automne.*[82] In turn, while the style of La Fresnaye's work was influenced by Delaunay's *L'Equipe de Cardiff,* its theme was inspired by a typically Apollinairian analogy :

> De même que l'on avait promené une œuvre de Cimabue, notre siècle a vu promener triomphalement pour être mené aux Arts-et-Métiers, l'aéroplane de Blériot tout chargé d'humanité, d'efforts millénaires, d'art nécessaire. Il sera peut-être réservé à un artiste aussi dégagé de préoccupations esthétiques, . . . de réconcilier l'Art et le Peuple.[83]

For us it is almost impossible to think of Delaunay's *œuvre* other than in the series of the so-called windows, circular motifs and discs through which, in his retrospective accounts many years after Apollinaire's death, he claimed to be the inventor of abstract, non-figurative, or non-objective art.[84] Yet the status of these series of paintings is uncertain. It is more than likely that they were conceived as experiments and were used as preparatory studies in his large Orphic allegories. As a stylistic and icono-graphical device, the open window suggests a simultaneous experience of internal and external space. In their experiments with the integration of object and space into a spatial continuum by means of shifting viewpoints and arbitrary light effects, both Cubists and Futurists used the open window as a theme *par excellence.* While the window, both as a threshold and a barrier alluding to the *atelier,* signifies the artist's attitude to external reality, the image within the window frame refers both to the original motif (Nature) and to the created image (Art).[85] On the other hand, by depicting the original motif as a reflection on the window pane, visually and conceptually, it gains new dimensions. Theoretically the spatial continuum in such a reflected image does not depend on the artist's technique (simultaneous contrasts of form used in *cubisme scientifique*), as it is an affirmation of physical law. And when visual reality is considered in a neo-Platonic sense—as Apollinaire and his Cubist friends did—as the "reflection" of absolute reality, that is cosmic harmony manifest in light, then the artist representing the reflection of a " reflection " has reached the realm of pure and autonomous art.[86] With the representation of this simultaneous image " ready-made " on a monumental scale, research into the properties of light become imminent. While Delaunay's " circular motifs " elaborate on Leonardo's illustration of transverse light waves,[87] his " discs " combine the lesson of the neo-impres-

sionist colour wheel with the sensation of La Grande Roue de Paris.[88] Yet their experimental nature does not altogether eliminate a symbolic signifi- cance. Originally entitled *soleil* and *lune*, they assert the power and purity of the sun unaffected by the lesser celestial body, an idea probably inspired by the cosmic pyrotechnics of the partial eclipse of the sun observed in Paris on 17th April 1912.[89]

Thus Delaunay's *La Ville de Paris* is related to those paintings in which the motifs—whatever they may be—are shown either through the open window or as reflections on the window pane. A similar transition is even more explicit in Marc Chagall's almost contemporary Orphist allegory *Paris vu sur la fenêtre* (see Plate 27), where the picture plane is so divided that external objects are visible both through the open window and as reflections on the window pane.[90] Both paintings celebrate Apollinaire's aesthetics which the poet had associated with the city to which the first book printed in France was also dedicated : " De même que le soleil répand partout la lumière, ainsi toi, ville de Paris, capitale du royaume, nourricière des Muses, tu verses la science sur le monde."[91] On the other hand, Delaunay's *Troisi- ème représentation, L'Equipe de Cardiff* is the consummation of those " simul- taneous windows " and " circular motifs " in which the window-pane is synonymous with the picture plane.[92] Here, this becomes an enormous magical screen on which oscillating luminous colour, dynamic revealing evocative inscriptions (L-ASTRA-CONSTRUCTION-AÉ, the name of an aeroplane factory but alluding to the prophesies of the Fourth Eclogue, MAGIC-PARI, referring to Orphic art) and dematerialized emblematic motifs (the Eiffel Tower and Grande Roue alluding to Serapis and the Wheel of Fortune, while the ball of the leaping rugby players is juxtaposed with a biplane) conjure up the new legendary cosmopolitan metropolis against which man's Promethean aspirations are reaffirmed.[93] Notwith- standing the universality of Delaunay's masterpiece, similar aspirations are once again discernible in Chagall's little known *La Grande Roue*.[94] Yet it was not Delaunay but Chagall who fused the cosmic significance of the " simultaneous disc " with the sublime.

In Chagall's *Hommage à Apollinaire* (see Plate 28) the segmented con- centric circles of the colour wheel (alluding to the Grande Roue and the circle of the Zodiac) is combined with the fragmented face of the clock, so that it incorporates the mystic half-male and half-female Hermaphrodite, the Orphic symbol of the perfect man (with allusions to Adam and Eve, the hermetic androgyne, and to the hands of the clock), the whole of which shows a monumental version of the neo-Platonic image of the universe. This painting may be regarded as Chagall's answer to Apollinaire's ironical question : " Qu'est-ce que tu vois mon vieux M. D. . ."[95]

★ ★ ★

Apollinaire's almost obsessive preoccupation with allegorical imagery in which the modern private significance is embellished with universal connotation, can only be understood when personality factors are seen in a socio-cultural context. He rose in the heyday of capitalist enterprise, bourgeois liberalism, philosophical individualism, historical hero-worship, comparative religion, anthropological mythology and symbolist aesthetics, when individual action was mythicized, bohemian attitudes were condoned, and poets and artists had the confidence that an art of personal experience has universal validity. In this milieu, the coincidence that one of the christian names of the illegitimate Guglielmo Alberto Wladimiro Alessandro Apollinare Kostrowitzky originally stemmed from the god of sun, had a new momentum when he decided to yield to a poetic vocation. After all, unlike Baudelaire and Rimbaud, he was even by name a *fils du Soleil*. The pseudonym he had chosen in July 1902[96] became ominous. Inadvertently it predicted an attitude that led to events which might not have happened otherwise; a process known to philosophers of history as "Oedipus effect".[97]

The Symbolist revival of hermetic confraternities, philosophical banquets, literary soirées and the restitution of ritualistic customs in Montmartre, permitted Apollinaire's ostentations which he would have found inadmissible in ordinary life. Yet Apollinaire was not a Symbolist. On the contrary, instead of the nostalgic, historicist and bigoted *evocation* of a lost heritage, an antiquated Church and the obsolete occult,[98] he *enacted* the rituals of neo-Platonic mysteries, claiming

> Rien n'y finit rien n'y commence
> Regarde la bague à ton doigt[99]

The meetings at the café du Départ, the *Bateau-Lavoir*, the Closerie des Lilas and his own apartments became extensions of his personality. There, in a half-serious and half-jesting manner he took on the attitude of a hierophant solemnly addressing his disciples though sounding like a modern parody of an ancient cryptic ritual. It was only play, yet ironical.[100] For those who shared the Platonic identification of ritual with play and considered play the right way of living,[101] these enactions had to mean a higher dimension of reality. Through these secluded initiations to cosmic mysteries,

> L'homme se divinisera
> Plus pur plus vif et plus savant
>
> Il découvrira d'autres mondes
> L'esprit languit comme les fleurs
> Dont naissent les fruits savoureux
> Que nous regarderons murir
> Sur la colline ensoleillée[102]

In Apollinaire's view, purification is the first step toward the divination of the artist, the central assumption of his modern neo-Platonic aesthetics. It is by disputation and ritual-cum-play that the artist recognizes the wisdom and achievement of ancient civilisations, which he always had instinct-

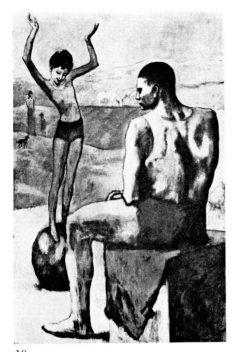

19

Vt spierae Fortuna, cubo sic insidet Hermes:
 Artibus hic, uarijs casibus illa praeest.
Aduersus uim Fortunae est ars facta. sed artis
 Cum Fortuna mala est, saepe requirit opem.
Disce bonas artes igitur studiosa iuuentus,
 Quae certae secum commoda sortis habent.

1796

20

21

22

23

Lineæ hæ malignum denotant morte violen-
tâ moriturum.
Mulierem verò pericula perpeſſuram in par-
tu, imò & in illo morituram.

24

LE DAUPHIN

Dauphins, vous jouez dans la mer,
Mais le flot eſt toujours amer.
Parfois, ma joie éclate-t-elle ?
La vie eſt encore cruelle.

25

Comment ilz manifeſtoient couuertement vne
choſe indigne d'eſtre diéte, & abbuminable.

Pour la repreſenter, ou bié abhominatió,
ilz cótrefaiſoiét vn poiſſon, pource que
ceulx qui manient les choſes ſacrées, ont hor
reur & execration d'en menger. A cauſe que
tout poiſſon eſt de ceſte nature, qu'il deuore
tout ce qu'il rencontre, & meſmes ſe rend
cruel enuers ſon genre propre.
 e.

26

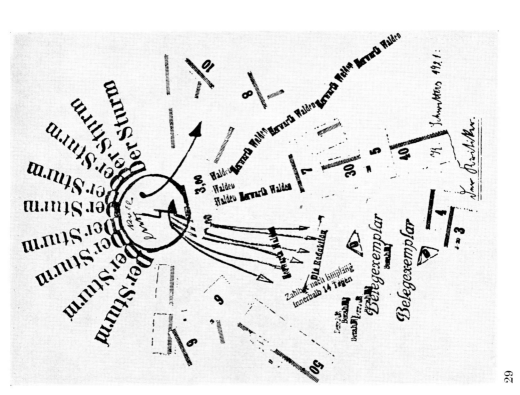

29

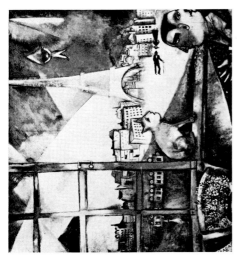

27

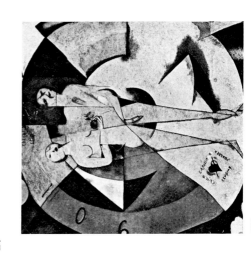

28

31

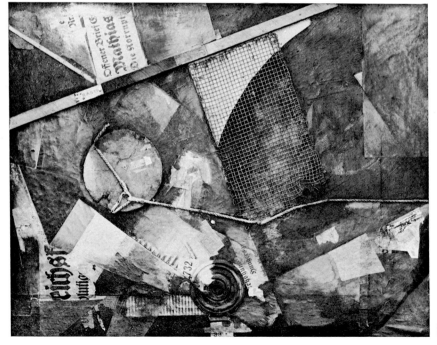

30

ually in the depths of memory. When fully in possession of this inheritance, that is a *logique idéale*, he can separate reason from fallacious sense-perception.[103] Purity as *l'oubli après l'étude* recalls Ficino's explanation of how Socrates purified his mind :

> putting aside for some time the usual unrest of research, he took refuge in moral philosophy so that with its help the mind, dispelling the corporeal clouds, may become serene and at once receive the light of the divine sun that shines at all times and at all places.[104]

Only when purified, can the artist recognize his own rationality and superiority over nature. Through internal experience he gained a particular insight by which the objects of the visible world appear to him in a new light. It is now that he becomes the absolute creator, the master of the universe :

> le peintre doit avant tout se donner le spectacle de sa propre divinité et les tableaux qu'il offre à l'admiration des hommes leur conféreront la gloire d'exercer aussi et momentanément leur propre divinité.
>
> Il faut pour cela embrasser d'un coup d'œil : le passé, le présent et l'avenir.
>
> La toile doit présenter cette unité essentielle qui seule provoque l'extase. . .
>
> Le tableau existera inéluctablement. La vision sera entière, complète et son infini au lieu de marquer une imperfection, fera seulement ressortir le rapport d'une nouvelle créature à un nouveau créateur. . . .[105]

Few of his artist friends ever came up to this standard of perfection. Even when they succumbed to his artistic intentions and iconographical programmes, he often had reason to be disappointed with their work.[106] Picasso was for him the divine artist *par excellence*, whose merits he thought to be comparable only to those of Apelles, Michelangelo and Rembrandt.[107] Perhaps he should have also thought of Dürer. In Apollinaire's view, Picasso originally belonged to the type of the *inspired* artist, " dont la main est dirigée par un être inconnu qui se sert d'eux comme d'un instrument ", but having undergone a fantastic metamorphosis he became an Orphic creator whose art is a vision born in his mind :

> Pour Picasso le dessein de mourir se forma en regardant les sourcils circonflexes de son meilleur ami qui cavalcadaient dans l'inquiétude.
>
> Un autre de ses amis l'amena un jour sur les confins d'un pays mystique où les habitants étaient à la fois si simples et si grotesques qu'on pouvait les refaire facilement.
>
> Et puis vraiment, l'anatomie par exemple, n'existait plus dans l'art, il fallait la réinventer et exécuter son propre assassinat avec la science et la méthode d'un grand chirurgien.
>
> La grande révolution des arts qu'il a accomplie presque seul, c'est que le monde est sa nouvelle représentation. Enorme flamme.[108]

The art of the artist whose " yeux sont attentifs comme des fleurs qui veulent toujours contempler le soleil "[109] has, therefore, an eschatological significance. In Apollinaire's circle where each of them had an *epitheton ornans* and an assumed name, Picasso was St John the Baptist, " qui lave les Arts

dans le baptême de la lumière ".[110] Yet it is worth remembering that in one of his contemporary drawings of an open window, this very light radiates from a magnified disc of the Sun, which Picasso inscribed : *Sainte Apollinaire*.[111]

GEORGE T. NOSZLOPY

Birmingham

NOTES

[1] " L'Art romantique ", in : *Œuvres complètes de Charles Baudelaire*, ed. F. F. Gautier, Paris, 1923, p. 288.
I should like to record my deep gratitude to Dr D. J. Kelley, of Trinity College, Cambridge, who has been a great help to me in developing some of the ideas put forward in this article.

[2] Cf. A. Rey, *Le Retour éternel et la philosophie de la physique*, Paris, 1927 ; and M. Eliade, *Le Mythe de l'éternel retour*, Paris, 1949, English ed. Bollingen Series XLVI, New York, 1954. On the Symbolist attitudes to the myth of revival, see I. Fletcher, *Romantic Mythologies*, London, 1967 ; A. G. Lehmann, *The Symbolist Aesthetic in France 1885-1895*, London, 1968, in general ; and J. Péladan, *Salon de la Rose+Croix, Règle et Monitoire*, Paris, 1891 ; cf. J. Lethève, " Les Salons de la Rose+Croix 1892-1897 ", in : *Gazette des Beaux-Arts*, December 1960, pp. 365 ff. ; R. Pincus-Witten, *Les Salons de la Rose+Croix 1892-1897*, exhibition catalogue, Piccadilly Gallery, London, 1968, in particular. On the Cubists' attitude to Symbolism, see D. Robbins, " From Symbolism to Cubism : The Abbaye of Créteil ", in : *Art Journal*, XXII, 1963-4, pp. 111 ff. ; and on Apollinaire's relationship with Symbolist ideas, see S. I. Lockerbie, " Alcools et le Symbolisme ", in : *La Revue des Lettres Modernes*, Nos. 85-89, 1963 ; and M. W. Martin, " Futurism, Unanimism and Apollinaire ", in : *Art Journal*, XXVIII, 1969, pp. 258 ff.

[3] " L'Esprit nouveau et les poètes " ; originally a lecture of November 26, 1917, the revised text was published in *Mercure de France*, 1918, 1 December ; cf. S. Bates, *Guillaume Apollinaire*, New York, 1967, p. 77. Although Apollinaire had actually compared the role of Paris to those of Renaissance Italy and Classical Greece at a relatively later date (cf. *Chroniques d'art*, Paris, 1960, pp. 271 ff., 399, 424 f.), he often compared the attitudes and achievements of modern artists to those of the " plus nobles époques de l'art en France et en Italie " (cf. e.g. *Chroniques d'art*, p. 164). On his idea of returning to first principles, see *Chroniques d'art*, pp. 188, 198 f.

[4] " Cortège ", (*Alcools*), in : *Œuvres poétiques*, Paris, 1956, pp. 75 f.

[5] Cf. *Apollinaire et la musique*, Actes du Colloque Apollinaire 1965 à Stavelot, Paris, 1967 ; also S. Bates, op. cit., p. 77.

[6] *Le Guetteur mélancolique* : *Rhénanes*, in : *Œuvres poétiques*, p. 534.

[7] *Madonna mit der Wickenblüte*, Wallraf-Ritchartz Museum, Cologne.

[8] *Chroniques d'art*, p. 22.

[9] On the iconography of the Virgin of the Rosary, see K. Künstle, *Ikonographie der christlichen Kunst*, I, Freiburg-im-Breisgau, 1928, pp. 638 ff. ; E. Panofsky, *Albrecht Dürer*, 3rd ed., I, 1948, pp. 110 ff. ; and S. Ringbom, " *Maria in Sole* and the Virgin of the Rosary ", in : *Journal of the Warburg and Courtauld Institutes*, XXV, 1962, pp. 326 ff. On the symbolic significance of the rosary, see *Acta Sanctorum*, I, pp. 422 ff.

[10] Cf. R. Tuve, *Allegorical Imagery* : *Some Mediaeval Books and Their Posterity*, Princeton, 1966, pp. 219 ff.

[11] *Le Guetteur mélancolique* : *Rhénanes*, in : *Œuvres poétiques*, pp. 538 f. The imagery of the Rhenish poems is discussed by M.-J. Durry, *Guillaume Apollinaire*, *Alcools*, Paris, 1956 ; and F. J. Carmody, *The Evolution of Apollinaire's Poetics 1901-1914*, Berkeley and Los Angeles, 1963, especially pp. 20 ff., mainly in connection with immediate literary sources. However, M. Poupon, " L'Année allemande d'Apollinaire ", in : *La Revue des Lettres Modernes*, Nos. 183-188, 1968, pp. 9 ff., mentions Apollinaire's interest in local history, folk-lore and in occult-religious philosophies. " Le Dôme de Cologne " recalls the neo-Platonic philosophy of Cornelius Agrippa von Nettesheim (his name refers to Agrippina, the Roman name of Cologne), whose work was closely associated with the late Gothic and Renaissance culture of Cologne. He was renowned for his lectures on the *Pimander* of Hermes Trismegistus ; no doubt Apollinaire was fascinated by his mysterious personality and teaching (cf. n.25 below). Cornelius Agrippa thought that the trispherical universe animated by cosmic forces emerging from the Divine Light, is comprehensible to man through the study of physics, mathematics and theology, thus the greatest intellectual ambitions can be fulfilled (*De occulta philosophia*). As a lesson from the Tower of Babel (Genesis, XI, 4), he recommended that man's achievements should consist in the praise of God and that he should return to the first principles of Christian doctrines (*De incertitudine et vanitate scientiarum et artium atque excellentia Verbi Dei declamatio*). Among his numerical-geometrical-pictorial emblematic devices was the Golden Cross. Both pun and symbolical content of " Dôme merveille entre les merveilles du monde / La tour Eiffel et le Palais de Rosemonde " are more fully exploited in two later poems of *Alcools* (" Palais " and " Rosemonde ", *Œuvres poétiques*, pp. 61 f., 107) and also in one of the Orpheus poems of *Le Bestiaire* (op. cit., p. 15), as it alliterates with *Rose du Monde*. Though superficially the image is related to Samuel Daniel's *The Complaint of Rosamond* (cf. *Œuvres poétiques*, p. 34), it is used in the spirit of Rosicrucian mysticism, which claimed the heritage of the secret wisdom of the East as well as of Antiquity and the modern world, and proposed an Apollonian metamorphosis of the universe. The movement was especially strong in Cologne where in the cathedral a shrine was devoted to the Magi. On the cult of the Magi, see H. Kehrer, *Die heiligen drei Könige in Literatur und Kunst*, Leipzig, 1908. The tower, palace, rose and the vision of carnival referring to the cosmic cycle are reminiscent of Christian Rosencreutz's (Johann Valentin Andreae) *Chymische Hochzeit*, Strasburg, 1616. The image of the carnival combined with the cathedral is similar to Ensor's etching *La Cathédrale* of 1886. Influenced by Hugo's *Notre Dame de Paris*, the Gothic cathedral became a loaded motif in Symbolist art and literature ; cf. e.g. Eugène Grasset's poster *Librairie Romantique*, Monet's 20 canvases of the " Révolution de Cathédrales ", Huysman's *La cathédrale*, and Rodin's self-contained fragment of two praying heads, *La cathédrale*. At this time, the most celebrated Gothic cathedral was " the flower and queen of Christian Churches, the Minster at Cologne " (cf. A. W. N. Pugin, *An Apology for the Revival of Christian Architecture*, London, 1843, p. 20), which was reconstructed from the original plans during the second half of the nineteenth century. Apollinaire's explicit fusion of neo-Platonic (" dorures d'enseignes "—" Christ-soleil "—" Hermès Trismégiste en son Pimandre ") and futuristic concepts and images (" fils Télégraphiques "—" la tour Eiffel "), and his implicit suggestion that a " city with a tower " has a cosmic significance was due to the structural similarity between Eiffel's obelisk-like steel tower and Gothic spire constructions. The simultaneous merging of internal and external space achieved by a geometrically correlated architectural

framework thoroughly penetrated by light and giving a paradoxical experience of space as if one were inside and outside at the same time, symbolized by purely abstract means man's aspiration towards the absolute ; cf. S. Giedion, *Space, Time and Architecture*, Cambridge, Mass., 4th enl. ed., 1965, pp. 241 ff.

[12] *Calligrammes*, in : *Œuvres poétiques*, p. 214. Besides being universal symbols of man's technological achievements and the French national spirit, these mediaeval and modern landmarks of Paris were looked at in analogical terms by many artists and writers at the turn of the nineteenth and twentieth centuries. In " Cortège ", Apollinaire seems to combine Cornelius Agrippa's notion of the Tower of Babel, Rosicrucian ideas of the cosmic cycle and the simultaneity of the Eiffel Tower, though only in terms of allusions : " Dont chaque homme tenait une rose à la main / Et le langage qu'ils inventaient en chemin / Je l'appris de leur bouche et je le parle encore / . . . / Amenaient un à un les morceaux de moi-même / On me bâtit peu à peu comme on élève une tour / Les peuples s'entassaient et je parus moi-même / Qu'ont formé tous les corps et les choses humaines . . .". The contemporary symbolical significance of the Eiffel Tower is best revealed, however, in Apollinaire's " Tour " (*Calligrammes*, in : *Œuvres poétiques*, p. 200 ; see also P. Cailler, ed., *Guillaume Apollinaire : Documents Iconographiques*, Geneva, 1965, pl. 82) and in Blaise Cendrars's " Tour ", in : *Dix-neuf Poèmes élastiques*, *Eloge de la vie dangereuse*, Paris, 1926.

[13] *Œuvres poétiques*, p. xliii (Preface by A. Billy). See also J. M. Brinnin, *The Third Rose*, London, 1960 ; and C. M. Bowra : " Order and Adventure in Guillaume Apollinaire ", in : *Creative Experiment*, New York, 1948, pp. 61 ff.

[14] C. Roth, ed., *Jewish Art*, Tel Aviv, 1961, pp. 378 f.

[15] S. Themerson, *Apollinaire's Lyrical Ideograms*, London, 1968, p. 16.

[16] " L'Esprit nouveau et les poètes ". Cf. n. 3 above.

[17] Cf. *Œuvres poétiques*, pp. 1076 ff.

[18] Cf. P. Cailler, ed., op. cit., pl. 67 ff. ; also *Apollinaire*, Exhibition Catalogue, Bibliothèque Nationale, Paris, 1969.

[19] A. Toussaint-Luca : *Guillaume Apollinaire : Souvenirs d'un ami*, Monaco, 1954, p. 49.

[20] Baltimore Museum of Art. The lamb in Picasso's arm has occasionally been identified as a white dog, Frika ; cf. F. Fels, *Art vivant, de 1900 à nos jours*, I, Geneva, 1950, p. 202 ; also P. Cailler, ed., op. cit., pl. 94. According to T. Reff, " Harlequins, Saltimbanques, Clowns, and Fools ", in : *Artforum*, X, October 1971, pp. 30 ff., Laurencin's painting " bears an intriguing relation to the *Family of Saltimbanques* (Picasso's *Les Bateleurs*), since it shows Picasso and Apollinaire, too, in the places they occupy in that work." The compositional arrangement of the figures is, however, reminiscent of Botticelli's *Birth of Venus*.

[21] " qui lave les Arts dans le baptême de la lumière " ; G. Apollinaire, *Les Peintres cubistes*, Miroirs de l'Art, Paris, 1965, p. 78.

[22] Formerly in Coll. Apollinaire ; another version in Baltimore Museum of Art ; P. Cailler, ed., op. cit., pl. 95.

[23] " We invented an artificial world with countless jokes, rites and expressions that were quite unintelligible to others . . ." ; cf. A. Salmon, " Testimony against Gertrude Stein ", in : *Transition*, February 1935, p. 14. See also pp. 26 ff. and n. 98 below. Among Renaissance examples the famous *Jubilatio* recorded by Felice Feliciano is perhaps the most relevant ; cf. P. Kristeller, *Andrea Mantegna*, London, 1901, pp. 472 f., Document 15. It is worth remembering that the rituals of Renaissance confraternities are discussed in books on the Italian theatre, in which Apollinaire was much interested at this time.

[24] Orpheus is sometimes depicted with a dog at his feet ; e.g. Bronzino's *Cosimo de' Medici* (?) *as Orpheus*, Philadelphia Museum of Art. A three-arched bridge has a central position in Poussin's *Landscape with Orpheus and Eurydice*, Louvre.

[25] I, 39. In P. Valderiano, *Hieroglyphica*, Basle, 1575, p. 39, the dog signifies *Sacrarum literarum professor*. On Gothic and Renaissance heraldic badges the dog symbolizes the loyalty of a knight for his lady ; e.g. Catalan Silver Brooch in Metropolitan Museum of Art, New York. Yet a line in " Cortège " (" O Corneille Agrippa l'odeur d'un petit chien m'eût suffi . . .") suggests that Apollinaire was perhaps familiar with Paolo Jovio's story that Cornelius Agrippa kept a demon servant in

the form of a black dog (*Elogia Doctorum Uirorum*, c. 101) ; see also J. Weye, *De Praestigiis Daemonum*, II, c.v. 11, 12, claiming that the dog *Monsieur* was only an ordinary animal.

[26] Compare the sweeping curve by which Gertrude Stein, Fernande Olivier and " un ange couronné de fruits " are interlocked on the left hand side of Laurencin's painting with Zephyr, Chloris and Flora on the right hand side of Botticelli's *Primavera*. The self-portrait of Marie Laurencin, however, seems to have been modelled on the figure of Daphne in the right bottom corner of Poussin's *Apollo and Daphne*, Louvre. Apollinaire made many puns on *laurel-Laurencin*, e.g. the sixth part of " Les Fiançailles " (*Alcools*, in : *Œuvres poétiques*, p. 133) ; also in *Le Poète assassiné*, Paris, 1916, p. 61.

[27] Musée des Beaux-Arts, Basle (second version with *œillets de poète* ; first version with gilliflowers in Pushkin Museum, Moscow).

[28] *The Inspiration of the Poet*, Louvre. I wish to thank Mr R. A. Lewis for the skilful photographic adaptation of Poussin's painting which is here reproduced.

[29] D. Vallier, *Henri Rousseau*, New York, 1964 ; also G. Apollinaire, " Le Douanier ", in : *Les Soirées de Paris*, No. 20, January 1914.

[30] S. Bates, op. cit., especially ch. III. The Muse can also be compared to a classical statue of *Flora* in Palazzo Doria, Rome ; and typologically to Renaissance representations of the Augustan Sibyl.

[31] National Gallery of Art, Washington D.C.

[32] Pushkin Museum, Moscow.

[33] A. Alciati, *Emblemata*, 1550, p. 107. Yet M. Shapiro (" Nature of Abstract Art ", in : *Marxist Quarterly*, I, 1937, p. 92) rightly claimed that in this painting " the experience of balance vital to the acrobat, his very life, in fact, is here assimilated to the subjective experience of the artist, an expert performer concerned with the adjustment of lines and masses as the essence of his art."

[34] Cf. J. Golding, " Guillaume Apollinaire and the Art of the Twentieth Century ", *The Baltimore Museum of Art News*, XXVI-XXVII, 1963, pp. 4 ff. ; F. Steegmuller, *Apollinaire, Poet among the Painters*, London, 1963, pp. 156 ff. ; and T. Reff, op. cit.

[35] Present whereabouts unknown ; cf. P. Daix and G. Boudaille, *Picasso : The Blue and Rose Periods, A Catalogue Raisonné 1900-1906*, London, 1967, D.XII.9. ; and A. Blunt and P. Pool, *Picasso—the formative years. A study of his sources*, London, 1962, fig. 160.

[36] See especially the drawing inscribed " La culture phisique " (*sic*), Collection Lionel Prejger, Paris ; cf. P. Daix and G. Boudaille, op. cit., D.XII.24 ; also A. Blunt and P. Pool, op. cit., fig. 156.

[37] As the *Pape du cubisme*. Present whereabouts unknown ; see P. Cailler, ed., op. cit., pl. 125 ; and as an *Académicien*, formerly Coll. Apollinaire, op. cit., pl. 126 ; also *Apollinaire*, no. 231. With or without Arion, dolphins were often used as an attribute of the true poet ; cf. Plutarch, *Septem Sapientium Convivium*, *Moralia* 162 f. ; and see Marie Laurencin's pen and ink drawing *Apollinaire m'enseignant*, reproduced in M. Adéma, *Guillaume Apollinaire*, Paris, 1968, fig. 15 ; also Pliny, *Naturalis Historia*, IX, viii, 24 ff. ; and on their symbolical role in French Renaissance art, see V. L. Goldberg, " Graces, Muses, and Arts : The Urns of Henry II and Francis I ", in : *Journal of the Warburg and Courtauld Institutes*, XXIX, 1966, pp. 206 ff., especially 211 f. The dolphins decorating the *wallace* (drinking fountain) opposite the *Bateau-Lavoir*, could have also contributed to the significance of this motif.

[38] *Mercure de France*, 1913 ; Collection Philippe Soupault ; cf. P. Cailler, ed., op. cit., pl. 115 ; also *Apollinaire*, no. 310.

[39] *Les Peintres cubistes*, p. 55.

[40] Op. cit., p. 73. The present whereabouts of Metzinger's painting is unknown ; however, a drawing *Etude pour le portrait d'Apollinaire* is in the Musée National d'Art Moderne, Paris ; cf. *Apollinaire*, no. 250.

[41] Collection Mr and Mrs Leigh Block, Chicago.

[42] " Les trois vertus plastiques " ; see *Chroniques d'art*, pp. 56 ff. ; cf. G. T. N. (George T. Noszlopy), " Cubisme ", in : *Encyclopaedia Universalis*, Paris, 1968, V,

pp. 204 ff. My colleague Mr Anthony Coles drew my attention to Ambrogio Loren-
zetti's famous *Allegory of Good Government*, Palazzo Publico, Siena, where Prudence
holds in her lap what looks like a fan from which three flames, inscribed Past, Present
and Future emerge. On the symbolic meaning of the three primaries, see A. Alciati,
op. cit., p. 128 ; J. Held, *Liber Emblematum*, 1567, no. 61. In nineteenth and twen-
tieth-century painting it often symbolised the Trinity ; cf. P. O. Runge, *Farbenkugel
oder Construction des Verhältnisses aller Mischungen der Farben zueinander* . . ., I,
Hamburg, 1840 ; J. B. C. Grundy, *Tiecke und Runge*, Strasburg, 1930 ; W. Ostwald,
Colour Science, London, 1931, I, p. 12 ; C. Henry, *Le cercle chromatique*, Paris, 1888,
pp. 62 ff. ; W. Kandinsky, *Über des Geistige in der Kunst*, 5th ed., Berne, 1956, p. 93 ;
H. Zehder, *Wassily Kandinsky*, Dresden, 1920, pp. 1 f. ; S. Ringbom, " Art in ' The
Epoch of the Great Spiritual ' occult elements in the early theory of abstract
painting", *Journal of the Warburg and Courtauld Institutes*, XXIX, 1966, pp. 386 ff. ;
G. Apollinaire, pointing out, in Gauguin's *Lutte de Jacob avec l'ange*, the " coloris si
énergique et chantant, pour ainsi dire, la gloire de la Sainte-Trinité . . . ; " see also
his poem " 1909 ", (*Alcools*), in : *Œuvres poétiques*, pp. 138 f., in this respect.

[43] Museum of Art, Rhode Island School of Design, Providence, R.I. ; cf. D. Cooper,
The Cubist Epoch, London-Los Angeles-New York, 1970, pp. 77 and 132 f.

[44] Philadelphia Museum of Art, Louise and Walter Arensberg Collection. The
right hand side panel of Massys's double portrait of Erasmus and Pierre Gilles of
1517. This is now divided between the Galleria Nazionale, Palazzo Corsini, Rome,
and the Collection of the Earl of Radnor, Longford Castle.

[45] Cf. e.g., A. Burkhard, *Hans Burgkmair der Aeltere*, Meister der Graphik XV,
Berlin, 1932, no. 9 ; E. Panofsky, " Conrad Celtes und Kunz von der Rosen : Two
Problems in Portrait Identification", in : *Art Bulletin*, XXIV, 1942, pp. 42ff.

[46] Referring to the Eucharistic wine as *Aqua Vitae* : John XV, 1, 5, 8 ; Mark XIV,
23, 24 ; Psalm CXVI, 13 ; I Corinthians X, 16 ; cf. I. Bergström, " Disguised Symbol-
ism in ' Madonna ' Pictures and Still Life ", in : *The Burlington Magazine*, XCVII,
1955, pp. 303 ff. and 342 ff. Both in the opening (" Zone " : " Le sang de votre
Sacré-Cœur m'a inondé à Montmartre ", or " Ta vie que tu bois comme une eau-de-
vie ") and in the closing poems (" Vendémiaire ") Apollinaire refers to Paris in general
and to Montmartre in particular as *Mons martyrum*. This connotation of Montmartre
was revived by the building of the neo-Romano-Byzantine *Sacré-Cœur*, a memento
of the *Commune* (cf. George T. Noszlopy, " The Embourgeoisement of Avant-garde
Art ", in : *Diogenes*, no. 67, Fall 1969, pp. 83 ff.).

[47] " Cortège ", (*Alcools*), in : *Œuvres poétiques*, p. 74.

[48] Formerly Collection Apollinaire.

[49] Quoted in English by J. T. Soby, *Giorgio de Chirico*, New York, 1955, p. 45 n.

[50] *Le Poète assassiné*, Paris, 1916.

[51] Op. cit.

[52] Paris, 1658, II, 133, ill. p.E.ij. See also, in this respect, Apollinaire's horoscope,
discussed in J. Richer, " Le Destin comme matière poétique chez Guillaume Apollin-
aire ", in : *La Revue des Lettres Modernes*, Nos. 166-169, 1967, pp. 3 ff.

[53] Cf. *Les Peintres cubistes*, pp. 49 ff.

[54] Cf. *Chroniques d'art*, p. 123.

[55] Cf. *Les Peintres cubistes*, p. 53.

[56] Cf. *Chroniques d'art*, p. 164. The painting is now in the Gemeentemuseum,
The Hague.

[57] For this term, cf. E. Panofsky, *Studies in Iconology : Humanistic Themes in
the Age of the Renaissance*, Oxford, 1939, pp. 64, 150.

[58] Cf. *Chroniques d'art*, pp. 284 ff. See also n. 93 below.

[59] J. Golding, *Cubism : a History and an Analysis 1907-1914*, London, 1959, p. 30.
Indeed, Apollinaire's claim : " Dans l'apparence monumentale des compositions qui
dépassait la frivolité contemporaine, on n'a pas voulu voir ce qui y est réellement :
un art noble et mesuré, prêt à aborder les vastes sujets pour lesquels l'impressionnisme
n'a préparé aucun peintre. Le cubisme est une réaction nécessaire, de laquelle, qu'on
le veuille ou non, il sortira de grandes œuvres . . . je sais bien que le cubisme est ce

qu'il y a de plus élevé aujourd'hui dans l'art français " (*Chroniques d'art*, p. 199) was justified by the Spring of 1912, when he declared that the works of the Cubists have a grandiose, monumental appearance that exceeds any works of the past great periods of art (" La peinture nouvelle, notes d'art ", in : *Soirées de Paris*, April-May 1912 ; this part is not reprinted in *Les Peintres cubistes*). And in 1913 he proudly pointed out : " Le sujet est revenu dans la peinture et je ne suis pas peu fier d'avoir prévu le retour de ce qui constitue la base même de l'art pictural " (cf. *Chroniques d'art*, p. 303).

[60] According to A. Blunt and P. Pool, op. cit., p. 23, the *Bestiaire* was first planned about 1906 and was to be illustrated by Picasso. Both Derain's illustrations for *L'Enchanteur pourrissant* and Dufy's for the *Bestiaire* show Picasso's influence.

[61] *Chroniques d'art*, p. 64.

[62] *Chroniques d'art*, pp. 151 f.

[63] *Œuvres complètes*, Paris, 1965, IV, p. 737.

[64] Cf. M. Poupon, " Quelques énigmes du *Bestiaire* ", in : *La Revue des Lettres Modernes*, Nos. 123 126, 1965, pp. 85 ff.

[65] *Œuvres poétiques*, p. 21 ; and Horapollo, op. cit., I, 33.

[66] *Œuvres poétiques*, p. 3 ; and Horapollo, op. cit., II, 4.

[67] Op. cit., II, p. 111.

[68] *Chroniques d'art*, pp. 223 ff. The painting is now in the Musée National d'art Moderne, Paris ; cf. my forthcoming study of the artist, mentioned in n. 84 below.

[69] *Chroniques d'art*, pp. 231 f.

[70] Apollinaire began his review of the 1912 *Salon des Indépendants* (n. 68 above) : ". . . je puis dire que depuis sept ans j'ai énoncé sur l'art contemporain . . . des vérités que nul autre que moi n'aurait osé écrire. Ces vérités éblouissaient parfois comme une lumière trop vive. J'avais cependant la satisfaction de savoir qu'elles éclairaient une élite. On s'habitue vite à la clarté. Mes flammes ont encore allumé d'autres flambeaux. Je ne suis plus seul aujourd'hui à défendre les disciplines des jeunes écoles françaises." See also n. 91 below.

[71] When first shown in the Spring of 1912, *La Ville de Paris* attracted the greatest attention among the artists and critics. See my forthcoming study of Delaunay.

[72] On Apollinaire's influence on the Cubist sections of the annual *Salon des Indépendants* between 1911 and 1914, see A. Gleizes, *Souvenirs : le cubisme 1908-1914*, Lyon, 1957 ; cf. J. Golding, op. cit., p. 24.

[73] Musée du Petit Palais, Paris.

[74] *Chroniques d'art*, pp. 297 ff. ; cf. also pp. 291 f. In both articles Apollinaire seems to connect this triumphant show of Orphism with Rimbaud's " Villes II ", in : *Les Illuminations*.

[75] *Chroniques d'art*, pp. 344 ff.

[76] " Le Salon ", in : *Montjoie !*, March 1914, pp. 21 ff.

[77] M. Vromant, " A propos du Salon des Indépendants. Du Cubisme et autres synthèses ", in : *Commœdia*, April 15, 1914, pp. 1 ff. ; cf. J. Golding, op. cit., p. 39. Also, R. Delaunay, *Du Cubisme à l'Art Abstrait*, Paris, 1957, pp. 140 f. On Apollinaire's view, in general, see n. 79 below.

[78] Collection Mme E. Gazel, Paris.

[79] Apollinaire had general reservations as well. Cf. *Chroniques d'art*, pp. 347 ff., especially p. 352. Though in late 1912 he was persuaded to write " L'Anti-tradizione Futurista ", he criticized the Futurist painters for " plus d'idées philosophiques et littéraires que l'idées plastiques. . . Ils se préoccupent avant tout du ' sujet '. Ils veulent peindre des ' états d'âmes '. C'est la peinture la plus dangereuse que l'on puisse imaginer . . . l'art nouveau qui s'élabore en France semble ne s'en être guère tenu jusqu'ici qu'à la mélodie et les futuristes viennent nous apprendre—par leurs titres et non par leurs œuvres—qu'il pourrait s'élever jusqu'à la symphonie " (*Chroniques d'art*, pp. 213 ff.). R. Allard had already claimed that Delaunay was following a Futurist principle (cf. M. Calvesi, " Il Futurismo di Boccioni : formazione e tempi ", in : *Arte Antica e Moderna*, II, April-June 1958, pp. 149 ff.), but Apollinaire's allusion

to Delaunay's "futurism" provoked a series of protesting letters, published in *Chroniques d'art*, pp. 474 nff. On Delaunay and Futurism, see also R. Delaunay, op. cit., pp. 134 ff.

[80] Cf. *Chroniques d'art*, p. 397.

[81] Cf. my forthcoming study on Delaunay.

[82] Museum of Modern Art, New York. On Apollinaire's view of this painting, see especially "Le Salon d'Automne", in : *Les Soirées de Paris*, November 15, 1913.

[83] *Les Peintres cubistes*, p. 92.

[84] His series of casual notes, published in R. Delaunay, op. cit., pp. 53 ff., are contradictory and often illogical. For a detailed discussion of Delaunay's writings see my forthcoming *Robert Delaunay's " La Ville de Paris " and the Origins of Orphic Cubism : Humanistic Themes in Early-Twentieth-Century Art*, ch. I.

[85] The question concerning the exact status of these paintings by Delaunay has only been tentatively mentioned recently ; for a detailed discussion, see my forthcoming study. Francis J. Carmody, op. cit., pp. 94 ff., rightly points out that Apollinaire's poem " Les Fenêtres " relates to Delaunay's earlier " open windows ", painted between late 1910 and early 1912, and not, as was retrospectively claimed by the artist, to his so-called " simultaneous windows ", where the image appears as a reflection on the window pane. See also S. I. Lockerbie, " Qu'est-ce que l'Orphisme d'Apollinaire ? ", in : Journée Apollinaire Stavelot 27-29 août 1965, *Actes du colloque* ; and " Le rôle de l'imagination dans *Calligrammes*, première partie : ' Les Fenêtres ' et le poème créé ", in : *La Revue des Lettres Modernes*, Nos. 146-149, 1966 ; J. G. Clark, " Delaunay, Apollinaire et ' Les Fenêtres ' " in : *La Revue des Lettres Modernes*, Nos. 183-188, 1968, pp. 100 ff.

[86] In mathematical terms this would conform to the so-called " law of signs ". Attempts to create the absolute image by mirrors or reflection in the water have been made since the Renaissance, and by reflections in the window pane since the seventeenth century. The small *Landscape of the Bois d'Amour*, dictated by Gauguin and painted by Sérusier on the top of a cigar box and treasured by the Symbolists as the " Talisman ", is an almost abstract reversible double-image referring to the metaphysical paradox of optical reflection. And in Mallarmé's poem " Les Fenêtres " the optical experience becomes a ritual of purification : " béni, / Dans leur verre, lavé d'éternelles rosées, / Que dore le matin chaste de l'Infini / Je me mire et me vois ange ! et je meurs, et j'aime / —Que la vitre soit l'art, soit la mysticité— / A renaître, portant mon rêve en diadème, / Au ciel antérieur où fleurit la Beauté ! " As early as 2nd November 1905, Feininger, a close friend of Delaunay, was planning to paint a series of two or three rows of " reflective windows " in primary colours for their mysterious beauty ; for a discussion of this in relation to Delaunay, see my forthcoming study.

[87] Leonardo, op. cit., no 69 ; illustrations in Cod. Forst. III, fol. 76r ; also in Ms A. fol. 61r in the Institut de France. See also P. Duhem, *Les origines de la statique*, Paris, 1906-7, and his *Etude sur Léonard de Vinci*, Paris, 1913, pp. 605 ff. Leonardo's theories are widely discussed in Cubist circles, especially at the Duchamp studio at Puteaux ; cf. G. H. Hamilton and W. C. Agee, *R. Duchamp-Villon*, New York, 1967, p. 12. Leonardo's analogy of the painting as a window (no. 83) and the eye as the " window of the soul " (nos. 21 ff. and especially 653) must have had an influence on Delaunay and on Apollinaire ; cf. *Chroniques d'art*, pp. 266 ff. and 297 f.

[88] See my forthcoming study of Delaunay.

[89] Cf. P. Klee, *Diary*, III 910, London, 1965, pp. 269 f.

[90] Solomon R. Guggenheim Museum, New York ; cf. *Chroniques d'art*, p. 391.

[91] G. Barzizius (Gasparin de Bergame), *Epistolae*, Paris, 1470. Since 1908 Apollinaire considered Paris as the centre of " cet art probe, sain et magnifique qui s'élabore en étonnant le monde et qui sera l'honneur du XXe siècle (*Chroniques d'art*, pp. 50 ff.) ; and in his poem " Vendémiaire " (*Alcools*, in : *Œuvres poétiques*, pp. 149 ff.), he hymned his New Jerusalem, Paris, as the centre of the universe ; cf. also *Chroniques d'art*, pp. 271 ff. and 373 f. On the symbolical aspects of the iconography of Delaunay's painting, see my forthcoming study. In Chagall's painting, the Janus head in the window is modelled on Apollinaire's famous " Roman profile " (cf. M. Adéma, op. cit., p. 121 ; and G. Picabia, " Apollinaire ", in : *Transition Fifty*, No. 6, Paris, n.d., pp. 110 ff., especially pp. 118, 124), while it follows the iconography of

the *Beardless Janus*, Roman coin in the Bibliothèque Nationale, Paris. The colours of the double heads, like the moon and sun motifs in the Delaunay, refers to the timeless moment or to the redemption (Malachi IV, 2). On the symbolism of Janus as the god of sun, presiding over the gates of heaven, and as the god of " all beginnings ", see Ovid, *Fasti*, I, 63 ff. ; and as a symbol of the " celestial souls that animate the firmament . . . (who) with eyes in front and behind, they can at the same time see the spiritual things and provide for the material ", Pico, *Commento* II, xxv (ed. Garin, III, iii, pp. 526 ff.). Janus was also associated with Hermaphrodite or the mystical androgyne ; see Pico, *Heptaplus* II, vi, (ed. Garin, p. 242) ; cf. E. Wind, *Pagan Mysteries in the Renaissance*, London, 1958, pp. 165 f., 173 f. The sphinx-like cat on the windowsill may refer to " Ton père fut un sphinx et ta mère une nuit " in " Le Larron ", (*Alcools*) in : *Œuvres poétiques*, p. 91.

[92] In this respect, see especially those " window " paintings which he exhibited in early 1913 under the titles of *Première représentation, Les Fenêtres simultanées. Ville 2e motif, 1re partie*, formerly Collection Jean Cassou Paris now Museum Hamburg, and of *Deuxième représentation, Les Fenêtres simultanées. Ville, 1re partie, 3 motifs*, now entitled *Fenêtres en trois Parties*, Philadelphia Museum of Art, Gallatin Collection.

[93] Around 1924 he still wrote about the stylistic and iconographic aspects of this painting in a relatively unbiased way ; R. Delaunay, op. cit., p. 63. Apollinaire's comment on Rude's *Marseillaise* can equally be applied to Delaunay's work (cf. n. 58 above). It is also comparable to the poetic imagery of " Zone " and " Vendémiaire " in *Alcools*, and " Les Collines " in *Calligrammes* ; *Œuvre poétiques*, pp. 39 ff., 149 ff., 171 ff. Introduced by Braque in early 1910, lettering became a standard device in Cubist painting, referring to the ambiguity between concrete image and abstract concept, thus enlarging upon the symbolical meaning as well as affirming its particular existence. The visual impact of the posters in Delaunay's painting corresponds with the synthetic cubist use of colourful planes. Apollinaire had also used them in " Zone ". For the iconography and symbolism of the painting, see my forthcoming study.

[94] Galerie Charpentier Paris ; reproduced in J. Wilhelm, *Paris vu par les peintres*, Paris, 1961, p. 82. Lettering in painting : PARI.

[95] " A Travers l'Europe ", (*Calligrammes*), in : *Œuvres poétiques*, p. 201 ; dedicated to M. Chagall. The painting, now in City Art Museum, St Louis Mo., is related to a cubist painting Chagall had shown at the 1913 *Salon des Indépendants*, entitled *Couple sous l'arbre (1912)* in the catalogue, though reviewed by Apollinaire as *Adam et Eve* (*Chroniques d'art*, p. 296). The composition of Chagall's *Hommage à Apollinaire* is based on Delaunay's *Disque*, now in Collection Mr and Mrs B. G. Tremaine, Meriden Conn. In Summer 1913, Chagall together with Apollinaire, Cendrars, Bruce and Frost stayed with the Delaunays in Louveciennes. Besides signifying the twelve months of the year, the Zodiac is also an attribute of Apollo ; cf. G. de Tervarent, *Attributs et Symboles dans l'Art Profane 1450-1600*, Geneva, 1958, col. 414. The internal history of Chagall's painting can be recreated on the evidence of preparatory studies in gouache. One of them, Galerie Berggruen Paris, shows the clock with telegraph-wires (?) interconnecting the inscriptions RUSSIE and PARIS, the latter accompanied by combined images of sun and moon. For an interpretation of the clock, see Baudelaire's " L'Horloge ", in *Les Fleurs du mal*, and especially Apollinaire's ideogram " La cravate et la Montre ", (*Calligrammes*), in : *Œuvres poétiques*, p. 192, where the hands are in the same position as the two trunks of the Hermaphrodite. On the Hermaphrodite and the hermetic androgyne in general, see M. Delcourt, *Hermaphrodite. Mythes et rites de la bisexualité dans l'Antiquité classique*, Paris, 1958. Together with the symbolical " disc " or circle, they recur in alchemical writings as well as in kabbalistic cosmogeny. On its Symbolist revival, see especially J. Péladan, *L'Androgyne* ; cf. I. Fletcher, op. cit., p. 42. Apollinaire, who was introduced to the Kabbala in Léon Cahun's circle in 1900, used this image in his " surrealist drama " *Les Mamelles de Tirésias*.

[96] Cf. F. Steegmuller, op. cit., pp. 62, 74 ; M. Davies, *Apollinaire*, Edinburgh and London, 1964, p. 27.

[97] Cf. K. R. Popper, *The Poverty of Historicism*, London, 1957, p. 13.

[98] Cf. R. Pincus-Witten, op. cit. ; also n. 46 above.

[99] " Les Collines ", (*Calligrammes*), in : *Œuvres poétiques*, pp. 171 ff.

[100] On " parody " as a meaning in modern art, and on irony as an attitude of the contemporary artist, see Adrian Leverkühn's confession in Thomas Mann, *Doctor Faustus*, Stockholm, 1947, ch. xxv. For a marxist analysis of this problem, see G. Lukács, *Essays on Thomas Mann*, London, 1968.

[101] Cf. Plato, *Laws*, VII, 803 ; J. Huizinga, *Homo Ludens* ; *A Study of the Play Element in Culture* ; and A. Chastel, " Le Jeu et le Sacré dans l'art moderne ", in : *Critique*, XI, 1955, pp. 428 ff.

[102] " Les Collines ", (*Calligrammes*), in : *Œuvres poétiques*, pp. 171 ff.

[103] Cf. *Chroniques d'art*, pp. 56 ff. ; *Les Peintres cubistes*, p. 46. Note also the last two verses of " Cortège ", (*Alcools*), in : *Œuvres poétiques*, p. 76.

[104] Cf. M. Ficinus, *Opera Omnia*, Basle, 2nd ed., 1576, pp. 286 ff. ; and P. O. Kristeller, *The Philosophy of Marsilio Ficino*, Gloucester Mass., 1964, p. 216 f.

[105] *Les Peintres cubistes*, pp. 47 f.

[106] Cf. his letter of January 9, 1912 to Ardengo Soffici ; *Œuvres complètes*, IV, p. 758.

[107] *Chroniques d'art*, pp. 210 f. ; cf. L. C. Breunig, " Apollinaire as an Early Apologist for Picasso ", in : *Harvard Library Bulletin*, Autumn 1953, pp. 365 ff. ; also *Les Peintres cubistes*, pp. 50 f., 100.

[108] *Les Peintres cubistes*, pp. 66 f. ; cf. " Les Fiançailles ", (*Alcools*), in : *Œuvres poétiques*, pp. 128 ff.

[109] *Les Peintres cubistes*, p. 61. The sunflower is a traditional symbol of devotion to beloved, or of devotion to royalty (often used explicitly to symbolize the relationship between subject and monarch) ; cf. J. Bruyn and J. A. Emmens, " The Sunflower as Emblem in a Pictureframe ", in : *Rijksmuseum Bulletin*, V, 1955, pp. 3 ff. ; and " The Sunflower Again ", in : *Burlington Magazine*, XCIX, 1957, pp. 96 f.

[110] *Les Peintres cubistes*, p. 78.

[111] *Vœux à Guillaume Apollinaire* ; reproduced in P. Cailler, ed., op. cit., pl. 116.

KURT SCHWITTERS' CONTRIBUTION TO CONCRETE ART AND POETRY

" Kurt Schwitters was called the master of collage. He *was* the master of collage. The heresy of giving a new value to odd and overlooked, down-trodden bits of reality—be they bits of wire or bits of words—by putting them together into some specific kind of relationship and creating thus a new entity, was the essence of Schwitters' art."[1] " Although he always emphasized that form alone was important for him, the mounted and pasted objects produced that suggestive spirit of reality in his ' abstract ' art that he was so passionately attached to. Above all, the fragments of words that Schwitters took from the daily press, with their terribly distorted letters, flash out the mood of that time between colour and form. In this way they signalize reality with great expressive force, as one can see particularly in the great ' Merz-pictures ' of 1919-21 and in several early collages. . . Later on, the writing in his pictures took on an objective character, corresponding to his development towards greater formal strength. Those expressive signal-like letters changed into typographic emblems. . ."[2]

Kurt Schwitters was concerned with images and words not only in his pictures, but in his writing too. For him they are no longer exclusively " means of communication ", they are not an " instrument of thinking ", but they are " *behaviour* ".[3] We are accustomed to the fact that printed words, letters and numbers appear in modern pictures, ranging from clearly legible words, such as *Journal* on many still lifes by Braque and Picasso, to purely typographic emblems.

In his book *Les Mots dans la peinture* (1969) Michel Butor has given some very interesting and stimulating comments on the relationship be-tween word and image in painting, dealing with works from the period of Jan van Eyck to modern times. But from the point of view of method the whole question requires investigation.

The Romantics played a decisive part in the break-away of the word from its exclusively representative function. Novalis thought that language had the same concreteness as reality, that it had a quasi real disposition of its material. For him, poetic language is " bloß wohlklingend, aber auch ohne allen Sinn und Zusammenhang, höchstens einzelne Strophen verständ-lich, wie lauter Bruchstücke aus den verschiedensten Dingen."[4] Baudelaire

[1] Stefan Themerson, *Kurt Schwitters in England*, London, 1958, p. 15.

[2] Kurt Schwitters, *Retrospective*, UCLA Art Galleries, Los Angeles, 1965, p. 8 (Intro-duction by Werner Schmalenbach).

[3] Themerson, op. cit., p. 19.

[4] Hugo Friedrich, *Die Struktur der modernen Lyrik. Von Baudelaire bis zur Gegen-wart*, rde, Hamburg, 1956, pp. 20-21.

and Mallarmé made yet wider the divorce between language and reality, whose final result was an ontological disharmony between language and reality.[5]

It was recognized that the word creates or constitutes its own plasticity or reality and this process found its parallel in modern non-objective painting. Just as words can be a material in their own right, concrete painting refers to itself. Its pictorial intention aims at an expression of the mind indifferent to nature. As the pictorial means no longer have a representative function, it was a decisive step for the Futurists and Cubists to introduce " real details ", among them printed letters and words, into their pictures. Umberto Boccioni, in his book *Manifesto tecnico della scultura futurista* (1912), and Apollinaire, in his book *Les Peintres cubistes* (1913) had recommended the painters any material they chose : " c'est légitimement que des chiffres, des lettres moulées apparaissent comme des éléments pittoresques, nouveaux dans l'art, et depuis longtemps déjà imprégnés d'humanité."[6] In his book *Der Weg zum Kubismus*, Kahnweiler also refers to those " real details ", which carry with them memory images. Combining the " real " stimulus and the scheme of forms, these images construct the finished object in the *mind*.[7] To facilitate that assimilation the cubist painter should choose descriptive titles, such as " Bottle and Glass ", " Playing Cards and Dice ". It is evident that these concrete namings of objects should appear in the pictures themselves. The picture plane which is covered with words, letters and numbers thus becomes the constitutive element of such texts. The position of the word-material on the plane, the distance of texts from each other and the compactness of the texture—in the linguistic and optical sense—transform the text into an optical appearance, an additional dimension to the phonetic and semantic articulation of the text.[8] Kandinsky, in his article " Über die Formfrage ", refers to this peculiarity of the letter itself.[9] Thus the " innere Klang " of a single letter is the expression of an " inner necessity ", which cannot be reduced beyond itself. The conceptual, rather than the merely visual intellectuality of the eye experiences it.

[5] Cf. Friedrich, op. cit., p. 93.

[6] Apollinaire, *Les Peintres cubistes*, ed. P. Cailler, Geneva, 1950, pp. 35-36. Similar tendencies are expressed in Marinetti's " Parole in Libertà " (1913).

[7] Kahnweiler, *Der Weg zum Kubismus*, Munich, 1920. Cf. Jürgen Wismann, " Collagen oder die Integration von Realität im Kunstwerk ", in : *Poetik und Hermeneutik II, Immanente Ästhetik, Ästhetische Reflexion*, Munich, 1966.

[8] Franz Mon, *Texte über Texte*, Neuwied/Berlin, 1970, pp. 45-46.

[9] W. Kandinsky, " Über die Formfrage ", in : *Der Blaue Reiter* (1912). Dokumentarische Neuausgabe von Klaus Lankheit, Munich 1965, p. 157 : " Wenn der Leser irgendeinen Buchstaben dieser Zeilen mit ungewohnten Augen anschaut, d.h. nicht als ein gewohntes Zeichen eines Teiles eines Wortes, sondern als *Ding*, so sieht er in diesem Buchstaben außer der praktisch-zweckmäßigen vom Menschen geschaffenen abstrakten Form, die eine ständige Bezeichnung eines bestimmten Lautes ist, noch eine körperliche Form, die ganz selbständig einen bestimmten äußeren und inneren Eindruck macht, d.h. unabhängig von der eben erwähnten abstrakten Form. . . . Wir sehen nur, daß der Buchstabe aus zwei Elementen besteht, die doch schließlich *einen* Klang ausdrücken. . . . Und, wie gesagt, ist diese Wirkung doppelt : 1. der Buchstabe wirkt als ein zweckmäßiges Zeichen ; 2. er wirkt erst als Form und später als innerer Klang dieser Form selbständig und vollkommen unabhängig."

The typographic lay-out of Mallarmé's *Un Coup de dés* (1898) brought back the role of the plane as a constitutive element of the text. We take the text at one and the same time temporally (through memory) and spatially (as a visual entity). The text is given in the shape of a sinking boat or of thrown dice. Apollinaire continued that deliberate optical presentation of the language in many of his poems in *Calligrammes* (1915), where the display of the text offers a shape corresponding to the content of the relevant poem. Word-composition and picture-composition are super-imposed. Paul Klee in his picture *Einst dem Grau der Nacht enttaucht* . . . (1918) or Juan Gris in his picture *Nature morte avec poème*[10] superimpose the text as a legible foil to the pictorial composition. Language manifests itself in time and in space. Schwitters had something similar in mind when he wrote :

> Mein Ziel ist das Gesamtkunstwerk, das alle Kunstarten zusammen-faßt zur künstlerischen Einheit. Ich habe Gedichte aus Worten und Sätzen so zusammengeklebt, daß die Anordung rhythmisch eine Zeichnung ergibt. Ich habe Bilder und Zeichnungen geklebt, auf denen Sätze gelesen werden sollen. . . Dies geschah, um die Grenzen der Kunstarten zu verwischen. . . Das Merzgesamtkunstwerk aber ist die Merzbühne. . . Die Merzbühne kennt nur die Verschmelzung aller Faktoren zum Gesamtkunstwerk.[11]

The idea of the *Gesamtkunstwerk*, which is an essential part of German Romanticism and which found in Richard Wagner and in the *Blaue Reiter* group its immediate application, is an important element in Schwitters' artistic conception. The superimposition of text and image, as quoted in Schwitters' own words, is another preoccupation in his work. He called his pictures *Merz-pictures*. " ' Do you know what *Merz* means ? ' he asked me once. ' Isn't it a German word for something you throw away, like rubbish ? ' I said. ' Well, not really ', he said. ' But I'll tell you. There was an advertisement in a newspaper, headed *Kommerz und Privatbank*. I cut the first syllable of the first word off, and *Merz* remained ', —and he smiled his innocent and mischievous smile, as if saying : Isn't it all wonderfully simple ? "[12] " Das Wort entstand organisch beim Merzen des Bildes, nicht zufällig, denn beim künstlerischen Werten ist nichts zufällig, was konsequent ist. Ich nannte seinerzeit das Bild nach dem lesbaren Teile ' das Merz-bild ' ".[13]

The writing in his pictures of 1919-21 not only forms an integral part of the composition, but was intended to be read and understood. Schwitters frequently chose the visually most dominant word from his pictures as the title of it. When he says about his writing : " Elemente der Dichtkunst sind Buchstabe, Silben, Worte, Sätze. Durch *Werten* der Elemente gegenein-

[10] Michel Butor, *Les Mots dans la peinture*, Geneva, 1969, pp. 31-32 (Paul Klee) and p. 173 (Juan Gris), with reproductions.
[11] Werner Schmalenbach, *Kurt Schwitters*, Cologne, 1967, pp. 107-108.
[12] Themerson, op. cit., p. 20.
[13] Schmalenbach, op. cit., p. 96.

ander entsteht die Poesie. Der Sinn ist nur wesentlich, wenn er auch als Faktor gewertet wird. Ich werte Sinn gegen Unsinn ",[14] and " In der Dichtung werden die Worte aus ihrem alten Zusammenhang gerissen, entformelt und in einen neuen, künstlerischen Zusammenhang gebracht, sie werden Form-Teile der Dichtung, weiter nichts "[15], that definition could be applied to his pictures, especially to the relationship between word and image. The word, though part of the formal arrangement of the picture plane, has not become illegible ; in reading the word *Merz* we understand its " meaning ", in regarding its shape we perceive its formal structure. Functionally the word presents reality (mimesis), formally it constitutes reality (poiesis). In his pictures of 1919-21 Schwitters deals mainly with the superimposition of the functional and formal structure of the writing ; later he reduced its functional structure in favour of its formal structure. " Sense-less " word fragments, meant to be typographic signs, are perceived entirely by conceptual, rather than the merely visual intellectuality of the eye. A similar tendency can be seen in his writing, where he dissolves the descriptive and representative function of the word, which enables him to arrive at picture-poems, or pure number- or letter-poems, or at his Sonata in primitive sounds, *Sonata in Urlauten.*

Schwitters' early pictures are in a sense exercises in German Expressionism. They find their parallel in his poetry of the same period (1917-19). Like his pictures, which are entitled *Church-yard in the mountains* (1919), *The sun in the high mountain-chain* (1919), *The forest* (1917—Expression No. 1)[16] and which are in the specifically German expressive and romantic tradition, his poems which he wrote under the influence of the Expressionist August Stramm,[17] are reflections of that same, pronouncedly expressionist vital energy. Meaningful words, similar to those which appear as the titles of his paintings, are part of his poetic experiments. " Abstrakte Dichtung wertet Werte gegen Werte. Man kann auch ' Worte gegen Worte ' sagen. Das ergibt keinen Sinn, aber es erzeugt Weltgefühl."[18]

Linguistic material produces manifold associations in the poem " An Johannes Molzahn " ;[19] a-logical relations between the words break open the logical structure of the sentence and suspend the familiar continuity of the narrative process. The highly expressive words give way to an independent movement of their own. The leitmotif " Kreisen Welten Du " in the poem "An Johannes Molzahn" re-appears as a theme and title in the Merz-picture *Weltenkreise.* Hugo Ball, one of the founders of the Dada movement in Zurich in 1916, spoke of the " Plastizität des Wortes. Auf Kosten des

[14] Ibid., p. 211.

[15] Ibid., p. 211.

[16] Cf. the works by Franz Marc or Ernst Ludwig Kirchner.

[17] August Stramm, *Das Werk*, herausgegeben von René Radrizzani, Wiesbaden, 1963.

[18] Schmalenbach, op. cit., p. 203.

[19] Ibid., p. 205.

logisch gebauten, verstandesmäßgen Satzes. Wir haben das Wort mit Kräften und Energien geladen, die uns den evangelischen Begriff des ' Wortes ' (logos) als eines magischen Komplexgebildes wieder entdecken ließen."[20] Max Ernst, who met Schwitters in 1920, defines his technique of collage as the " Systematische Ausbeutung des zufälligen oder künstlich provozierten Zusammentreffens von zwei oder mehr wesensfremden Realitäten auf einer augenscheinlich dazu ungeeigneten Ebene—und der Funke Poesie, welcher bei der Annäherung dieser Realitäten überspringt."[21] Ernst's definition refers to his collages and to his poetic writing as well. Hans Arp, Schwitter's friend, applies a similar artistic principle to his poems " Wolkenpumpen " of 1917 : " Dialektbildung, altertümelnde Klänge, Jahrmarktslatein, verwirrende Onomatopoesien und Wortspasmen sind in diesen Gedichten besonders auffallend. Die ' Wolkenpumpen ' aber sind nicht nur automatische Gedichte, sondern schon Vorläufer meiner ' papiers déchirés'."[22]

In Schwitters' poems and pictures of the years 1917-19 word and pictorial elements have a quality which transcends the expressive values, though they are still controlled by the observation of the visible reality. The a-logical composition of the elements is important, his method of " weighing words against words ". In his drawings, such as *Das Herz geht vom Zucker zum Kaffee,* or *Das ist das Biest, das manchmal niest,* Schwitters transfers his former expressionist experiments into Dada art (1919). Here pictorial elements and written words subsist together. Though this technique is not altogether new, Schwitters is the first who applies it consistently to his Merz-pictures. The pictorial space still bears the Futurist qualities of paintings by Delaunay, Chagall, Marc or Feininger.

In his " Stempelzeichnungen ", Schwitters uses the imprints of ordinary rubber stamps, which are displayed in a highly decorative and rhythmic composition, as in his drawing *Bahnhof,* which corresponds to his poem of the same title.[23] The rhythmic sequence of imprints, among them " Der Sturm ", " Herwarth Walden ", " Belegexemplar ", " Bezahlt ", produces the witty drawing of *Der Kritiker* (see Plate 29). The result of such a technique is the apparent de-composition of language and image as a traditional portrayal or representation of visible reality. Expressionist words still embellish those text-collages. In comparison with the poem " An Johannes Molzahn " the linguistic structure in his " Stempelzeichnung " and poem " Bahnhof " is filled with expressionist word material (sun, heart, etc.) and common words which indicate concrete objects (mill, ladder, etc.). It is this juxtaposition of words that creates a sense of absurdity.

[20] " Die Flucht aus der Zeit ", in : R. Döhl, *Das literarische Werk Hans Arps,* Stuttgart, 1967, p. 58.

[21] *Jenseits von Malerei.* Max Ernst exhibition, Cologne-Zurich, 1963, p. 25.

[22] " Wegweiser ", in : R. Döhl, op. cit., p. 61.

[23] Schmalenbach, op. cit., pp. 206-207 (text and drawing).

The title and the arrangement of the Merz-picture *Sternenbild* of 1920 (see Plate 30) still refers to Schwitters' earlier " cosmic " compositions. But the " real details ", such as pieces of wood, wire, string or wooden disks, are covered with words and sentences, as for example " eichsk " (for " Reichskanzler "), " Offener Brief E. Mathias Die Korrupt ", " erhohung hungersge gegen die Stillegung ", " Generalleutnant ", etc. It is obvious that these fragments of text have here both an optical and an intellectual function. They point to the political and economic situation of postwar Germany. The Gothic letter type adds a further dimension to the handbill character of these quoted inscriptions. Schwitters continues the Futurist compositional arrangement : the dominating circles and circular segments, further heightened by the varying intensity of painted colours, are joined together with splinter-like elements, which produce a rotating effect to which the inserted texts belong as an integral part. The legible texts are related to the general spatial movement. Indeed, the *Sternenbild* portrays a sky with stars ; but it is no longer a metaphor for romantic nostalgia, it is a parody of itself. On these pictures, which are collages and montages, the visually dominant text often re-appears as the title of the relevant picture : *Undbild* (1919), *Arbeiterbild* (1919) (where the words " worker " and " strike " are fused with the rotted material), *Oscar* (1920).[24] The fragments of text are of great importance for the content, the message of the picture itself. Even in the collage *Ohne Titel* of about 1921 (see Plate 31), the fragments of text are of considerable relevance. They can be deciphered as " Straßenbahn A [ge] lehnt haben, in den Streik abge. . . Die Elektrizitätsarb[eiter] . . . [G]esamthei[t] " and finally the big writing of " Mai 191 " ; the sequence of the colours black, red, gold are those of the German Republic—and a bit of blue at the right hand corner might suggest hope amidst the social-critical collage. Never does the collage appear to be illustrative, it always works as a very subtle and suggestive signal. Schwitters' merit is that he entirely concentrated on the refuse, leaving the texts mingled with it to illuminate the particular *Zeitgeist*. Though these works may today have lost their historical, critical and even meaningful relevance, they nevertheless are works of art because they fulfil the artistic maxim of " weighing forms against forms ".

As text and pictorial forms participate in the overall artistic effect, the texts keep their genuine meaning.[25] The text itself becomes the subject of the collage *Ohne Titel (fec.)* of 1920 (see Plate 32). The trials of the Supreme

[24] Cf. Schwitters' " cosmic compositions ", such as *Das Kreisen, Bild mit heller Mitte*, etc.

[25] Schmalenbach's view is therefore dubious : "Es braucht also nicht zu schaden, obschon es nur selten nützt—, wenn man sich in die ' Lektüre ' einer Merzzeichnung vertieft." And : " Die vielen lesbaren Stellen aber verführen nicht zur Lektüre ; derartig plakativ herausgehobene Wortfetzen werden unmittelbar optisch aufgenommen, dringen ins Unterbewußtsein schneller als ins Bewußtsein ein. Sie erzeugen das Gefühl einer bedrängenden Realität—der Realität jenes hektischen, politisch überhitzten, von Revolte beunruhigten, auf Inflation und Arbeitslosigkeit zusteuernden Klimas in Deutschland der ersten Nachkriegsjahre." Op. cit., pp. 129, 120.

Court of Justice, especially their proclamation text, inspired Schwitters to cut up the relevant text and to transfunction it into an apparent linguistic and visual non-sense. The textual collage gains its meaning from that particular transfunctioning of a compromised and corrupted language, displayed optically and linguistically.

The traditional term " text " acquires a totally new meaning : the sequence of movement has been enriched by associations and movable scenery ; the linguistic material produces its own autonomous movement ; the discrepancy between word and description suggests a new reality. " Merz is form. To form means to de-formalize ", proclaimed Schwitters. Because language has become a lifeless formula, Schwitters tries to de-formalize (*entformeln*) it and to make its new dimension visible.

In his famous poem " An Anna Blume " (" Eve Blossom ") (1919) Schwitters had already demonstrated the particular means of the de-formalization, when he parodied the narrow-minded views of his beloved Eve Blossom.[26] He even takes language in its logical sense and arrives at absurd results, when he says :

Prize question :
1. eve Blossom is red.
2. eve Blossom has wheels.
3. what colour are the wheels ?
Blue is the colour of your yellow hair,
Red is the whirl of your green wheels,
Thou simple maiden in everyday dress,
Thou small green animal,
I love thine !
(Schwitters' own English version).

Schwitters also used his technique of collage in his text " Auguste Bolte " (1925), where " die Sprache [. . .] wird zum bloßen Vehikel von Realitätsscherben, Versatzstücken, auch Funktionsmaterialien, die die Geschichte weiter transportieren ".[27] The rhythmic sequence of the word material refers back to its own system ; it is therefore structurally self-sufficient. Schwitters does it in his i-drawings of around 1920. " Die einzige Tat des Künstlers bei i ist die Entformelung durch Abgrenzung eines in sich rhythmischen Teiles."[28] (Schwitters). For example his i-poem consists of only the small letter i in the German Sütterlin style and the caption : " Lies : rauf, runter, rauf, Pünktchen drauf." Here the tendency is clear, namely to unmask the actual process of writing, whereby the sign becomes more important than the meaning it signifies.[29]

The " de-formalization through separation of a specific rhythmic part " becomes an important artistic principle in Schwitters' writing and collages from 1920 onwards. There is no doubt that his experiments, as early as

[26] Themerson, op. cit., p. 25.
[27] Mon, op. cit., p. 78.
[28] Schmalenbach, op. cit., p. 133.
[29] Mon, op. cit., p. 60.

1920, gave rise to the works of modern concrete poetry. At the same time the legible texts in Schwitters' collages become less frequent, as the typographic interest gains more attention in the artist's activity.[30] In his collage *Mz Lustig* (1921) (see Plate 33) the letters " s ", " u ", and " g ", which appear vertically on the right side, seem to be the abbreviation of " Lustig ", because one is trying to read the title into the collage. At a second glance one realizes one's own optical mis-reading. Here Schwitters plays with perception. The destruction of the syntactic, orthographic and typographic structure—already evident in his poem " An Anna Blume "—results in the use of the typographic material as an autonomous figuration.[31]

As far as the collage *Mz Lustig* is concerned, the typographic " reality " as such refers back to itself and is no longer to be interpreted.[32] The de-formalization appears as a transformation of certain materially given elements into signs. This process does not even stop short at the de-formalization of letters and numbers, as the following example will show. This leads to the concretisation or materialisation of letters and numbers. Between 1920 and 1933 Schwitters created a large number of works which are very close to concrete art. As Schwitters was in fact involved in these works, it seems rather difficult to accept Werner Schmalenbach's view that " der ' ganze ' Schwitters nicht in diesen Kompositionen lebt . . . daß die Gesetze, nach denen sich sein lebenssprühender Geist bewegte, nicht die der ' konkreten Kunst ' waren."[33] In contrast to Schmalenbach, Reinhard Döhl has pointed out that the literary works of, for example, Helmut Heißenbüttel or Franz Mon, cannot be understood without knowing of these relations and scarcely be thought of without the influence of Schwitters.[34] Schwitters used the stylistic means of montage, alienation, parody, permutation, etc., which only function against the background of the conventional forms of language and poetry, from which they distance themselves.

Concrete poetry is poetry insofar as it consists of words, letters or numbers. As his i-poems were a consistent demonstration of the sign and not its meaning, his number-poems, such as " Zwölf ", show the extreme consequence of his tendency towards de-formalization :

ZWÖLF
EINS ZWEI DREI VIER FÜNF
FÜNF VIER DREI ZWEI EINS
ZWEI DREI VIER FÜNF SECHS
SECHS FÜNF VIER DREI ZWEI
SIEBEN SIEBEN SIEBEN SIEBEN SIEBEN
ACHT EINS

[30] Kandinsky. Cf. note 9.

[31] Schmalenbach, op. cit., pp. 180-193. In this connection we can only make brief mention of Schwitters' great contribution to the new typography in the 1920s—of his collaboration with Jan Tschichold, Lissitzky, Max Burchartz, van Doesburg.

[32] Max Bense. Cf. note 37.

[33] Schmalenbach, op. cit., p. 150.

[34] Döhl, op. cit., p. 75, note 188.

NEUN EINS
ZEHN EINS
ELF EINS
ZEHN NEUN ACHT SIEBEN SECHS
FÜNF VIER DREI ZWEI EINS.

Here the visual arrangement of the numbers follows a very specific rhythm. The numerical values from one to eleven—the numerical value of twelve is only suggested in the 9th line as the sum of eleven and one—are the elements which constitute the poem. In the abstract rise and decline of the numerical values in the first four lines, in the repetition of the number seven in the fifth line (five times !), in the regular addition of one to the rising numerical value from eight to eleven, and finally in the decline of the numerical values from ten to one, a regular principle in the structure of the poem is evident. The means consist of elementary progressions and regressions, repetitions, inversions, variations, reductions, etc. This " text-reality " means only itself. The decoding of the pattern witnesses to the aesthetic reality of the poem, whose emblems are numerical values.

The visually composed *Gesetztes Bildgedicht* (1922) (see Plate 34) consists of letters, the smallest units of the language. Here the visual arrangement is of particular importance. The language has been reduced to letters which act as signs establishing a visually perceptible figuration. The picture plane —so to speak—is subdivided into 25 squares. Geometry becomes an integral part of this letter poem. Schwitters visualizes to the extreme what Novalis had defined as poetry, namely magic in connection with " construction " and " algebra ". Poetic language is similar to mathematical formulae, " sie machen eine Welt für sich aus, spielen nur mit sich selbst."[35] E. A. Poe saw a relationship between the poetic function and the " strict logic of a mathematical problem " ; Baudelaire claimed that

la phrase poétique peut imiter (et par là elle touche à l'art musical et à la science mathématique) la ligne horizontale, la ligne droite ascendante, la ligne droite descendante ; qu'elle peut monter à pic vers le ciel, sans essoufflement, ou descendre perpendiculairement vers l'enfer avec la vélocité de toute pesanteur ; qu'elle peut suivre la spirale, décrire la parabole, ou le zigzag figurant une série d'angles superposés.[36]

Mallarmé sought for the "geometry of sentences"—the typographical display of his poem *Un Coup de dés* is a first attempt in that direction. Apollinaire finally required poetry to do everything, in order to rival the boldness of mathematics.

Schwitters has chosen the letters A, B. J, O and Z to point to the entirety of the alphabet, to concentrate on specific geometrical forms, such as the circle (O), the horizontal, vertical and diagonal directions, to take into consideration the phonetic quality of vowels (A, O) and consonants (B, J,

[35] Friedrich, op. cit., p. 20.
[36] Baudelaire, " Projet de Préface des *Fleurs* ", in : *Les Fleurs du Mal*, ed. A. Adam, Paris, Garnier, 1959, p. 249.

Z). (This is in connection with his experiments in phonetic transcriptions, which were to lead to onomatopoeia.) The display of these elements follow obvious structural principles. The letter poem proposes a visual and phonetic identification of the letter material. On the formal (optical) and on the linguistic (phonetic) levels the elements constitute a world of their own, not related to a semantic external world, i.e. it has no meaning that refers beyond itself. Thus the language, reduced to its elements, has been made visible in a spatial and temporal structure. The arrangement or composition of the linguistic material follows a mathematical purpose, linguistic content and optical reference correspond to each other.

We have analysed as " texts " Schwitters' poems consisting of numbers and letters, but an extended meaning has been given to the term *text*, which Max Bense defines in this sense as consisting of

> linear, flächig oder auch räumlich angeordnete Mengen von *Material* und *diskret* gegebener *Elementen*, die als *Zeichen* fungieren können, auf Grund gewisser Regeln zu Teilen oder zu einer Ganzheit zusammengefaßt. In dieser Weise konstituierte Texte heißen *materiale Texte* oder *Texturen*, sofern sie nur durch die Materialität oder Realität ihrer Elemente gegeben werden, aber nicht durch Zuordnungen von Bedeutungen, die außerhalb der Konstituierung liegen. Materiale Texte haben also nur eine (semiotische oder linguistische) *Eigenwelt*, jedoch keine (semantische oder metasemiotische) *Außenwelt*.[37]

Schwitters' merit lies in the fact that he has successfully reduced language to its structural and semiotic elements.

> *Konkrete Texte* benutzen im idealen Falle die Sprache nicht nur als *Bedeutungsträger*, sondern darüber hinaus und vielleicht noch betonter als lautlichen und visuellen Akt. Das Wort erscheint also gleichzeitig auf der *Morphem-Ebene* (der Bedeutung), der *Graphem-Ebene* (der figürlichen Wahrnehmung) und der *Phonem-Ebene* (des Klangverlaufs) als poetisches Gestaltungsmittel. Der *Kontext* eines *konkreten Textes* ist gleichzeitig semantischer, visueller und phonetischer Zusammenhang.[38]

Here mention should be made of Schwitters' phonetic poems, for which he discussed the possibilities of a special phonetic script, called " Systemschrift ". It had to realize the identity of the phonetic and visual linguistic elements. In 1927 Schwitters had published a long article on " Anregungen

[37] Max Bense, *Einführung in die informationstheoretische Ästhetik, Grundlegung und Anwendung in der Texttheorie*, rde, Hamburg, 1969, p. 76. This difficult text may be translated as follows : " *discrete* given *elements* and *material*, arranged as linear, plane or also spatial quantities, which can function as *signs* and which are drawn together according to certain rules to form parts or an entirety. Texts constituted in this way are called *material texts* or *textures* insofar as they only exist by virtue of the materiality or reality of their elements, not by virtue of their relation to meanings which exist outside the structure. Material texts have therefore only an *autonomous world* (semiotic or linguistic), but no *external world* (semantic or metasemiotic)."

[38] Bense, op. cit., p. 95. Translation : " Ideally, *concrete texts* use language not only as something that *carries a meaning*, but in addition and perhaps more emphatically as a phonetic and a visual act. The word therefore appears as a poetic structural element simultaneously on the *morpheme-level* (meaning), the *grapheme-level* (figurative perception) and the *phoneme-level* (sound-process). The *context* of a *concrete text* is simultaneously that of a semantic, visual and phonetic correlation ".

zur Erlangung einer Systemschrift " in the Dutch periodical *i 10* : " Wie auch immer die zu vermittelnde, zu übersetzende Sprache ist, die Schrift muß optophonetisch sein, wenn sie systematisch gestaltet sein will. System-schrift verlangt, daß das ganze Bild der Schrift dem ganzen Klang der Sprache entspricht.''[39] But the project had proved utopian ; Schwitters had transcribed his *Sonata in Urlauten* into the conventional Futura in 1932, though by nature it should have required an optophonetic writing. In his " Explanation of my Sonata in primitive sounds " (1932) Schwitters charac-terised his work thus : " Sie bewegt sich in einem Zwischenbereich . . . kühn in der konsequenten Anwendung reiner phonetischer Mittel, traditionell in der Durchgliederung als ' Sonate ' ''.[40]

Just as Schwitters' Sonata in primitive sounds needed a conventional structure, so it is " bezeichnend, daß die Konkrete Poesie immer der Ergän-zung, Erläuterung durch konventionelle Sprache bedarf, obwohl (und weil) sie selbst sich dem logischen Zugriff entzieht.''[41] Eugen Gomringer used the term *concrete poetry* for the first time in 1955, when he spoke of " das auf-zeigen der sprachstruktur, ihrer magie, aber auch der transparenz in gehalt und bild." (sic !)[42] The main characteristic of concrete poetry is the visual-isation of the language. Schwitters made an impressive contribution to this problem as early as 1920 ; modern poets owe him a considerable debt.

<div align="right">ULRICH FINKE</div>

Manchester

[39] Schmalenbach, op. cit., p. 193.

[40] Ibid., p. 224.

[41] E. Juergens, " Zur Situation der konkreten Poesie ", in : *Text + Kritik*, 30, (konkrete Poesie II), April 1971, pp. 48-49.

[42] *Vom gedicht zum gedichtbuch*, 1966, p. 291. E. Gomringer was Max Bill's Secretary at the Hochschule für Gestaltung at Ulm. Max Bill applied the term *concrete art*, as Theo van Doesburg defined it in his " Manifesto of concrete art " (1930), and gave a more precise meaning to it in his theoretical writings. Cf. Friedhelm Lach, *Der Merz Künstler Kurt Schwitters*, Cologne, 1971. (On concrete poetry, pp. 112-120) : " Die heutige Schule der konkreten Poesie von Gomringer bis Jiří Kolár hat Schwitters wegen dieser Gedichte mit Recht als einen ihrer grossen Anreger genannt " (p. 114).

VI

PAUL ELUARD'S EARLY POEMS FOR PAINTERS

Donner à Voir and Voir

If Guillaume Apollinaire was the first post-symbolist poet of stature in France to explore possible affinities between poetry and painting, it was Paul Eluard who carried some of the same preoccupations much further, both in his poetry and his aesthetic theories. Eluard's work with painters falls into two categories—the illustrated books and poems (the Pléiade edition of Eluard's works numbers over fifty artists who collaborated, if one may use the term loosely, with the poet) and, on the other hand, the many poems he wrote entitled simply with the name of a painter—including friends like Max Ernst, Pablo Picasso, Joan Miró, René Magritte and, later, Marc Chagall. A number of these poems were originally scattered through various chapbooks which appeared in the 20s, 30s, and 40s, notably *Capitale de la Douleur, La Vie Immédiate, Cours naturel, Le lit la table*. Many but not all were subsequently republished, together with new poems in the same vein, in two collections particularly concerned with poetry and painting, *Donner à Voir* (1939) and *Voir* (1948) [5].[1]

Of the more than fifty painters who inspired Eluard to write twenty-three poems in *Donner à Voir* to which he added twenty-two more in *Voir*, all but a few artists illustrated one or more of his poems ; and of these few, Paul Klee, at least, entertained that project without bringing it to fruition ([3] I, p. 1379). In other words, the interest between poet and painter was usually reciprocal in nature. That seems to me a remarkable phenomenon, considering the number and variety of artists involved. It is to some extent explainable by the visual nature of Eluard's poetry and by his comprehensive aesthetic which reveals an unusual sympathy for the visual arts.

In *Donner à Voir* we find the poet concerned primarily with his own artistic evolution. He opens with poems on various subjects, starting with

[1] References will be by number, to the following bibliography of works consulted :
[1] André Breton, *Le Surréalisme et la peinture* (1928-1965), Paris, Gallimard, 1965.
[2] Luc Decaunes, *Paul Eluard*, Rodez, Subervie, 1964. [3] Paul Eluard, *Œuvres Complètes*. Paris, Gallimard (La Pléiade), 1968. [4] Paul Eluard, *Le Poète et son Ombre*, Paris, Seghers, 1963. [5] Paul Eluard, *Voir*, Poèmes, peintures, dessins, Geneva and Paris, Edition des Trois Collines, 1948. [6] Ursula Jucker-Wehrli, *La Poésie de Paul Eluard et le thème de la pureté*, Zurich, Juris-Verlag, 1965. [7] A. Kittang, *D'amour de poésie, l'univers des métamorphoses dans l'œuvre surréaliste de Paul Eluard*, Paris, Minard, 1969. [8] L. Parrot et J. Marcenac, *Paul Eluard*, Paris, Seghers (Poètes d'aujourd'hui), 1969. [9] Raymond Jean, *Paul Eluard par lui-même*, Paris, Seuil, 1968. [10] *La Révolution surréaliste 1924-1929*, New York, Arno Press, 1968. [11] Jean-Pierre Richard, *Onze Etudes sur la poésie moderne*, Paris, Seuil, 1964. [12] *History of Modern Painting from Picasso to Surrealism*, chapters by Jacques Lassaigne, Geneva, Skira, 1950. [13] Marcel Jean, *Histoire de la peinture surréaliste*, Paris, Seuil, 1967. [14] George Mullins, *The Art of Georges Braque*, New York, Abrams, 1968. [15] Herbert Read, *The Art of Jean Arp*, New York, Abrams, 1968. [16] William S. Rubin, *Dada, Surrealism and their Heritage*, New York, Museum of Modern Art, 1968. [17] James Thrall Soby, *Joan Miró*, New York, Museum of Modern Art, 1959.

the dream narratives of *Les Dessous d'une Vie*. Gradually, however, *Donner à Voir* begins to focus upon relationships between poets and artists, in the essays on poetry, the seven prose poems on painters, a garland of symbolist and surrealist quotations and the final series of twenty-three poems on painters. In *L'Evidence poétique*, originally a lecture given at the London Surrealist Exhibition of 1936, Eluard explicitly identifies surrealist painters with poets. His notion of art history is that the young painters have made a clean break with their mimetic predecessors : " Les peintres surréalistes, qui sont des poètes, pensent toujours à autre chose. L'insolite leur est familier, la préméditation inconnue. Ils savent que les rapports entre les choses, à peine établis, s'effacent pour en laisser intervenir d'autres, aussi fugitifs " ([3] I, pp. 515-16). He thus emphasizes qualities which are as much a part of literary surrealism as of surrealist art : the use of " l'insolite ", the lack of meditation, the importance and, at the same time, the ephemerality of " les rapports entre les choses ". There is a mixture, in this essay, of Eluardian thought and what might be called the Bretonian " line ".

As the passage continues, it reads increasingly like a manifesto, emphasizing the fraternity of artists and poets whose common purpose is to work for the liberation of man's imagination : " Ils suivent tous le même effort pour libérer la vision . . . pour considérer tout ce qui est possible comme réel, pour nous montrer qu'il n'y a pas de dualisme entre l'imagination et la réalité . . ." ([3] I, p. 516). At the same time, there emerges the notion of a kind of materialism and "interpenetration" which Eluard had glimpsed in Max Ernst's art ten years earlier, in his second poem for the painter, and which was also part of his own poetic theory : " tout ce que l'esprit de l'homme peut concevoir et créer provient de la même veine, est de la même *matière* que sa chair, que son sang, et que le monde qui l'entoure " ([3] I, p. 516). A final observation in this passage distinguishes Eluard's own aesthetic from Breton's, as it emphasizes the priority of vision over that of the word ; both poets and painters express through images the unity of the inner and outer world : " Ils savent qu'il n'y a rien d'autre que communication entre ce qui voit et ce qui est vu, effort de compréhension, de relation —parfois de détermination, de création. Voir c'est comprendre, juger, déformer, oublier ou s'oublier, être ou disparaître " ([3] I, p. 516). The final string of infinitives suggests the art of a number of painters for whom he wrote poems, including Ernst, Miró, and Chirico. Thus *Voir* for Eluard in the 30s comes to have an all-encompassing mystical meaning comparable to that of *le rêve* (especially the dream that is expressed in words) for Breton in the 20s.

Even when, in " Physique de la Poésie 1 ", first published in *Donner à Voir*, Eluard exclaims : " Les mots gagnent. On ne voit ce qu'on veut que les yeux fermés, tout est exprimable à haute voix " ([3] I, p. 938), his statement, in part an echo of Chirico, must be understood in its context, as pertaining to the richness of the symbolist tradition and to what he con-

siders the insufficiency of 19th-century art, and not as a confirmation of literary supremacy or of the supremacy of words over images in the unconscious ; for, in the final section of that essay, we find that the triumph of words belongs to the past : " A partir de Picasso les murs s'écroulent." Like Breton, Eluard sees, in Picasso's art, one source of the surrealist vision. Even more significant, his dominant ideas in the two major essays of *Donner à Voir* are the fraternity between poets and painters, the mystical interpenetration between all objects and aspects of creation, and the priority of vision over the other sense perceptions. These three themes, essential to Eluard's thought about painting, are expressed in various ways in poems dating from his earliest maturity.

In *Voir* Eluard seems to have re-thought some of the aesthetic problems which interested him in *Donner à Voir*. Here, nine years later, we find all the poems which appear in the final section of the earlier book, except those to Arp and Picasso. Included also are four of the prose poems to the painters. There are additions : fifteen poems, written uniquely for *Voir*, and a number of poems which appeared during and after the second World War, including a new Picasso suite, the poems for Chagall and Dubuffet, and several poems first published in *Le lit la table*.

The make-up of *Voir* is significant. Each poem or group of poems is placed between a drawing and a painting by the artist : thus verbal images are enclosed by visual images ; words are enclosed by objects. Eluard may even have had in mind a kind of progression or development from the black and white drawing (sometimes a version of a painting, as in the drawings of Chirico and Magritte) to the black and white words on a page to the rich colors of a painting. It may at first puzzle the reader that the visual images do not always relate directly to the poems and can not be considered as " illustrations " accompanying a text. Eluard's choice of pictures for *Voir* will be referred to repeatedly, as we discuss specific poems.

It is the purpose of this essay to examine five poems in *Donner à Voir* and in *Voir* in the light of three principal questions : how does one suggest a visual image by words, when a picture occupies space and a poem occupies time ? Does Eluard impose his own aesthetic or does a poem faithfully reflect an arrangement of visual images ? How did the poet intend these texts to be read ? That is, what is their function, their intended relationship to the painter's world ?

PREDECESSORS : BRAQUE, CHIRICO

The poems we shall discuss were published, with one exception, in *Capitale de la Douleur* (1926) and all, during what William S. Rubin has called the " heroic period " of surrealist painting ([16], p. 64), between the first (1924) and the second (1929) manifestos. They include among the best of the poems which Eluard wrote for painters. Although he was eclectic in his tastes, Eluard never wrote about art which was completely abstract.

He was, of course, especially drawn to surrealist art which is based on images, drawn both from the external world and from the internal world of vision and dream. He was interested in the techniques used by the painters (irrational juxtapositions, automatism, dream images, collage, frottage), some of which correspond to the techniques of literary surrealism and to his own ideas about art and poetry. They are at times echoed or evoked in his poems. Although Eluard does not write uniquely of surrealist painters, he finds in nearly every artist who interests him surrealist values, and, in particular, values which relate to his own poetic universe, and this, even when others in the surrealist group, including André Breton, do not agree with him.

A striking example of his independence from the group in matters of taste is the poem " Georges Braque ", first published in *La Révolution Surréaliste*, no. 4, 15 juillet, 1925. Less than a year later, in *La Révolution Surréaliste*, no. 6, 1 mars, 1926, Breton says : " C'est que Braque *aime la règle qui corrige l'émotion*, alors que je ne fais, moi, que nier violemment cette règle " ([1], p. 10). If Breton theorizes concerning Braque's aesthetic and praises or criticizes it according to its relationship to surrealist dogma, Eluard, as nearly always, writes a delicate and affirmative appreciation of the artist. What interests Eluard in Braque's painting is not the artist's studied avoidance of spontaneity, but a quality which Breton has described : " celui dont nous parlons reste le maître des *rapports concrets*, si difficilement négligeables, qui peuvent s'établir entre les object immédiats . . . de notre attention " ([1], p. 12). This sensibility to relationships between objects Eluard translates by imagery which echoes, I think, his own poetic universe rather than the world of Braque's paintings :

> Un oiseau s'envole,
> Il rejette les nues comme un voile inutile,
> Il n'a jamais craint la lumière,
> Enfermé dans son vol,
> Il n'a jamais eu d'ombre.

> Coquilles des moissons brisées par le soleil.
> Toutes les feuilles dans les bois disent oui,
> Elles ne savent dire que oui,
> Toute question, toute réponse
> Et la rosée coule au fond de ce oui.

> Un homme aux yeux légers décrit le ciel d'amour.
> Il en rassemble les merveilles
> Comme les feuilles dans un bois,
> Comme des oiseaux dans leurs ailes
> Et des hommes dans le sommeil. ([3] I, pp. 191-192)

The point of departure is seemingly one of Braque's birds (a prophetic note, since birds take over the last paintings, only in the 50s, especially after Eluard's death). In the surrealist aesthetic, which is always seeking

unexpected juxtapositions, any image may, loosely speaking, substitute for any other image ; hopefully, some of these substitutions will generate associations, at once surprising and illuminating. Thus *oiseau* in Eluard's vocabulary may suggest a feminine presence : " L'oiseau prend racine dans la femme " ([3] I, p. 929). In this poem, if the association seems not too far-fetched, the poet was inspired, in part, by the nudes Braque was painting in the early and mid-20s (see Plate 35, the drawing Eluard chose for *Voir*). The Eluardian *oiseau* of course is also an inevitable source of light and harmony ; and so it seems fitting that the poet chose both the drawing of a Braque nude contemporary with the poem and the painting of a guitarist of ten years earlier (around 1914) to accompany the poem in *Voir*.

By association with birds and flight, Eluard introduces other images in the second stanza—notably the image of leaves and the notion of affirmation which suggests, among other things, liberty. Is it going too far to say that the lyrical repetitions in this stanza echo the repeated lines and patterns of Braque's cubist period ? The last stanza describes the artist whose role, for the surrealists but also for the symbolists before them, is to bring together diverse objects—such as leaves in the forest, birds in their wings, men in their sleep, and to point out or to create relationships between them. Significantly, in describing the artist, Eluard employs two interesting terms—the verb *décrire*, which suggests the kinship between the painter's and the poet's act of creation, and the phrase *le ciel d'amour* which, I think, evokes his own universe rather than Braque's. Even more significantly, two surrealist themes are suggested in the last stanza by *les merveilles* (events or objects are marvelous, if we see them as such, and even more marvelous when unexpectedly juxtaposed) and *le sommeil* (although an ambivalent word for Eluard, here it suggests that dream state in which man is free to explore his unconscious). The poem moves along two levels. An image in a painting creates a series of associations in the poet's mind which inspire him to meditate on the role of the artist. At the same time, an association is gradually built up, beginning with an image common to both the painter and the poet (and frequent among surrealists generally), ([13], pp. 141-142), and ending with an evocation of surrealist liberty.

The poem for Braque illustrates a technique often used by Eluard : in the first part of a poem a verbal image translates a visual image, evokes an atmosphere and supposes not only an object but a gazer ; in subsequent stanzas, a reflective note gradually predominates ; an evaluation of the images which pass before our eyes is suggested through the reaction of the gazer, as in the above poem, or sometimes through the imagined effect on the artist, if he or a character in the painting " speaks " the poem.

An example of the latter process is " Giorgio de Chirico ", published in *Mourir de ne pas mourir* (1924). Here, once again, the poet meditates on an older painter, this time, one the surrealists considered an immediate predecessor. Chirico may have influenced Eluard's aesthetic : notably in 1914

he emphasizes vision as the supreme sense perception and paradoxically evokes the image of the artist whose eyes are shut : " Ce que j'écoute ne vaut rien ; il n'y a que ce que mes yeux voient ouverts et plus encore fermés " ([1], p. 18). Although the surrealists increasingly criticized Chirico's creative activity after the first World War, he was still doing some " metaphysical " painting in the early 20s, including, it may be, the " Intérieur Métaphysique " chosen by Eluard for *Voir*. In any case, Eluard and Gala made a pilgrimage to Rome to see Chirico in the snowy winter of 1923 and bought some of his new paintings ; these were severely criticized by Breton on their return to Paris ([13], p. 134). With his typical independence in matters concerning taste, Eluard did not hesitate to publish a poem to Chirico at a time when the painter was attacked by other surrealists, and to republish it twice later :

Un mur dénonce un autre mur
Et l'ombre me défend de mon ombre peureuse.
O tour de mon amour autour de mon amour,
Tous les murs filaient blanc autour de mon silence.

Toi, que défendais-tu ? Ciel insensible et pur
Tremblant tu m'abritais. La lumière en relief
Sur le ciel qui n'est plus le miroir du soleil,
Les étoiles de jour parmi les feuilles vertes,

Le souvenir de ceux qui parlaient sans savoir,
Maîtres de ma faiblesse et je suis à leur place
Avec des yeux d'amour et des mains trop fidèles
Pour dépeupler un monde dont je suis absent.

([3], I, pp. 143-144)

Here, once more, the first stanza sets the stage. We are reminded of such key images of Chirico's work as *l'ombre* and *la tour*, of his " spatial theatre " ([16], p. 77) and of the walls which seem to separate the speaker, here, from the " tour de mon amour ", elsewhere from the departing train or the invisible sea (see Plate 36). Not mentioned but evoked is the empty town square, " cette place," says Eluard, in " Le Tableau de Chirico ", " sur laquelle il semblait ne jamais rien devoir se passer . . ." ([4], p. 25). Not only imagery but atmosphere is established in this first stanza. There is an undernote of menace (*dénonce, défend, peureuse*) and of loneliness (*filaient, blanc, silence*) mixed with desire (" O tour de mon amour "). The pun, (*O tour . . . autour*), an uncommon technique with Eluard, considering how much it was used by other surrealists, may suggest the tower as a phallic symbol ; it may echo the wordplay with which Apollinaire, in " Les Fenêtres ", evoked Delaunay's paintings and theory of light. It is intended, however, not as humor but as nostalgic incantation. The objects suggest primarily a mood, but the various moods of menace, love, silence, are conflicting and the result is enigmatic, as in sybilline prophecy. The fluctuation in tenses between present and imperfect adds to the mystery. The change in tenses

might conceivably refer to the evolution of Chirico's art before the end of the first World War, as described by Breton much later ([1], p. 63) : thus, *les lieux éternels* become *les lieux hantés*, white walls become denouncing walls. Or the switch from tense to tense may create a confusion in time and space and, like the line " Tous les murs filaient blanc autour de mon silence ", reflect Chirico's use of a " vanishing perspective " ([16], p. 80), or the association he experienced between perspective and metaphysics ([12], p. 107).

It is more probable, however, that Eluard simply evokes a melancholy in which most of Chirico's early work is steeped and which corresponds to an aspect of the poet's own temperament especially dominant at the time the poem was written and indicated by the title *Mourir de ne pas mourir*. In " Le Tableau de Chirico " Eluard speaks of " tout ce qui semblait s'être définitivement figé à un moment particulièrement vide de la vie " ([4], p. 25). There were certainly such moments in Eluard's own life, and his visit to Chirico in Rome occurred only a year before a period of upheaval. Images recur in Eluard's poetry with a similar connotation : walls imprison, they suggest emptiness or separate the poet from his desire ; the empty square suggests loneliness and the impossibility of crossing it. An image not specifically evoked in this poem but which occurs in the work of both poet and painter is the statue in the square which for Eluard may represent frustrated desire ([11], p. 109), while Chirico speaks of " le côté tragique de la statuaire " ([13], p. 178). As Jean-Pierre Richard has so beautifully put it, everything for Eluard begins with *l'autre* and *le regard* exchanged between two lovers. This other presence, so necessary to the poet, is lacking in Chirico's work whose *monde dépeuplé* thus has a personal significance for Eluard and answers to the bleak moods he undergoes when he is alone.

The second stanza is increasingly ambiguous. *Toi* may refer to the eye of the gazer, of the painter, of the sky, or to the poet or his reader. This latter level, of the poet and his reader, is reinforced by various phrases : the painter speaks the poem, but, as in " Georges Braque ", he uses the poet's idiom, often deploying images reminiscent of other poems in the same collection. At the same time, these images comment on Chirico's art : the sky as the sun's mirror and the sky seen through leaves evoke one of Chirico's recurring techniques, the frame (or archway) within the picture frame. The image of " le ciel qui n'est plus le miroir du soleil " suggests also that Chirico's skies are new, never before created ; Eluard comments to the same effect in " Premières vues anciennes " : " Chirico a réalisé ce prodige de peindre des paysages nouveaux " ([3] I, p. 959). Again, " Les étoiles de jour parmi les feuilles vertes " may (in my opinion) echo symbolist imagery, particularly that of Mallarmé, and thus parallel Chirico's own variation on Renaissance themes.

Breton, in the passage already cited, describes later phases in Chirico's evolution, when " l'être vivant, disparu, n'est plus évoqué que par des

objets inanimés en rapport avec son rôle (de roi, de général, de marin, etc.) " ([1], p. 63). If one thinks of the poem as a summing up of the painter's evolution, this process of dehumanization may be indicated by the last stanza where the poet no longer uses images but speaks almost analytically. The first two lines might refer to the *objets inanimés*, that is, to those who had no real authority and whose role I the artist have assumed. On the other hand, if one takes the imperfect as an evocation of the nostalgic theme of childhood memories, which critics have so often seen in Chirico's paintings ([16], p. 80), and which are clearly present in the painter's poems, these first two lines suggest not only memories of the past but a childlike sense of culpability or *faiblesse* in the speaker, a feeling which has been definitely linked by critics of Chirico with the role of memory ([13], p. 50).

The poem, seen in this light, reveals in the last stanza a meaning particularly pertinent to Eluard's poetry—a yearning to break through the walls of habit and training, toward a natural freedom, a desire which for Chirico, in the poet's eyes, is forever doomed to failure. Even Eluard, surrealist and would-be revolutionary, felt at times trammeled : in an *enquête* significantly entitled " Du désir ", he states, using imagery reminiscent of the painter : " L'homme ne peut jamais complètement détruire les murs qui lui ont été imposés depuis son enfance " ([4], p. 22).

The last two lines analyse the attitude and the world of Chirico as they tend to become—his love for certain objects and colors, the superb technique (" les mains trop fidèles ") which may have contributed to his undoing in later years, and, finally, the uninhabited world from which even the speaker is absent. The personal withdrawal at the end of the poem is, on one level, Mallarmean, as Eluard, perhaps consciously, presents it ; that is, any deeply metaphysical concern depersonalizes and for that reason may become dangerous. Key words, occurring in each stanza at the end of a line, are *silence, pur* and *absence*. They suggest points in common with both Eluard and Mallarmé which one critic, thinking of both poets, has described as " une poésie de l'absence, du non-être qui conduit au silence . . . la hantise et l'impuissance de créer " ([6], p. 19). Mallarmé, however, in spite of periods of despair, did not let melancholy overwhelm him. He is, above all, concerned with artistic creation, that is, with affirmation, while Eluard himself is known, perhaps especially, for his poems of joyous love. Although Eluard obviously feels great sympathy for Chirico, he is well aware, in " Le Tableau de Chirico," that unrelieved melancholy may lead to *démence*—or to other forms of impasse. Later, in " Premières vues anciennes ", comparing Chirico with Nerval, he says of the former, " la même énigme . . . la même place dépeuplée . . . la même faculté de se perdre, mais chez Chirico, la faculté de tout perdre, de se gâcher, de se nier " ([3] I, pp. 958-959).

Whether the poem sums up Chirico's most significant life work or evokes one period, in any case, Eluard has expanded the poem's application by the choice of illustration in *Voir*. The poem is preceded by a drawing based on

the painting " Portrait de Guillaume Apollinaire," chosen probably not only for its subject matter but because it was considered prophetic of Apollinaire's wound and subsequent death. ([13], pp. 47, 198). Thus the poem, through the drawing, receives an orientation toward prophecy and can be seen as an anticipation of downfall rather than as a summing up of an evolution. The portrait of Apollinaire dates from the peak of Chirico's production. The " Intérieur Métaphysique ", I think, on the other hand already shows a decline in creative power, of which Eluard was compassionately aware, a failure to escape the binding walls, a negation of life—themes which are suggested above all in the last stanza of the poem. It may be that to Eluard this progression toward sterility and the accompanying vulnerability to the dangers of narcissism which he himself knew well ([11], pp. 124-125), seemed more imperative to indicate in *Voir* than any visual and literal echo of his poem which could have been furnished by the reproduction of a " typical " Chirico painting of walls and towers.

" Abstract " Surrealists : Arp, Klee, Miró

In discussing Eluard's poems for painters the drawback is the same as with a painter's illustrations for an anthology of poems by different poets. The comments on entirely different works are all by the same hand. It is always the same eye, the same voice and vocabulary, the same (in this case, surrealist) position which interprets and evaluates, except in so far as the poet himself evolves through time. Thus we have in these poems almost an equivalent of the role of the painter-illustrator. In *Capitale de la Douleur*, for example, one finds not only the poem to Braque but poems to Arp, Klee, Miró, Ernst, Masson and, of course, Picasso. To take several of these is to find many poetic techniques in common and, at the same time, a perception in most cases of what Eluard considers the essence of the artist's work at a given stage rather than the attempt at a literal translation of a given painting. We have already seen that, with the predecessors of surrealism, Braque and Chirico, Eluard proceeds from image to evaluation, and in both poems he translates visual by verbal imagery. Let us see how he deals with what Rubin calls the " abstract " surrealists, that is, some of those painters who are furthest from recognizable reality.

A little prose poem, entitled " Arp ", differs from the other poems, because it does not give the painter's full name and because it is not written in verse form. It consists of a single sentence lifted from a book review ([4], p. 49) which Eluard wrote in 1921 of *Le Cinéma Calendrier du Cœur Abstrait Maisons*, poems by Tzara with nineteen woodcuts by Arp, one of three collaborations between Tzara and Arp mentioned in Eluard's list of illustrated books in " Physique de la poésie 2 " ([3] I, p. 982). Curiously I have not been able to find mention of this source in the excellent Pléiade edition. Yet it is of especial interest as a link between Apollinaire (whose prose more than once metamorphosed itself into poetry) and Eluard who,

in the musicality of his language and in his place among the painters is, at least during the 1920s, Apollinaire's successor. The poem, published just after Arp's return to Paris ([13], p. 175), differs slightly but significantly from its prose origin : *Arp*, the subject of the sentence, becomes the title : *sourire* becomes plural ; *et* is omitted after " minuscule " and, most important, at the end of the sentence, a final phrase is added : " résiste au vent." The poem was republished in *Donner à Voir*, but omitted from *Voir*. The omission seems a criticism not of Arp but more likely of Eluard's later reaction to the poem : it is the earliest of the poems to painters (rather, it shares the honors with " Max Ernst I ", both published in *Action* in 1921) ; in addition, it was not originally intended as a poem and is perhaps as close as Eluard gets to Dada in what is called his " Dada period ". Thus he may have cast it off as unworthy, while keeping " Max Ernst I " which announces a long collaboration with that painter. On the other hand, the theme of metamorphosis fascinated the young Eluard for its own sake : " Principe de la métamorphose qui est la vie même ". As the poet grew older this theme may have assumed in his thought increasingly didactic aspects which he did not find in Arp's subsequent work, for the latter never entirely relinquished his Dada affiliations :

ARP

Tourne sans reflets aux courbes sans sourires des ombres à moustaches, enregistre les murmures de la vitesse, la terreur minuscule, cherche sous des cendres froides les plus petits oiseaux, ceux qui ne ferment jamais leurs ailes, résistent au vent. ([3] I, p. 193)

There is great emphasis on motion in this poem ; and generally in Eluard's poetry, to paraphrase Richard, one can say that things and creatures are in transit or else that the poet's gaze travels from one object to another. Arp's silhouettes are seen plunging and turning through space. At the same time, there is some one who sets in motion, records, seeks and resists. Eluard has solved the problem of chronology by matching our simultaneous impressions of ambivalent forms with a series of transformations. He evokes not only Arp's woodcuts and woodreliefs but also his automatic drawings of the early twenties where imprecise shapes suggestive of various objects float in space (see Plate 37, which, although it dates from 1929, continues the same techniques). Lack of shading or perspective is indicated by the phrase " sans reflets "—also, a new way of looking at things, " new . . . dimensions " ([16], p. 39), like the bird in " Georges Braque " which casts no shadow. By the heaping up of images : *courbes, sourires, ombres, moustaches,* Eluard suggests the viability of a woodcut's silhouette. In somewhat the same way he mixes noise, speed, size and emotion (*murmures, vitesse, terreur minuscule*), to suggest the arrangement of objects against a blank background and also the fiercely whimsical atmosphere generated by the picture. Finally, by a grotesque transformation of moustaches into birds he suggests what in Arp's work can be considered as a humorous visual pun, part of

his " biomorphism " ([16], p. 40). Thus the bird, a central image in Eluard's vocabulary, determines the climax of the poem.

One's impression of shapes whirling across the canvas becomes a realization of the artist's inevitable resistance to the mysterious wind which fills a seemingly empty space around the scattered objects. One meets elsewhere in Eluard's poetry with associations between birds and wind, between wind and poem. In " Arp " the birds are a visible indication of wind but it is the artist who struggles against the wind's power. Nothing is too minuscule, in Eluard's imagery, as in Arp's work of the early 20s, to swell with meaning. The tininess at the beginning of the poem which leads up to the vast unlimited image of the wind and its power is appropriate to the worlds of both the artist and the poet. As one reads the poem one is aware of a crescendo such as one might experience while looking at a work by Arp, gradually seeing it take on life as a unity of form and space. Eluard has vividly appreciated the way in which the arrangement of a few small silhouettes can make the huge space of a picture (or, as here, a page) swell and tremble with invisible life.

The poem for Arp, paradoxically when one considers his art, is composed throughout of precise images : at the same time, as in the poems for Braque and Chirico, there is a lively awareness of the artist's role. The same combination of concerns (or techniques) is true of a poem for another " abstract " painter, " Paul Klee ". Although Breton mentions him only in the First Manifesto, and not in his art criticism (presumably because Klee never officially joined the group, although he was interested in surrealist experiments), Eluard published a poem to Klee in a catalogue of the artist's work in 1925, before including it in *Capitale de la Douleur* the following year ; in 1928 he sent Klee a book of poems, hoping that he might illustrate them. The painter was much interested, " d'autant plus qu'il sentit entre lui et le poète français une forte parenté " ([3] I, p. 1379), but the project came to nothing, probably because the artist, who was extremely painstaking and slow, illustrated only two books in his lifetime. Eluard's early and continuing appreciation of Klee furnishes us with yet another example of the poet's quiet independence from group attitudes and of his keen artistic insight :

Sur la pente fatale, le voyageur profite
De la faveur du jour, verglas et sans cailloux,
Et les yeux bleus d'amour, découvre sa saison
Qui porte à tous les doigts de grands astres en bague.

Sur la plage la mer a laissé ses oreilles
Et le sable creusé la place d'un beau crime.
Le supplice est plus dur aux bourreaux qu'aux victimes
Les couteaux sont des signes et les balles des larmes.

([3], I, p. 182)

Paradoxically, this is one of the poems which, in my opinion, could stand alone, with no explanatory title. At first glance, it may seem to have little

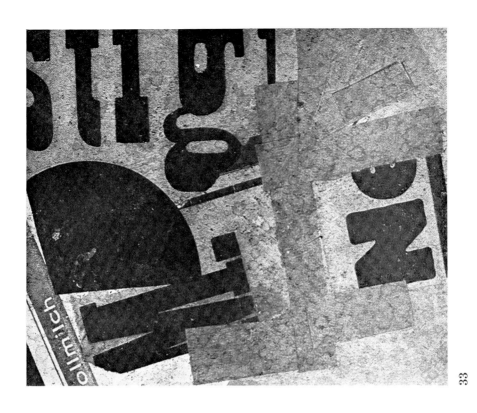

33

32

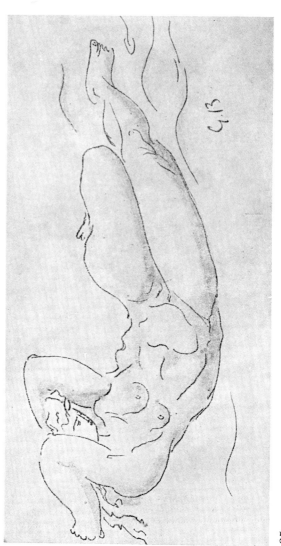

34

35

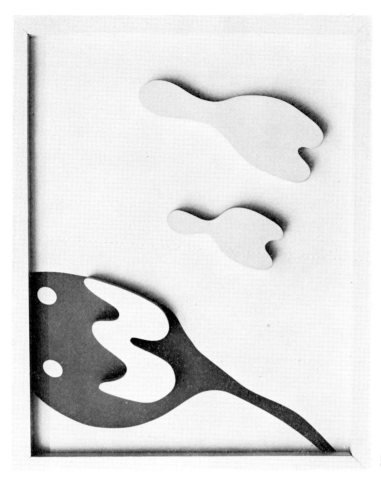

37

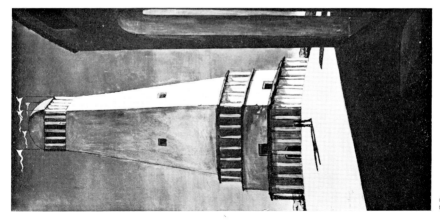

36

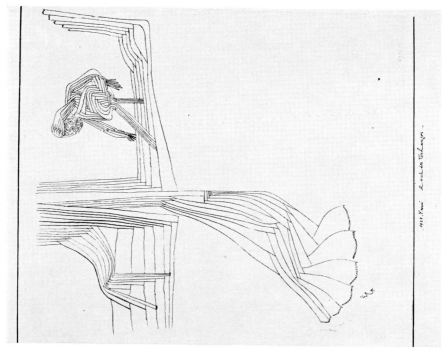

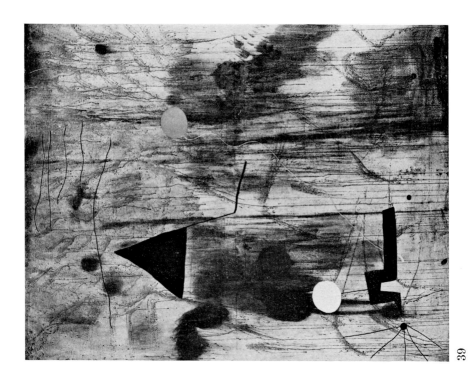

38

39

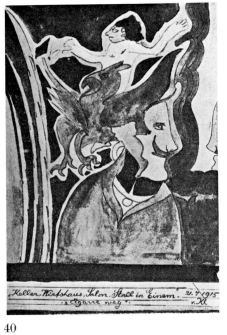

40

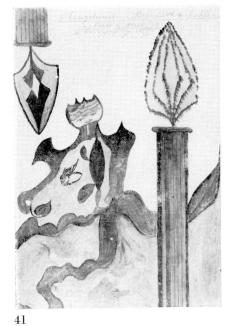

41

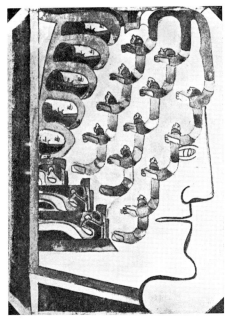

42

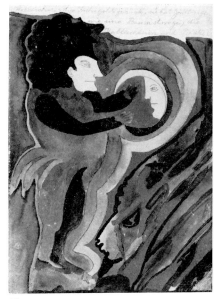

43

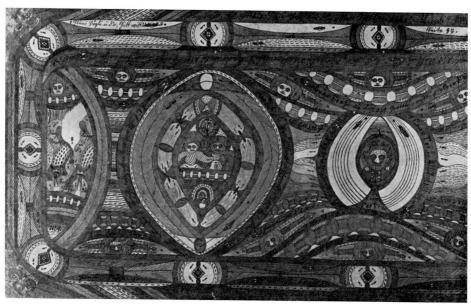

44

45

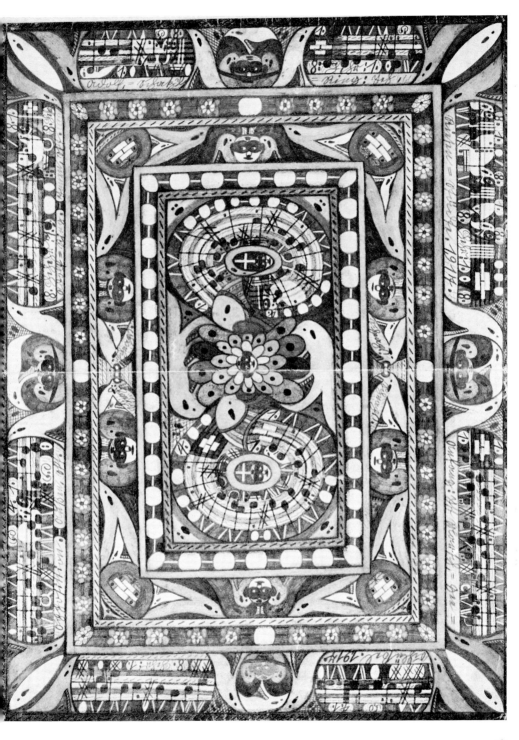

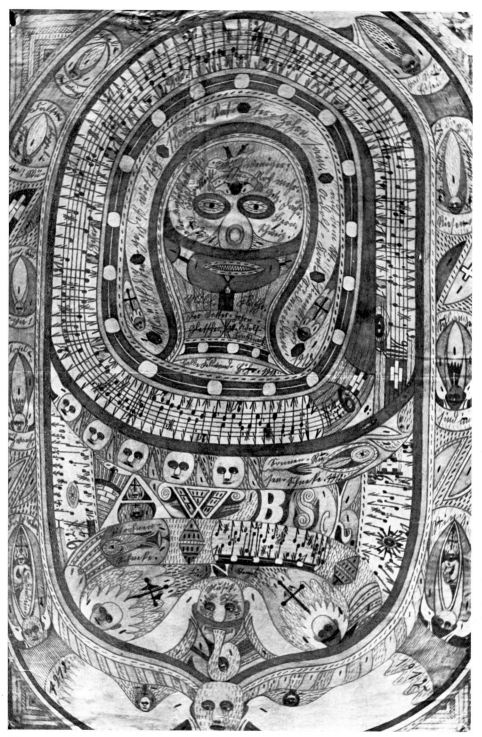

47

connection with the Klee we are familiar with. Yet it is a faithful evocation of the painter's art in the early 20s, as one can see by a glance at *Voir*. The drawing Eluard chose to precede the poem, " Reich des Vorhanges " (see Plate 38), shows a small human figure tottering at the peak of dizzy lines : it is reminiscent of a number of drawings of other little figures surrounded by labyrinthine lines which Klee drew in the early 20s.

The dominant color of the well-known painting chosen for *Voir*, with its brilliantly blue head, suggests, as do many of Klee's more delicately colorful paintings of the early and mid-20s ("Maid of Saxony ", " Landscape with Yellow Birds ", " Fish Magic ", his joy in color, especially the color blue. In Eluard's poem also blue is a human color, not an inhuman or super-human absolute, like Mallarmé's *azur*. On another level the persona of the traveler suggests Klee's experiments with automatism (at one time subject to question ([12], p. 166) but now seemingly established), his exploration of the unconscious which had considerable importance for the surrealists. There may also be, in the word *voyageur*, a teasing reference to Klee's numerous journeys. The traveler's perilous situation is expressed humorously by both artist and poet : Klee's *humour noir*, the mixture of fatality and joy which is expressed by line and color are suggested in Eluard's poem by phrases such as *la pente fatale* and *les yeux bleus d'amour*. Other images also suggest technique as well as atmosphere : *verglas* and *caillou* may be playful refer-ences to the mottled spotty background sometimes prepared by Klee, and which may seem at one moment inviting and at another menacing.

Eluard, I think, sees in Klee's art a relationship between all things, including a kind of interchange between color and form, laughter and tears, which corresponds to his own aesthetic : " O vieille fée, fée Confuse, qui mêles innocemment toutes choses, les couleurs et les formes, les rires et les larmes . . ." ([3] I, p. 929). Except for the word *fatale*, the entire first stanza suggests joy. If the color blue suggests the human emotion of love, on a more general plane, it suggests the artist's love of all things created. Even the stars are humanized and possessed. Their association with rings may be a faint echo of the opening lines of *La Jeune Parque*, but the association between hand and star suggests rather Desnos' play *La Place de l'étoile* or his scenario filmed by Man Ray, *L'Etoile de mer*. In the 20s and 30s, hands fascinated people as diverse as the surrealist poet Eluard and his friend the cubist painter Marcoussis. There exists also for Eluard, as for Apollinaire before him, a traditional association between a finger ring and the circle, symbol of infinity, which, since it is made up of a series of points or links, represents also the finite. One might say that by analogy the image of the ring suggests that the artist is in communication with the whole world and, at the same time, with each individual being in it ([11], p. 124).

In the second stanza the pun in the first line on the literary Spanish expression *la orillia del mar* (instead of *la playa*) points out humorously a visual likeness between the form of an ear and that of a wave. Visual

resemblances return in the last line of the poem, where tiny curved images, *couteaux, balles, larmes*, indicate the importance of *le trait* in Klee's work. The pun on " ear " is perhaps the most obvious touch of humor in a poem devoted to a painter known for his humor, satire and irony. The entire second stanza, however, can be viewed as ironic. It carries out, I think, in a playful manner, an allegory on the attempted exploitation of the unconscious by the artist who finds it difficult to remain for long purely in the realm of automatism. The theme announced by the first line's adjective *fatale* now becomes the menace of the hollow in the sand. In the innocence of this image resides the humor (one thinks of certain tales of Sherlock Holmes or Father Brown or of the *Fantomas* films, where horror hides in a trivial phenomenon). There is an amusing element of suspense : is the mysterious *beau crime* in the past or future ? And why the adjective *beau* ? We probably arrive at an elusive description of the crime itself in the final lines which suggest both the bloodthirstiness of a child's fairy tale and a fanciful comment on the artist and his viewer : for either can be viewed as the *bourreau*, and either, the *victime*. The two nouns could equally well describe imaginary characters in Klee's universe or two aspects of his own personality. Eluard suggests Klee's penchant for humorous or ironic revelation of what one critic has called " metaphysical anguish " ([12], p. 163 ; see also [13], pp. 148-149) but which may simply be a pessimistic temperament given to making fun of itself, a tendency which is hardly an innovation in European art or literature. The ambiguity of the poem is heightened by a simplicity of style which answers to Klee's own naive mannerisms and by an ambivalent plot line : we gradually apprehend, but only dimly, a tale of a menaced traveler who may represent any or all of us ; at the same time, the picture takes shape and fills with mysterious tiny images. What was once said of Eluard could equally be applied to Klee and surely to this poem : " La limpidité se fait énigme " ([9], p. 100).

Most successful of Eluard's poems to the " abstract " painters is " Joan Miró ", perhaps because of Miró's love of poetry (" I gorged myself on it all night long ") ([16], p. 66), his sympathy for poets, especially for Dadaists and Surrealists ([17], pp. 10, 38), and, among those, notably for Eluard. One of Miró's major works are the woodcuts in color for Eluard's *A toute épreuve* (published posthumously) to which he devoted many years ([17], pp. 135-138) in collaboration with Eluard who helped to plan the typography. Miró's own desire, as he states it, is to " go beyond form to achieve poetry " ([17], p. 37). Like Ernst, Miró experimented with " Painting poems " and, reminiscent of Eluard's attitude, are his words concerning them : " I make no distinction between painting and poetry. It therefore happens that I illustrate my canvasses with poetic phrases and vice versa " ([17], pp. 96-98).

Eluard, both in his poem of 1926 and in " Naissances de Miró ", the prose poem published in *Donner à Voir*, comments on what he sees as Miró's

unique quality : the nudity of his paintings, in spite of the latter's tenderness for " un chemin orangé et mauve, des maisons jaunes, des arbres roses, la terre en deçà d'un ciel de raisins et d'olives . . ." ([3] I, p. 946). This tenderness for ordinary concrete objects, for colors and shapes, has much in common with Eluard's own poetic universe with its emphasis on the shining outlines of creatures and objects, on earthbound pleasures, the joy of the present moment, a world eternally young.

Miró's bare style and his " arbre des couleurs " ([3] I, p. 946) have been emphasized by modern critics whose comments would indicate that Eluard's poem is concerned precisely with the period 1925-1927, when Miró was especially influenced by surrealism, specifically by surrealist experiments with automatism ([16], p. 66). As in the poem to Klee, the style suggests a childlike vision comparable to the poet's, united with a humorous tone, especially in certain lines (2, 10) which answer to the painter's use of a humor " playful and naïve " ([17], pp. 74, 80) and, unlike Klee's humor, full of joy. The nudity of style can also be compared to Eluard's own search for " une poésie du dépouillement grammatical, du respect des mots nus . . . de l'ellipse " ([9], p. 100). On another level, Miró's bare style may have corresponded to an attitude toward life which is expressed in Eluard's poetry : a rejection of past clutter, a devotion to the present love, which Richard has described eloquently : " Loin du passé nous voici rendus à la clarté, à la nudité, à la jeunesse " ([11], p. 114), and which Eluard himself has sung amorously in *Répétitions* : " Chaque jour plus matinale Chaque saison plus nue Plus fraîche " ([3] I, p. 110). Inevitably nudity has metaphysical associations for the poet. If it represents a plunging into the eternal present, it is linked also, of necessity, since we are human, with rebirth and transformation, with beginnings and endings :

> Soleil de proie, prisonnier de ma tête,
> Enlève la colline, enlève la forêt.
> Le soleil est plus beau que jamais.
> Les libellules des raisins
> Lui donnent des formes précises
> Que je dissipe d'un geste.
>
> Nuages du premier jour,
> Nuages insensibles et que rien n'autorise,
> Leurs graines brûlent
> Dans les feux de paille de mes regards.
>
> A la fin, pour se couvrir d'une aube
> Il faudra que le ciel soit aussi pur que la nuit.
>
> ([3] I, pp. 193-194)

In the first stanza Eluard indicates the painter's attitude towards conventional reality. The *soleil de proie* (instead of *oiseau de proie*) which consumes traditional illusions is the *prisonnier de ma tête*, an inner compulsion. The poet ascribes artistic vision and the creative process to this automatic

force (a view held by many surrealists, including Ernst, Eluard, Breton and already suggested by Chirico). Lines two and three, among the most charming that Eluard ever wrote for a painter, are expressed in a language reminiscent of children's stories or folksongs ; they reflect Miró's style and suggest Eluard's own phrase about the painter : " ce monde innocent . . . dont Miró reflète . . . les plus transparentes métamorphoses " ([3], p. 947). Take away the hill, the forest, the dragonflies, the most elemental objects in a child's world, and space is more beautiful than ever. Note that the poet uses a technique which goes back to Cicero : he spends the first half of the poem dismissing images which, as he names, he evokes. Note also, it is the painter who, like God, dissipates with a gesture those precise forms : he banishes the old reality in favor of a new creation ; or one may think of the banished *formes précises* as prophetic of the biomorphism, probably inspired in part by Arp, which Miró investigated around 1929 ([17], p. 62) (I think Eluard is frequently prophetic, in the sense that he anticipates intuitively the direction an artist may take.) In contrast to symbolists like Mallarmé and, later, Wallace Stevens, for whom—to put it simplistically—form imposed upon space gives space its meaning, Miró takes away both form and meaning (" Enlève la colline, enlève la forêt "), as a first step towards his creation which will consist of imposing upon the external world his own internal structure of dreams and desires.

The removal of recognizable objects evoked in the first stanza may suggest Miró's turning from realism to fantasy (and then to a kind of " abstraction ", based on experiments with automatism) ([16], pp. 68-69) and, thus, constitute a summing up of his evolution until 1926. In the development from the first stanza to the second, there is a latent conflict between form and light, line and color, which assumes importance : as the forms begin to blur, the light becomes more brilliant, increasingly " pure ". This process, which Eluard ascribes to the painter, may also be attributed to the poet. Light and transparency are recurring themes in Eluard's poetry : much as he seems to dread the night, he loves the sunlight which bathes the world, its objects, its lovers ; and like the mutual gaze which gives life to the lovers, light may be a source of creation ([11], p. 102). The victory of pure light seems to be what Eluard celebrates in the paintings of Miró's surrealist period. There is an accompanying victory of the artist over space. Space, suggested in the poem by images of clouds and sky, has an entirely different meaning from the empty dehumanized space of city squares, evoked in the poem to Chirico, although Miró's space lacks that other presence, so necessary to the poet's happiness.

In the second stanza, Eluard evokes what he will later describe in " Naissances de Miró " as " Premier matin, dernier matin, le monde commence " ([3] I, p. 946). " Nuages du premier jour " suggests a time even before creation, before human sensibility and divine authority, a time of innocence. Thus I the artist exist before God : and light is created by my instantaneous

gaze. "Les feux de paille de mes regards" suggests, with humor approaching self-mockery, not only this idea of the artist's divinity but also the imperative importance of the present moment. Eluard, I am convinced, was thinking specifically of Miró's painting " La Naissance du monde " (see Plate 39), painted in 1925, and referred to later indirectly by the title of the prose poem in *Donner à Voir*, " Les Naissances de Miró ". Rubin describes the process used by the painter for this picture : " Miró poured a blue wash over lightly primed burlap and then, using rags and a sponge, spread it rapidly in a ' random ' manner. Within the pictorial chaos of these patches, which suggested iconographically a primordial sea, he began to improvise with painted lines that in turn led to flat percussive shapes of black and primary colors. Together these suggested an incipient iconograph of living creatures." ([16], p. 68).

The last stanza introduces the theme of the last day, confused with a new dawn or beginning. One thinks of Eluard's own ideas concerning metamorphosis and " un monde qui se crée en se détruisant " ([17], p. 78). It is also the final stage of the painting and the end of the poem. Note the implications of the construction *Pour . . . il faudrait que . . .* that is, at the final stage of his creation the artist takes over consciously, no longer autimatically, but with an intention in mind. Rubin has cited Miró on his method : " Rather than setting out to paint something I begin painting and as I begin to paint the picture begins to assert itself, or suggest itself under my brush. . . . The first stage is free, unconscious, . . . the second stage is carefully calculated " ([16], p. 68). Eluard in his poem has described a painting in process, from the first dismissal of objective reality to the final purity of the finished work : " Le ciel aussi pur que la nuit " brings in once more a prophetic note, as it suggests not only a sky empty of forms, essential, but—as it turned out years later—a sky eventually to be filled with " Constellations ".

Most of these poems stand alone, as visual evocations of a mood. Usually, however, without some familiarity with the particular painter's universe, the landscape they conjure up can have little specific meaning and give only a general impression of lyricism in, for the most part, a surrealist context. In other words, they bear a comparable relation, occasionally to an individual picture, more often to a stage in a painter's development, as does an illustration to a poem in a *livre de peintre*. If one thinks of Eluard's comment in *Donner à Voir* concerning the *livre de peintre* : " des images n'accompagnent un poème que pour en élargir le sens, en dénouer la forme" ([3] I, p. 982), or Roger Chastel's comment, concerning his illustrations for Eluard's *Le Bestiaire* nine years later : " Les courbes du dessin épousent les inflexions du mot, le verbe se continue dans le trait, *on n'illustre pas un livre on le prolonge . . . dans un autre domaine possible . . .*" ([3] II, p. 1108), one realizes that the aim of the painter-illustrator is to recreate the poem itself as well as his reaction to the poem, in his own medium, and not literally

to accompany a text, however admirably. In the same way, a poem by Eluard may illumine a painter's art and " prolong " visual images into the domain of poetry.

The ideal of fraternity, equality and mutual fertilization is, I am sure, the point of departure for *Voir*, where visual images outweigh the text, in terms of space, but not necessarily in terms of density. If the poet writes a series of poems, the " prolongation " changes, as the painter evolves in time and as the poet's perception deepens. The investigation of a series of poems on a single painter, however, is beyond the scope of the present study. What has puzzled at least one critic of *Voir* is that the correspondences are not always clear : the poetic and visual images seem inappropriate or, on the other hand, all too pat. What lay behind the poet's choice ? Expediency ? Eluard's sense of the direction in which an artist was headed ? Whatever the answer, we must realize that *Voir* has its roots in surrealism and that to search for a rational correlation between text and image is useless. In other words, the impulse which made Eluard choose one drawing or painting rather than another can hardly be termed a " reason ". Sometimes text and image merge ; sometimes they don't. Always there is the nebulous link of atmosphere or feeling. Other questions arise : one wonders about the exclusions. Why is that first nestling of a poem to Arp, a true surrealist happening, excluded, when one considers how eclectic was Eluard's taste in art and, in particular, how many painters he wrote about in *Voir* who are now scarcely remembered ? These and other questions come to mind to which the answers now may never be known.

Finally, and most important, the poems we have considered, like all Eluard's poems for painters, are designed to be at once read and seen—or envisioned (surely such was the intention of the poet)—not as substitutions for the works of art but as evocative and illuminating commentaries, as well, perhaps, as an experiment in the relationship between poetry and painting, comparable to those already attempted by Apollinaire in such poems as " Les Fenêtres " and " A travers l'Europe ". This is how Breton saw them, since he included " Max Ernst I " and " Max Ernst II " in *Le Surréalisme et la Peinture*. They can help us put into words our impressions of a visual experience. At best, they can help us, we who are so often trapped by our own words, *to see*.

ANNE HYDE GREET

University of California,
Santa Barbara

IMAGE AND WORD IN SCHIZOPHRENIC CREATION

The term schizophrenia, coined by Eugen Bleuler, designates a group of functional disorders amounting to a progressive mental illness characterized by disturbance of habitual thought-patterns, withdrawal from reality (autism), and dependence on phantasy, often in conjunction with delusions and hallucinations (paranoid schizophrenia). Erwin Stransky viewed schizophrenia as a disruption of the normal relations between the affective, the intellectual and the motor mechanisms of the psyche, a failure to " connect " that leads to incongruous mental or physical behaviour. He applied the term " intrapsychische Ataxie " to the inner discord common to schizophrenic states, a term which has been paraphrased as " a giddiness within the mind ".[1] Sigmund Freud's contention was that the psychosis could be interpreted as being not just a condition—mental illness—but an activity —a reaction to illness equivalent to a search for coherence.[2] This is to postulate the co-existence of a destructive and a constructive " moment " in schizophrenia, the former being evinced in the initial acute phases of the psychic collapse, when the patient experiences the disintegration of his personality and suffers the anguish of " losing himself " ; the latter in the reactive phase where anguish is gradually allayed by behavioural patterns conducive to the revival of confidence, and indeed a sense of " finding himself " again, even if the diminishing of psychic giddiness cannot always be equated with the restoration of a " sane " balance.

The attention of psychiatrists especially of the German-speaking world has been more and more drawn in recent years to the phenomenon of artistic creativity amongst schizophrenics, and to its therapeutic role as a vehicle of psychic restitution. Previous to the introduction of art-therapy in hospitals came the realisation that certain schizophrenics who have no encouragement to create and no artistic training manage to produce works of extraordinary expressive power. For some time a debate on the significance of such creations has been sustained amongst psychiatrists, and is beginning to attract interest from outside the medical circle. The question of whether psychotic art may be called " art " at all is not one that I wish to examine here.[3] My concern is not so much with aesthetic objects as with the pro-

[1] David Stafford-Clark, *Psychiatry Today*, Harmondsworth, 1952, p. 158.

[2] Cf. Leo Navratil, *Schizophrenie und Sprache*, Munich, 1966, p. 38.

[3] As long ago as 1922, Hans Prinzhorn argued that there exists a single creative urge common to all men ; the view is upheld in recent writings of Leo Navratil and Alfred Bader, the latter maintaining that " il n'y a pas à proprement parler d'art psychopathologique, car le phénomène artistique, l'acte créateur ne sont pas modifiés dans leur essence par la maladie mentale." (*Petits maîtres de la folie*, Lausanne 1961, p. 33). Aesthetic issues raised by psychotic art are examined in the cogent text " Das Phänomen der Begegnung mit der Kunst Geisteskranker " (*Kreativität in der Psychose*, Hanover, 1970) by Jan M. Broekman, who concludes that the question of aesthetic

cesses revealed in schizophrenic creation, and in particular the relationship between graphic expression and the written word. (My discussion does not extend to the equally important media of the spoken word, grunts, gestures and the like, which may well embody meanings for the psychotic, as Arnulf Rainer has stressed.[4]) The fact of estrangement from reality in the psychosis leads me to the proposition that schizophrenic creators are likely to have a freer choice of medium than artists susceptible to external pressures. Hans Prinzhorn points out that a psychotic may very well derive considerable psychic satisfaction from a page of scribbles that will signify nothing at all to anyone else. Lack of semantic content need not rule out the expressive value of these scribbles.[5] Whereas Prinzhorn goes on to argue that one ought to try to draw up a syntax of expressive gestures so as eventually to interpret even the most incoherent scrawl, the point I am content to underline is that *a scribble that is neither word nor image can truly articulate something for the scribbler*. Now, if schizophrenic creation implies constructing not a work for others to admire but a model for a reconstituted personality, the psychotic's choice of one medium as against another will clearly not depend on external opinions as to whether or not he draws convincingly or uses words correctly. The locus of evaluation remains internal.[6] Being wrapped up in himself, the schizophrenic artist will thus be more concerned to satisfy his desire for self-expression than to worry about the adequacy of a given medium as a means of communication with others.[7] Provided the choice is spontaneous, e.g. provided the doctor does not prompt his patient to draw rather than to write, it may be assumed to emerge unrestrainedly from the centre of his being. Moreover, if a scribble that is neither one thing nor the other can be expressive, the hypothesis arises that there may exist a common source from which spring both pictorial and verbal inspiration, an undifferentiated level of the mind *anterior*, so to say, to any preference for words as against shapes. With this hypothesis in view, the relation between image and word will be examined in the works of two schizophrenic artists, August Klotz and Adolf Wölfli, who showed marked interest in both drawing and writing.

evaluation is ultimately inseparable from the psychological question of whether the spectator is really prepared for an authentic existential encounter with the works of the mad or not. The appreciation of psychotic art cannot be dissociated from social and cultural attitudes towards madness itself. In my book *Outsider Art* (London, 1972), I examine the conflict between culturally acceptable art and extra-cultural art (Art Brut), including psychotic art. It may be noted that works by Adolf Wölfli were exhibited—40 years after his death—alongside the works of living artists at the 1972 Documenta exhibition in Kassel.

[4] Cf. A. Rainer, " Katatonenkunst ", in : *Manuskripte*, Graz, 1969.

[5] H. Prinzhorn, *Bildnerei der Geisteskranken* (1922), Berlin, 1968, pp. 57 ff.

[6] Cf. C. R. Rogers, " Towards a theory of creativity ", in : *Creativity*, ed. P. E. Vernon, Harmondsworth, 1970.

[7] Jean Dubuffet, who has long argued the case for psychotic art, holds that art is only truly authentic if created *for oneself* : " Nous croyons fermement qu'il y a un antagonisme irréductible entre la création d'art et le désir d'une communication avec le public." (*L'Art Brut*, No. 6, 1966).

AUGUST KLOTZ

August Klotz, born in Swabia in 1864, developed symptoms of paranoid schizophrenia after an illness in 1903.[8] As his autism grew more pronounced, he saw devilish faces in the patterns of wallpaper, and interpreted the movements of those around him as threats. After a year or so in a psychiatric clinic, Klotz was found one day rubbing fat into a carpet to form what he called masonic signs. At the same time he was composing innumerable letters to the authorities, and compiling various mysterious lists. These may be seen as reflecting the operation of re-structuring a damaged psyche.

The psychotic system developed by Klotz may not have been so ambitious as Wölfli's, but it was still highly organized. In 1905, he sent his uncle, who dealt in textile dyes, the following " colour-alphabet " :

1 a = England = roth, rothe Rübe
2 b = Bronzfarben Metall
3 c = Cochenille = roth
4 d = Sonnenlichtgelb = Straßenstaubfarbig
5 e = Orangefarbig=Deutschland
6 f = feuerflamigroth
7 g = gold
8 h = heliotropfarben
9 i = himmelblau Vergißmeinnicht
10 k = braungold (Hahnenhals Cochinchina)
11 l = braun, Maikäferflügel
12 m = Marineblau, Bethunie
13 n = naturfarben
14 o = tagweiß, Österreich-Ungarn
15 p = purpurfarbig
16 q = quarzfarbig (Crystall Glimmer, Marienglas)
17 r = rosenroth La France
18 s = kleines s = schwarz Rabe, großes S = citronenfarbig gelb
19 t = lila = Veilchen
20 u = grün = Frosch = Rußland
21 v = Pfauenblau
22 w = Wasserfarben (Sonnenlicht durch Wasserglas auf den Tisch fallend)
23 x = lacrimae Christi = roth = Eisenroth (Blut-Eisen)
24 y = ; ; ; ; ; ; ; ; ; ;
25 z = zinnoberroth

The alphabet is a secret key to the relations that make up Klotz' redesigned reality. Numerals are connected with letters and colours, and an example confirms the correspondence. Thus the number 1 is linked with the letter A and the colour red, confirmed by the reference to beetroot and to England (the country usually appears red on maps). Similarly 20 u green is related to frog and to Russia. The colour itemized as 23 x is a shade of red reminiscent of rust, therefore of blood and Christ's tears. The letter " s " will produce an association with black (raven) but will become associated with yellow (as a lemon) if written as a capital. On the face of it, the

[8] For most of the material in this section I am indebted to Prinzhorn's study of Klotz in *Bildnerei der Geisteskranken*.

system is coherent, if a little bizarre. Another list of Klotz' lays down the appropriate connections between colours and chemical substances and herbs. For instance, strychnine is linked with the colour green, hence with leeks, chives and garlic. Under the heading " sulphur ", one finds the colour yellow, which gives rise to the associations of egg-yolk, nitrogen and corpses from an epidemic. Though macabre, these chains of associations have a strange poetry, and are reminiscent of synaesthetic codes evolved in hermetic traditions (one is reminded of the " Voyelles " sonnet of Rimbaud) —systems that tabulate perceptual analogies and thus correlate various levels of phenomenal experience. Whether or not a given list can be implemented in any effective sense, they at least hold the potential for a world system.[9] Klotz, however, seems to have been more interested in the tables *per se* than in their application to reality. By 1914 a yet more complex system had been devised, consisting of a more succinct allocation of numerical values to letters :

1 = tghys	5 = s	9 = c
2 = p	6 = eb	10 = kl
3 = im	7 = x	11 = sidnow
4 = nv	8 = ar	12 = gft

Klotz could add up with astonishing speed the numbers appropriate to the letters of a given word. Thus the word *Rabe* would equal 8+8+6+6= 28, written in the form " Rabe (28) ". From this Klotz might go on to find another word that added up to the same total, and set it by the first as having a necessary connection with it. To this might be added the colour association corresponding to that number, and so on. Or he might arrive at the " simple " number at the basis of the total (in our example, 2 plus 8 gives 10), and see what colour this indicated. Again he might separate the two digits in 10 to give (1) (0), which he interpreted as the dissolving of a crystal or a marriage, 1 being the male, 0 the female. . . .

These few examples convey something of the fascination that games can have when the player is both submitting to the rules and secretly inventing them as he goes along. Since the rules do evolve—the colour for England is red in 1905 but changes to green by 1914—it may be inferred that the sheer fun of inventing arcane connections was more important than establishing a definitive system. The alphabets are of especial interest in that they represent instruments for taking quasi-concrete measurements of words. Furthermore, the analogical alphabets are a meaningful clue to the principles of pictorial composition in Klotz' work : the same passion for resemblances characterizes his drawing method.

Klotz used to draw without preconceptions as to a subject. Anything could be a point of departure : a leaf, a shape in the clouds, a mark on the wall. Sometimes he would place a flat stone on the paper and run a pencil

[9] In the Jewish Kabbala the alphabet was revered as having magical properties, and constituted a cryptogram of the cosmos. Cf. G. R. Hocke, *Manierismus in der Litzratur*, Hamburg, 1959, p. 45.

round it. Or he might make lines with a small ruler, as in the drawing *Der Luftkrieg*. From this mechanical start, he would proceed to add shapes, still without clear intentions in mind. After thus drawing for a while, more or less automatically, he would stop and see what he had produced. Having made a conscious identification of what he saw, he would then go back to his drawing, later pausing for further interpretation, and so on. One may surmise that at each successive stage of composition the creative process would become increasingly purposeful, as the subject took on more consistency in his mind. Alternately free and directed, this is essentially an example of interpretative automatism not unlike that carried out (though with perhaps more awareness of what was going on) by the artist Paul Klee. An arbitrary scribble or line gives rise to figurative associations that are gradually integrated until the drawing emerges as a complex of interconnected forms, a kind of analogical system. A fairly early example of the method is Klotz' drawing *General v. Wölkern Exc. Orden, Ritter pp.—Phantastische Zeichnungen nach dem Gewölk*.[10] It appears on the first side of a sheet of paper folded so as to leave three sides for an explanatory text, the artist's customary method. The text takes the form of a doggerel poem in which various figures are identified. Here is part of it :

> Die Madonna sieht aus einem Orden,
> Der Karneval nach der Feierabendglocke,
> Der Wintersmann vom hohen Norden,
> steht über dem Hosenanzieher Herrn Korday :
> Die Dame bewundert den Schlangenhund,
> die auferstandene Schönheit beschattet :
> zwei Karpfen sind da, mit dem Fragemund :
> Wird denn in einer Heilanstalt auch begattet ?

Sure enough, the picture does contain what looks like a nun's face, two men one above the other, a woman beside a dog with a snake-like body, two fish, and so on. The contours of the figures are coterminous and the juxtapositions not without humour : the lady is clearly not amused at the way the phallic dog presses up against her with a leering look. The carps' query about coition in a clinic may be a wistful joke about Klotz' sexual frustrations. One might surmise that pressing pictorial figures together was his substitute for mating.

Such " cloud formations " or graphic conglomerations run parallel to the artist's fondness for compound nouns. This is well illustrated in the prose explanation of a drawing of six interlocked faces, three of which are numbered 1 to 3.[11] This supposed key begins by identifying these faces with three compound nouns that presumably refer to their shapes : " (1) Oberkugel, (2) Unterring, (3) Mitteneibogen ". But Klotz cannot resist a supplementary explanation : " Die Conglomeratseele ' Fichtdichsan ' dem Spitzwart : Reuchhaupt, Loisset, Flammer . . ."—which takes us com-

[10] See Prinzhorn, op. cit., p. 172.
[11] See ibid., p. 174.

pletely away from the image. The " Conglomeratseele " of the work develops further on the third page, where the associations swell into compound nouns of grotesque length : " (1) Halmdolchfischgradtropfeneiweiß, (2) Weidenfleischgansspringerbogendotter, (3) Ameisengoldvogelschnabelzwickeglas : Sternhautbrennemabspinnennetzkorbgeflechteschtantlederfinnenteppichlaushautfett." Is this word-salad a string of arbitrary associations, or is it a deliberate attempt to pin down at speed a network of ideas of great complexity ? The definitions, already irrelevant to their ostensible object (the three faces) do convey a novel impression. What Prinzhorn calls Klotz' *Wortungeheuer* are conglomerates that may be said to coalesce separate incidents into one pregnant moment. The reader is obliged to fill in imagined verbs and conjunctions so that the elliptic condensations can expand into meaningful sequential statements. The sequence in the first of these telegrammatic " poems " conveys a dynamic impression : (grass)blade/dagger/fish-bone/drop/egg-white. Would it be far-fetched to read these as irrational metaphors of erection and ejaculation ? Bearing in mind that each constituent of the noun is integral to the total object being defined, i.e. each component is in apposition to each other component, one could read these as quasi-surrealist sequences wherein a concrete object once mentioned is subject to instantaneous metamorphosis into something else. There is a surrealist flavour to the prose passage that follows the above texts :

> 7000 Morkblätter einspinnen, daß er den Baum falle, wie ein Nachtwächter des Tages das Licht ausbläst = am Malvendocht der Häringsseele seilet sich der abgefallene Fischschwanz und Transportleuchtestiel in das Mutterat = den Mehlbürzel der Bierzellenkreide—als er in den Wald stieg und zog am Ätherleinenwurzelfaserluftgewebe wie ein Moeßmer an der Samenglocke, rammelte er als Affe in den Haarfedern des Mimosenfleisches Rührmichnichtan vom Boxhornapothekerstrich im Mädchenscheibenglas des Schädels Nasenherz, die Jagdstube. . . .

The breezy humour of this nonsense is close to that of the surrealist writer Benjamin Péret ; there is even a hint of a proper meaning hidden away behind a lot of mischievous double-dutch. These giddy ramblings may be the result of a semi-deliberate exercise in conjuring up enigmas. The barbarous nouns and non sequiturs that sabotage meaningfulness may be evidence of a delight in mystery for its own sake. In this respect Klotz' prose could be called " mannerist ", in the sense that Gustav René Hocke uses the term—having its *raison d'être* not in the formulation of messages but in the sheer enjoyment of manipulating a medium in a convoluted way that suppresses more than it transmits. The final significance of mannerist works as so defined is their very aversion to explicitness : their meaning is Enigma, their refusal to speak out is their whole message.[12] Schizophrenic art being a mode of self-affirmation, and often of self-defence, Klotz' elaborate puzzles are an index of his autism.

[12] Cf. Hocke, *Die Welt als Labyrinth*, Hamburg, 1957, and Leo Navratil, *Schizophrenie und Kunst*, Munich, 1965, pp. 17-21, 98-99.

Prinzhorn draws attention to a schizophrenic tic of Klotz, the accentuating of certain lines and contours so as to produce an effect of mysterious polyvalence. A good example lies in the picture *Keller, Wirtshaus, Salon, Stall in Einem. Cigarre weg* ! (see Plate 40), in which the quiff of hair of the central male figure is *also* the outstretched wing of an eagle. Prinzhorn shows that the picture demonstrates the same principles of condensation, superimposition and contamination familiar to students of dream-work and Freudian analyses of speech-errors and jokes. Like a dream that can achieve a marvellous concentration of disparate mental events, the drawing depicts four superimposed locations—cellar, inn, salon, stable, all in one. If one is receptive to metonymy—a given locale being signalled by the presence of a single part or aspect of itself—one can see how the four places are crowded into one. Prinzhorn interprets the curve on the left as a barrel from the *cellar*, and the face on the right as that of an *innkeeper* ; the dandy in the middle represents the *salon*, and the ox in the right-hand corner stands for the *stable*. (Prinzhorn does not explain the naked boy being borne off like Ganymede on the eagle's back, nor the lighted cigar he is tossing away. There is a peculiar buoyancy about this part of the scene.)

A penchant for what Prinzhorn calls '' schwebende Doppeldeutigkeit '' can be felt in both prose and drawings. One of Klotz' pictures bears the intriguing title *Kaminfegerschnee im Frühling*, which combines two contradictions : black/white and winter/spring. This suspension of opposites is like an arrested dialectical process, a having-both-ways rather than a compromise or synthesis, and seems to typify the thought-processes of schizophrenia. In the drawing *Der Luftkrieg* (see Plate 41), the two spear-like shapes appear to counterbalance one another, one pointing up and the other down. The drawing *Wurmlöcher* (see Plate 42) contains a number of highly successful ambivalent shapes. Here is a profile decorated with various shapes in lieu of hair. There are twelve little curved motifs, construed by Prinzhorn as an absurd combination of worms, caterpillar heads and fingers with nails. To the left are five nun-like faces (there is a similar half-hidden face in *Walfischer*—see Plate 43), and these look out from curved hoods which are *also* the neck and head of some sort of flamingo. There is a further set of three shapes, more angular, which I cannot make out. The whole head appears flattened at the back of the skull like a cross-section of planed woodwork. The effect of this remarkable puzzle-picture is enhanced by its long-winded prose '' explanation '' :

Wurmlöcher (Badegesichter) Wurmzüge (Klaviermusikstockzähne) Wurmbänder (Speichelbadeleben der Erzleiergallerie-Zinn-Zeitler-Spieglereien : ad Mutterzuckermond im Siebensalznasenwasser. Die Sehzunge ist in den Kopfmandeln der Unterleibhoden im Wechselzuckfünfer der Nasenspitze ad Sehsim-Kalender 1905 Jordon ad Biblia = Leib = Ja = Eselsbrücke = Heytrajekt = Stalenlöcherstecher = Kastanienholzgeistameisen = Kupferroth = Glasmilch = Lakmus = Lakaien = Kalium : Lamm—Ohr am Stein Aug am Herz

= Scholle unter dem Brunsteiter = Krebs : Gottfels = Sohn = salzsule = Hymengeist = Dreiheit Ammoniak Salmiak Spiritus veris (Ameisengeistwurmdrehe) Igelfisch = Kaviarstaterlocher = im = Magennasenaftermaul, auge' = Politur = Polizze = Daumen = Damenschlafsilberhandel = ad M. 500 000 Y ad Eschrich Zimmermann. 27. März 1919 Fingerhackeldaumendamenniere = Frl. Schwarz (30) Y "Siehe dies an und unterstütze" (206) Untergesichts —Taster—Strontiam—Salat Dr.

Though maintaining the tone of a specific, even pedantic guide to the contents of the drawing, the text is a freely roaming collection of irrational associations, with equation-marks as a variant on the running-together of nouns into compound formations. (German hyphens, as Wölfli's handwriting shows, are often indistinguishable from equation-marks.) There are some easy-going " clang " associations (" Lakmus / Lakaien / Kalium / Lamm " ; " Politur / Polizze " ; " Daumen / Damen "). Looking more carefully, one can pick out apparently thoughtful fragments of meaning : there are mentions of names and dates, parts of the body, and reminders of the alphabetical tables in the references to colours and minerals and the totting-up of letters towards the end (though the 1914 table seems inapplicable to the scores 30 and 206). All in all, though, the rationale of the passage (if any) remains Klotz' secret.

The later drawings of this artist exhibit a stable symmetry that corresponds to the levelling-out phase of the schizophrenic process. They are confident, rather monumental representations of Egyptian scenes, which I find much less stimulating than the earlier, more eccentric works where one is kept guessing, thanks to Klotz' refusal to recognize a firm distinction between control and spontaneity, intention and accident, secret code and sheer nonsense.

ADOLF WÖLFLI

Adolf Wölfli (1864-1930) was certified a dangerous psychotic in 1895, and spent the rest of his life in the Waldau clinic near Bern.[13] His condition was analyzed as paranoid schizophrenia, manifested in autism and occasional outbursts of violence. Eventually Wölfli was confined in isolation—much to his satisfaction !—and his bare cell became the background for a colourful phantasy-world, elaborated over the years in a prolific output of drawings and writings. When he died in 1930, hundreds of pictures and sheets of writing were left stacked metre-high in his cell. In his study of Wölfli, Walter Morgenthaler stresses the artist's obsessive concentration, which he inter-

[13] My main source for this section has been Dr W. Morgenthaler's study *Ein Geisteskranker als Künstler* (1921), translated by Henri-Pol Bouché in *L'Art Brut*, No. 2 (Paris, 1964) with a lively introduction and many illustrations of Wölfli drawings from the Collection de l'Art Brut. I have also referred to Dr Th. Spoerri's *Die Bilderwelt Adolf Wölflis* (Basle, 1964) and to the excellent catalogue of the 1971 Wölfli exhibition in the Kupferstichkabinett, Basle. I should like to thank Dr Gunter Hofer for his assistance in collecting illustrations for this article, and Dr Eva Maria Krafft for transcribing one of Wölfli's texts.

prets as being directed towards the reconstruction of the dissociated personality by the organisation of patterns on paper. During the vertiginous outpouring of lunatic inspirations, there emerged a normative principle as a corrective to disintegration and chaos.

Wölfli's works are based upon an elaborate personal mythology. In his grandiose vision, he places himself next to an all-powerful Creator as God's child, the infant St Adolf II. Allegedly relating memories of his childhood up to the age of 8, Wölfli tells of the travels he undertook with his parent and guide when they would go on endless journeys of inspection through the cosmos, usually with a retinue of gods and goddesses, members of the divine family, fiancées, grandchildren. . . . Travelling by air, sea or rail, St Adolf crosses oceans and continents, calling in on royal Cities full of Grand Hotels, cathedrals and banks, located in all corners of the globe. In this imagined realm, Wölfli is the indefatigable manager of the magnificent spectacle of his possessions. He perceives and therefore owns all things : glaciers, mountains, gigantic caves, limitless forests where lurk strange birds and giant snakes with scales marked with musical notes, and constellations of stars whose value he will spend hours calculating. One feels that Wölfli's Creation resembles a series of concentric rings that encompass progressively more extended gatherings of space. The uniform epic of St Adolf's travels is punctuated by the catastropes that befall him, for he regularly tumbles off a cliff or a tower, smashing to smithereens below, only to be resurrected by one of the protective goddesses in his entourage. Again and again he confronts death—occasionally shown in the drawings as a naked demon with a huge scythe—and each time imaginative vitality wins out over imagined destruction. For as master of this expanding universe, Wölfli can never die and equally may never falter in his effort to relay the totality of his visions.

Wölfli's drawings, done in black or colour pencil on various sorts of paper, constitute the *Inszenierung* (his own term) of this fantastic autobiography. Apart from some numbers of a travel magazine called *Über Land und Meer* and an old atlas, Wölfli appears to have had no sources of inspiration from the time he entered the clinic. His art springs spontaneously from the undifferentiated levels of his psyche, there being little or no elaboration of a reasoned, analytical kind : his subjects emerge fully-developed and are recorded in a mechanical way. Unlike Klotz, Wölfli does not develop ideas as he goes, and his method of composition allows for a diminishing range of choices once the picture has been embarked upon. He begins at the edge of a sheet with a patterned border, often advancing some way towards the centre before launching into the main subject of the design. Secondary details are then added, but lack of space will usually prohibit development beyond the initial idea. Much of the later work will be pure decoration. After the drawing is completed, Wölfli turns it over to write a prose explanation—here, as we shall see, frequently seizing the chance to go off at a refreshing new tangent.

The pictures may be " read " from all angles, since they were composed
by turning the sheet round to suit the artist's convenience (a *modus operandi*
not uncommon among schizophrenic artists). Few spaces are left blank :
Wölfli has a limited but effective repertoire of stereotyped motifs that he
uses to fill in gaps—what he calls his *Vögeli* ("little birds", shaped like
distorted high-heeled shoes and bearing two dark blobs which have been
variously interpreted as semi-colon, the eye and ear of a bird, or the female
orifices) ; oval shapes or " slugs ", also equipped with blobs ; stars, circles
and " rings of bells " (discs connected by a line). Using permutations of
these, Wölfli manages to create aesthetic intensities of nigh-abstract appeal.
Though Wölfli's actual subjects are varied—buildings, railways, rivers,
animals, people, etc.—his method of representation is not very flexible.
Male figures are distinguishable from female ones only because they sport
flamboyant handlebar moustaches ; there is rarely any sign of facial ex-
pression, a not uncommon feature of schizophrenic work. As Wölfli grew
older, he paid more and more attention to the eyes of his figures, and the
three drawings reproduced here show the evolution from heavily stressed
eyebrows to eyes surrounded by areas of black that have the effect of masks.
Generally the bodies are depicted with little sense of solidity or strength.
They are all unsubtle, primitive manikins, so that in a given scene, the
characters are very difficult to differentiate. There is scarcely any attempt
at perspective : a picture of Bern, for example, will show the city flattened
out and viewed from above like a street-map. Undeniably the drawings
lack finesse as representations of the scenes they supposedly portray. As
an outsider, one is forced to seek the artist's explanation if one is to apprehend
his meaning. It is possible that Wölfli himself turned to prose for the same
reason : dissatisfaction with the pictorial medium on its own.

The prose commentaries—what Wölfli called his *Erklährungen*—appear
on the reverse of his drawings from about 1915 onwards. These texts are
written in a looping Germanic script of large size that snakes restlessly but
systematically across the paper, usually to fill all available space (see Plate
44, the text to the circular picture *Schützenfest*). The lettering is not in
fact very difficult to decipher, yet its unfamiliarity may make us receptive
to its intrinsic pictorial qualities : the curling letters " h " and " d " and
the jagged " s " and " r " create abstract rhythms that may precede seman-
tic content in the mind of the reader. However, our starting-point must be
to assume that the explanation is just that : a verbal supplement to what
has, adequately or otherwise, been expressed in the drawing. The explan-
atory text of *Riesenstadt* has just this function of a specific guide or key to
the elements of the drawing (see Plate 46). The text firstly gives the words
that belong to the musical score at the centre and again at the circumference
of the picture. It then goes on :

> Erklährung. Das gantze Bild ist die, 10,000 Stund, ausrechnungs-
> ansatz haltende, an Ihre Süd-Grentze, an Aschen-Hall : Ost-Grentze,

an Soventt-West : Nord-Grentze, an Zobel-Stadt : und, Westseits,
an Grum-Wand-Ost, an Grentzende Riesen-Stadt, Waaben-Hall, mit-
samt dem gleichnamigen, Skt. Adolf-Ring, ditto, Schatz'l-Ring,
Zentrums-See und gleichnamigen Insel-Ring mit der ditto Skt. Adolf-
Bank. (Die Riesen-Fonttaine hat 500, Stund, Sprung-Durch-messer :
Mitsamt dem Fall, ditto, 1.055, Stund : Und, 111,000 Stund, Schrung-
Höhle.) auf den nördlichen Baleaaren im Königreich Spanien. Der
innerste Riesen-Grand-Palast-Ring, rings um genantten See, das sohg.
Töchter-Institutt, ist 11,000, Stund, im äußer'n Umfang : 2,75 Stund
breit : Und hat 1,750, Stund im Rechnungs-Ansatz. Eine kleine
Ansicht desselben, (Nuhr ein kleiner Theil von einem Arbeits-Saal.)
ist natuhrgetreu, ersichtlich, im, Über Land und Meer-Band, 38,
Jahrgang, 1,877 auf Seite, 1,017. Vom genantten Saal habe ich im
Jehnseits, 45 Gemahlinnen. Und, sihe, Bild auf Seite 813, Variat-
tion No 4, ist meine Wenigkeit und, die großgroßkeiserliche Krohn-
Prinzessin, von Aschen-Hall : Die springende Mina Untten rechts, ist
ditto, von Waaben-Hall. getz. Skt. Adolf II. Bern. Schweiz. 1917.
Dieß ist ein Meister-Werk. Porträt-Wert. 2.00.000 Fr. Mach's nach,
wehr kann.

This explanation describes the town, with its lake, bank, fountain (accurately
measured), and other features of note. We are allowed a view of a classroom
in a girls' school, where St Adolf peeps in on no less than 45 imaginary
wives. . . . A pseudo-erudite authentification is afforded by the reference
to the magazine *Über Land und Meer*, page-numbers and all. The text
winds up with the proud estimate that this unrivalled masterpiece is worth
200,000 Swiss Francs.

Though details may escape us, we would accept that the character of
this text is that of a clarification of the drawing. Yet other of Wölfli's
so-called explanations are no more than pretexts for extrapolations that
diverge completely from the image. Such texts rival with, and even super-
sede the picture, so that even if they appear on the back, they may be con-
sidered separate works. An example of such an " independent " text is this
lively description of cosmic travelling :

Erklährung. Von meinem Gebuhrts-Jahr, das heißt, vom 1. Märtz,
1864, ahn, bis Februahr, 1890 : Durchreißte ich mit der Groß-Gott-
Vatter-Familie, in 10, jeh, voneinand'r getrennten, verschiedenen
Reise-Perioden, nach allen Richtungen der Wind-Roose hinn, von
Steern zu Steern, auf einem gewalltigen, Riesen-Blitz-Transparantt
der Obgenantten, die gantze und gesamtte, alte und Neue, höchst
eigene, Skt. Adolf-Riesen-Schöpfung : Wie auch, ein gantz gewalltiger
Theil der absolutt, End und Grentzen-lohsen, ditto Ewigkeit. Nach
der Abreise von Unserer Erde, kahmen Wihr in spiralförmigen Kreis-
Linien ahnsteigend, viele Tausendmahl um den Südmeridian-Zohrn-
Hochalp-Stock, ditto Riesen-Gletscher und Riesen-Fonttainen-Thurm
herum, direkt auf den riesenhaften, Lila-Stärn, von woh aus, Wihr
des Nachts, gegen Norden zuh, deen, noch viele Tausend mal größeren
brennend und dunkelroht gläntzenden und funkelnden, Nelly-Stärn,
erblickten. . . .

The divine family travels to all points of the compass on a lightning-fast aerial

vehicle that takes them in spirals across southerly mountain peaks, a huge glacier, a tower, finally to reach a massive star whence the company can view a yet more distant monster star, shining dark-red in outer space—a powerful vision.

Discrepancy between image and word should not surprise us, since schizophrenic verbalisation can often be a febrile *Vorbeireden*—a talking off or beyond the point whereby irrelevancies gain the status of central arguments until ousted by further divagations. Successions of ill-related points are however more prevalent in Klotz than in Wölfli, whose parade of novelties does have coherence thanks to the omnipresent theme of St Adolf's unique status as " das Zentrum von diesem gantzen Chaos ". Here the relaxation of control over thought-associations does not lead to nonsense : indeed, the more one explores Wölfli's inner world, the more it " adds up ".

Some characteristics of Wölfli's prose style are immediately striking. He uses an eccentric punctuation, placing commas in odd places, often to stress the following word. At the end of a sentence, his full stop is inordinately large, as though to give an impression of monumental finality to the statement. Wölfli's native tongue was *Berntütsch*, and this colours his German considerably, resulting for example in the drawing-out of certain vowels, the elision of others, the use of clipped interjections such as *Ebjä* !, dialect forms such as *isch* for *ist* and *itz* for *jetzt*, and the diminutive suffix *-li*, as in *Grittli* (Gretchen). These divergences from standard German are further aggravated by deliberate deformations of spelling, such as the doubled vowel in the word *Kultuur* or the ' h ' added in *Uhrwald*.[14] This last word is also a pun : *Uhrwald* = *Uhr* + *Urwald*. Henri-Pol Bouché points out how after associating " clock " with " jungle ", Wölfli goes on with imperturbable logic to give the spatial measurements of the jungle in terms of hours and minutes. Elsewhere he will dislocate syllables to form absurd sequences, as in " Zingel-Schlange oder Schlingel-Zange ", or " Vonnaari-Kagali " (instead of " Kanari-Vögeli "—canary). At one point Wölfli proudly refers to his " Allgebra in Schrift, patentiertte, Sälbst-Erfindung ". Like Klotz he revels in long compound nouns, though his hyphens make them more manageable. The typical formulation " Skt-Adolf-Allmacht-Riesen-Grand-Saal " shows his obsession with grandeur and his customary labelling of everything with his own name. Existing words are sometimes used by Wölfli in an entirely novel sense. We have seen how *Stunden* becomes a measure of physical distance ; for Wölfli, *Aphorismen* is a precious stone, and foreign words like *Information* or the Latin tag *Probatum est* are introduced irrespective of their true meaning. (The latter phrase is contaminated by the associations *essen* and *fressen* to move through the form " Probatum : Eßt " to that of " Probatum : Fräßet ".) As a means of calculating his

[14] Navratil points out that certain patients add extra letters as if to show off how good they are at spelling. Such *Überkorrektheit* may be invalid as proof that the schizophrenic knows the rules of orthography, but could be a deliberate means of undermining those rules. Cf. L. Navratil, *Schizophrenie und Sprache*, Munich, 1966, pp. 126-7.

immense riches, Wölfli invented a numerical sequence that takes him far beyond the limited range of mere trillions and quadrillions. The following neologisms constitute an alphabetically conceived numerical sequence, each successive number being a thousand times greater than the preceding one : Regoniff, Suniff, Teratif, Unitif, Vidoniß, Weratif, Xylotif, Ysantteron, Zernantt, Agoniff, Benitif, Corrantt, Deritif, Eratif, Ferrantto, Geratif, Horatif, Inioth, Kariffa, Legion, Miriaaden, Negrier, Oberon. Wölfli may have adjusted the alphabetical sequence in order that the final number should be in " O "—Omega. *Oberon* was for a time considered the ultimate unit, but Wölfli later took a word beginning with " Z ", *Zorn*, the German word for " anger ", pressing it into service as the supreme number, and deforming its spelling to give it maximum stress : *Zorn, Zoorn, Zohorn, Zohohrn.* (The word appears elsewhere as the name of one of St Adolf's uncles).

There is a strange humour, macabre and childish, in much of Wölfli's prose. The following text describes a hunting trip in which a panther tears the 10-year-old Princess Wiegalinda to pieces and gobbles her up. When the beast is captured, she is nonchalantly ressuscitated, as though this were a perfectly normal occurrence !

Die vohrgenantte, heilige Wiegalinda, Eine, damals, kaum zehn Jahre alte, Großgöttliche und, Großgroßkeiserliche Krohn-Prinzessinn, von der Riesen-Stadt, Skt. Adolf-Wiege, auf der Pantter-Bann-Insel, im indischen Ozean, wurde, während Unseres dortigen jagens in einem grossen Uhr-walde. im Jahr, 1,866, von einem gewalltigen Pantter, tottal zerrissen und sauber, aufgefressen, Derselbe wurde dann Uns're Beute und, die Unglükliche, wurde sogleich wieder, auferweckt.

Wölfli's tone is often a skittish mixture of the pompous and the trivial. Evocations of splendid cities will lapse into obscene comments and unfunny jokes. Spoerri writes of " diese Mischung von Enttabuiert—Erschreckendem, Bänkelgesang, tragischem Lebensschicksal, allgemeiner Chiffrenhaftigkeit und Hoppla-Hopp-Gelächter ".[15] The vacillations between the divine and the vulgar must run parallel to the schizophrenic's switches in self-awareness whereby he sees himself at one moment as Saint Adolf, supreme emperor of the cosmos, and at the next as Adolf Wölfli, patient in a mental hospital.

It remains to consider the area where image and word co-exist most intimately, when verbal elements are inserted within the actual picture-frame. Sometimes Wölfli introduces explanations into the drawing to serve as helpful comment or means of identifying a given character or episode. Such a pointer is placed in the picture *Der Vatter Zohrn* next to the tiny figure in elegant boots, shown upside-down (see Plate 47). Here we benefit from the information that this is Saint Adolf falling from a great height. The inserted note gives the precise distance of the fall : " Der Unglückkfall ist, 32 000 Fuss. Nicht weniger : Noch mehr. Getz. (= gezeichnet) Doufi.

[15] Theodor Spoerri, " Kreuzigung meiner Wenigkeit ", in : *Sonntags Journal*, 21 March 1971.

Bern. Schweiz." The figure is identified across the back by the name " Doufi Wölfli ". A precise location is given below the large face of Vatter Zohrn himself : " Milch-Flasche. Der Vatter-Zohrn-Gletscher. Skt. Adolf-Kontinentt. Halbe Felswand-Höhe. 1912." Thus the scene takes place on a glacier (though the milk-bottle remains unexplained). Down the right-hand side of the same picture, Wölfli has inserted an explanation of two elements in the design, the horse-shoe and the musical snake : " Das Roß-Eisen und die Musik-Riesen-Schlange sind im Ring. 1912." The writing inside the horse-shoe apparently gives Vatter Zohrn's comments on the situation : " Na ! Ik d'Jenge, daß wirt sich schon der Vatter-Zohrn sain." The giant snake is recognizable at the centre bottom by the inscription on his forehead. His humanized face is distinguished from a human face by the attribute of a long tongue.

Most of these explanations consolidate what is given. However, the presence of two giant slugs would have escaped our notice altogether had the artist not written on their completely abstracted forms the labels "Sonnen-Riesen-Schneke. 1912" (middle right) and "Zitrohnen-Schneke" (low left). Here the inserted word clearly compensates for an inadequate image. On other occasions, Wölfli inserts words with no apparent reason other than to mystify. A number of pictures are entitled *Bilder-Rähtsel*, and at least one of these embodies a primitive cryptogram—a text written out backwards.[16] In many pictures there are isolated letters or numerals that serve no obvious denotative function. In *Der Vatter Zohrn* the large letters " A W B Sch " in the lower-centre panel can be appreciated as a shorthand for the signature " Adolf Wölfli, Bern, Schweiz ". Yet they have more impact than they would have had in ordinary handwriting, being fashioned in a ceremonious way like ornate illuminated capitals. Furthermore, there are other letters in the picture whose denotative content is nil : a line of capital Z's in the outer ring, and a row of capital N's alternating in a panel with five circular heads, just below centre. Finally, there is the date 1912, an example of a sign in transition from a message-bearing to an ornamental function. When it occurs twice at either side of the bottom of the picture, it serves as a purely formal device in a symmetrical design.

It has been suggested that the non-referential use of letters is an example of " verbal alchemy " where the lettering requires to be read as a calligram of magical import in its own right.[17] The same comment could be applied

[16] I refer to *Bilder-Rähtsel No.* 1 (1916), reproduced in Spoerri, *Die Bilderwelt Adolf Wölflis* and Cardinal, *Outsider Art.* When re-arranged the text reads : " Obernderouf, Sieg, Rütendaler Rosina Komtesse in Sankt Adolfheim." An ordinary inscription offers a massive prize and promises " Auflösung folgt, in No. 2."

[17] Hocke sees excessive decoration of letters as indicative of an early stage of literary mannerism (*Manierismus in der Literatur*, p. 18). Navratil confirms that the insertion of unco-ordinated letters or numerals into drawings is widespread amongst schizophrenics (cf. *S. und Kunst*, p. 99). Conversely they may introduce visual patterns into their texts, such as spirals (cf. ibid., p. 102). In the work of the mediumistic artists Laure Pigeon and Madge Gill I have found examples of texts in which the linear movement of the writing is disrupted by arabesques that transform the words into pictures. In

to the introduction of musical notations into the drawings, as is the case in each of the reproductions given here. Wölfli spent a lot of time composing, noting down mazurkas, waltzes and marches in exercise books and performing them by tooting down trumpets made of rolled-up paper. Wölfli evidently took his music seriously, and in some compositions there are traces of attempted counterpoint : but the means of notation he used is so idiosyncratic that it is unlikely that anyone will manage to play these pieces properly. In the drawings, there are scores in the form of a single stave of six ledger lines (instead of the conventional five) plentifully strewn with little black notes, kept apart rather than linked as in ordinary music. Sharps are indicated aimlessly, as is the time-signature, usually " 2:1 ". Bar-lines are infrequent. Sometimes the notes appear without benefit of stave, as in *Der Vatter Zohrn* ; or the stave itself may occur alone, as in *Craw Fort*, where it curves round in an oval. Morgenthaler observes that Wölfli's tunes were invariably highly rhythmical, and the effect of an insistent march-beat is found in the texts inserted in the latter drawing, full of vigorous monosyllabic rhymes (" witt/litt/Gritt/zitt/nitt/") interspersed with the urgent time-signature " 2:1 "—" Craw Fort, all fort 2:1 Grittli, ritti 2:1 Craw Fort ", etc. (see Plate 45).

Thus even if the musical notes had a genuine auditory value for Wölfli, their impact upon us is that of visual rhythms within a pictorial structure. The words of *Craw Fort* combine with the staccato hammering of black notes to create an insistent pulsation analogous to the effect of the reiterated *Vögeli*. In Wölfli's work, one senses an underlying abstract rhythm that informs all elements : graphic, verbal, musical. The poet Rilke, impressed by Morgenthaler's study of Wölfli, writes in a letter of the instinctive way schizophrenia applies the rhythmic principle to elicit harmony from psychic chaos. He surmises that these findings may throw new light on the sources of creativity.[18]

FINDINGS AND HYPOTHESES

Though by no means similar in style, the works of Klotz and Wölfli have at least some features in common. Wölfli seems the more harmonious and perhaps the more sophisticated artist. The fact that he worked in from the outer frame in his drawings suggests a confidence in his inspiration quite distant from the tentative, exploratory approach of Klotz ; though it should be said that Klotz' later work does show more resistance to aberrant association, and more attention to symmetry and the careful repetition of shapes. Both creators seem eventually to have attained a measure of restitution,

" Le Mot et l'image " (*Le Surréalisme, même*, No. 4, 1958), Robert Benayoun laments the minimalisation of pictorial content in Western calligraphy. Examples of picture-letters or texts in the shape of objects are anthologized in Massin, *La Lettre et l'image* (Paris, 1970) and Berjouhi Bowler, *The Word as Image* (London, 1970).

[18] R. M. Rilke : Letter of 10 Sept. 1921 to Lou Andreas-Salomé, quoted in the exhibition catalogue *Imaginäre Welten—Gestalteter Wahn*, Hanover, 1970.

reflected in an orderly pictorial "syntax". Nonetheless, the idea of patterned, symmetrical work seems more applicable to their pictures than their more impulsive prose. The act of turning the sheet over and writing as if to satisfy an unfulfilled impulse to create, at least suggests a need for relief from the self-imposed discipline of elaborating a personal language of shapes. Does the schizophrenic artist need to relax in uncontrolled play with the less personal medium of language ? If his pictures create a painstakingly unique personal law that can stabilize his psyche, his words are equally a mode of self-affirmation, but this time exhibited through defiant deviation from the external law of conventional linguistic behaviour. In Wölfli's case, the prose manifestly confirms his *control* of the delusional scheme ; Klotz' more anarchic linguistic inventions exhibit a laxer grip which could be seen in two ways : either as a sign of nonchalant confidence, or as evidence of complete psychic disorientation.

Many of the stylistic characteristics I have mentioned may be generally ascribed to the schizophrenic condition. Leo Navratil's handbooks *Schizophrenie und Kunst* and *Schizophrenie und Sprache* list the common features of schizophrenic creativity, such as the tendency to stereotyped reiteration, associative agglutination, distortion, and so on.[19] Although no isolated feature can be counted as a sufficient basis for the diagnosis of schizophrenia, one aspect seems remarkably insistent—the introduction of letters or numerals into pictures. Though, of course, perfectly sane artists such as Klee and Schwitters have employed the device, the way in which a letter is thus envisaged in its distinct " concreteness " and no longer as a subservient element in the language code, seems strongly redolent of the schizophrenic preference for concrete rather than abstract qualities. Further, the habit of inserting letters into pictures is at variance with the ordinary conventions of picture-making, and as such may be a useful index of aberration or rejection of the norm. Navratil draws attention to the parallel between schizophrenic artists and mannerists and posits the relevance to studies of schizophrenic art of Hocke's inventories of the stylistic features of mannerist creators. Their favourite motifs include masks, mirrors, clocks, labyrinths, and spirals. There is a cardinal principle involved here : the love of things abstruse, secretive, inscrutable.[20] Klotz and Wölfli share a love of Enigma, and have a liking of ambiguities and polyvalence. A private language inaccessible to others is something extremely satisfying to the ego : it is a protection against external reality and a confirmation of autonomy. Hence the schizophrenic's delight in his own puzzles, of which he alone bears the secret—even if that secret is merely that there is no solution to the puzzle !

[19] Where language is concerned, most of these deviations are classifiable as manifestations of schizophasia. (Cf. J. H. Plokker, *Artistic self-expression in mental disease*, The Hague, 1964, p. 31). Brendan Maher deals with linguistic disturbances in " The Language of Schizophrenia—a review and interpretation ", in : *The British Journal of Psychiatry*, Jan. 1972.

[20] Cf. Navratil, *S. und Kunst*, p. 19.

Navratil notes of the taste for Enigma that " es kennzeichnet die Stimmung des Menschen, der im Begriffe ist, in eine neue Ordnung einzutreten, aber noch nicht fähig, diesen Schritt zu tun."[21] The implication is that playing with pseudo-meanings is a sign not so much of a regression to autism as an effort to attain a higher position where the prospects of communication will become clearer. To label a drawing " puzzle-picture " is at least to challenge others to solve the puzzle, hence a minimal gesture of communication. Klotz' convoluted titles equally stimulate at the same time as they thwart us. This sort of coquetry with an imagined audience may reflect a need to show off (to become objectively admirable), whilst remaining invulnerable (subjectively admirable). It may be that, to the disordered mind, the process of drawing carries more risk of exposure ; verbal delivery —launched at an insistent, attention-grabbing pitch—may be a means of diverting attention from the exposed image and encouraging an oblique perspective on it. By this I mean that the word may be a means of erecting mystery around unwitting confessions. What Prinzhorn calls the *Fremdheitsgefühl* and Gruhle the impression of *das Gewollt-Ungewöhnliche*[22] would then be signs that the schizophrenic is not just making messages for his own exclusive pleasure, but may be quite painfully aware of an audience.

The problems of intentional enigma-making and involuntary self-exposure aside, it may be possible to make a few observations about the relationship between the expressive media concerned. On the one hand, there is evidence of a *divergence* between image and word at various points : the word will take over from the image the better to express an idea ; it may even contradict the image, or at least instigate new developments that supersede it. The two sides of the paper then have an antagonistic, rather than a reciprocal relation. On the other hand, there is evidence of *convergence* whenever pictorial forms can be seen to *behave like* verbal forms, as with the graphic agglutinations and compound nouns of Klotz, or, more strikingly, with the textual insertions of Wölfli, where words are literally one with the image. Such affinities may support the hypothesis of a common primary stimulus, neither essentially verbal nor pictorial, a stimulus that derives from an intimate creative matrix of inarticulate forms. The late stage of schizophrenia produces an " équilibre oblique "[23] that guarantees a measure of psychic stability to the personality. Might it not then equate to a regulating mechanism that would direct affective discharges through either image or word, in such a way that at any given moment, (and given an absence of external interference), one mode of expression would be chosen as being more creative, more fulfilling than the other ?

Such speculations remain unproven. Yet even if invalid, they may at

[21] Ibid., p. 49.

[22] Cf. Navratil, *S. und Sprache*, p. 50.

[23] Cf. Th. Spoerri, " L'Armoire d'Adolf Wölfli ", in : *Le Surréalisme, même*, No. 4, 1958.

least serve to raise a query that passes beyond the domain of psychotic art to formulate the general problem of the relation of image to word. Why do some artists have the capacity to create in two media ?[24] Why did a movement like Surrealism flourish around the association of painting with poetry ? The problem of the tensions between pictorial and verbal language is of undoubted relevance to any consideration of the work of artists such as Miró (insertion of words into pictures), Ernst (reciprocity of image and word in his collage novels) or Magritte (semantic conflict of picture and title). For the present, the validity of my remarks must rest on the credibility of my analogies. Admittedly their strength lies in their affective appeal, since the intellect is more alert to discrepancies. Even so, emotion and intuition are not to be discarded in an enquiry into such mysteries. In any event, my analogies are not in any sense intended as final proofs. Karl Jaspers once gave a model of the methodology appropriate to such research when he wrote of his own approach : " Was wesentlich ist, geht erst bei konkreter Betrachtung des Einzelnen, bei Gliederung der Fragestellung und bei kontrastierenden Vergleichen auf. Nur so kann erreicht werden, um was es sich mir handelte : nicht vermeintliche beherrschende Einsichten, durch die man etwa ' dahinterkomme ', sondern Einsichten als Mittel zur Gewinnung der Standpunkte, auf denen echte Rätsel gesehen und bewußt werden."[25]

ROGER CARDINAL

Kent

[24] The question is examined by Walter Sorell in *The Duality of Vision*, London, 1970.

[25] K. Jaspers, *Strindberg und van Gogh*, Munich, 1949, p. 5.

INDEX